NATURE PHOTOGRAPHY
Through Four Seasons

PHOTOGRAPHS & TEXT BY

Arnold Wilson

DESIGNED BY
GRANT BRADFORD

Fountain Press

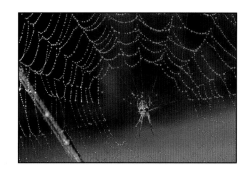

Published by
FOUNTAIN PRESS LIMITED
Fountain House
2 Gladstone Road
Kingston-upon-Thames
Surrey KT1 3HD

Text and Photographs
ARNOLD WILSON

Designed by
Grant Bradford

Edited by
Graham Saxby

Design Assistant and Diagrams
Alisa Tingley

Page Planning
Rex Carr

Index
Leigh Priest

Colour Origination by
Global Colour

Printed in Hong Kong by
Midas Printing Limited

ISBN 0 86343 312 X

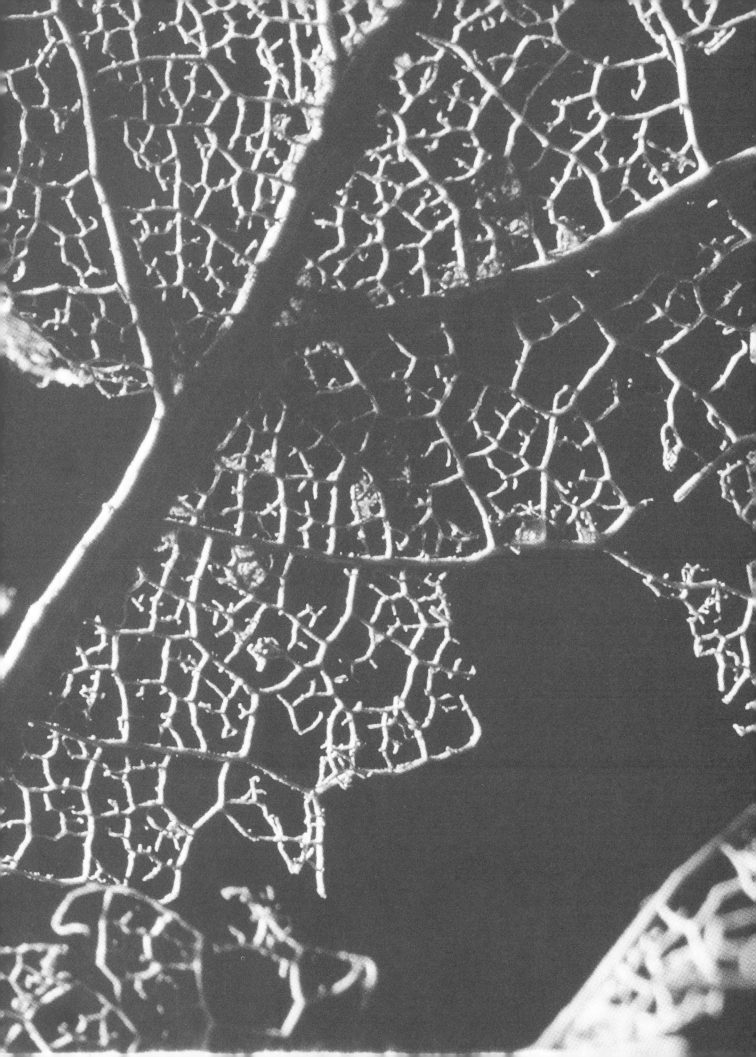

NATURE PHOTOGRAPHY
Through Four Seasons

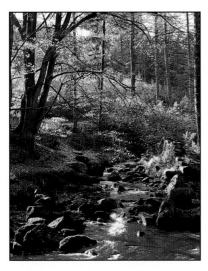
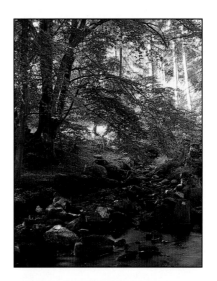
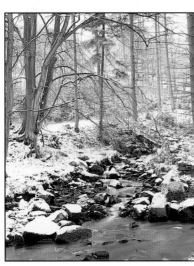
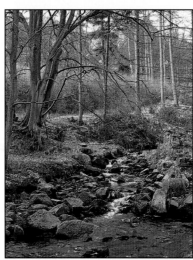

PREFACE

This book has been written with two groups of people in mind: the serious amateur or semi-professional photographer who has mastered the basic techniques of photography and is developing an interest in natural history and the person who is primarily a naturalist and would like to take better photographs of plants and animals in the field.

My approach is a practical one, all the equipment described having been used regularly by myself. How each photograph was taken is described fully, and potential problems highlighted.

An introduction on the origin of the seasons and their effects on animal and plant life is followed by three chapters dealing with equipment and techniques, including close-up work, with information and advice on the types of camera suited to nature photography and appropriate accessories. This is followed by a chapter on composition.

The main body of the book concentrates on the four seasons, with a chapter devoted to each. After a brief discussion about the animals and plants available in each season, I discuss methods of photographing them in the field and indoors. I have introduced some basic photomicrography in the chapter on Summer, to show how exciting photographs of the micro-world are well within the ability of an enthusiastic photographer. It is not necessary to travel abroad to find interesting animals and plants to photograph.

Apart from seabirds and seashore life, all subject matter was found within a few miles of my home, often in my own garden. I have also endeavoured to capture some of the action associated with animals, such as flying insects and birds, leaping frogs and swimming fish. In the plant kingdom, movement is exemplified by the ingenious mechanisms for dispersal of seeds, spores and pollen.

My overriding aim has been to demonstrate that nature photography can be a year-round activity: it is not difficult to find interesting subjects to photograph not only in the Spring and Summer but through the mists of November, the frost and snow of January, and the wet and windy days of March.

The manufacturers of cameras, accessories and other equipment mentioned in this book, together with conservation organisations and licensing authorities are listed at the end of the book.

Arnold Wilson

Leeds 1997

CONTENTS

 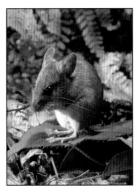

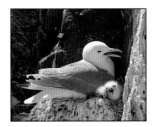

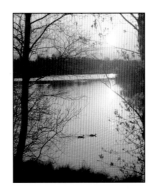

Spring *52*

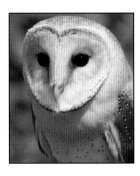

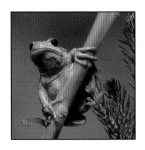

Summer *72*

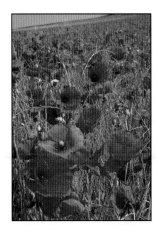

Autumn *98*

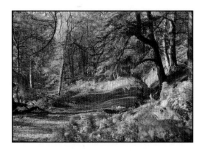

Winter *118*

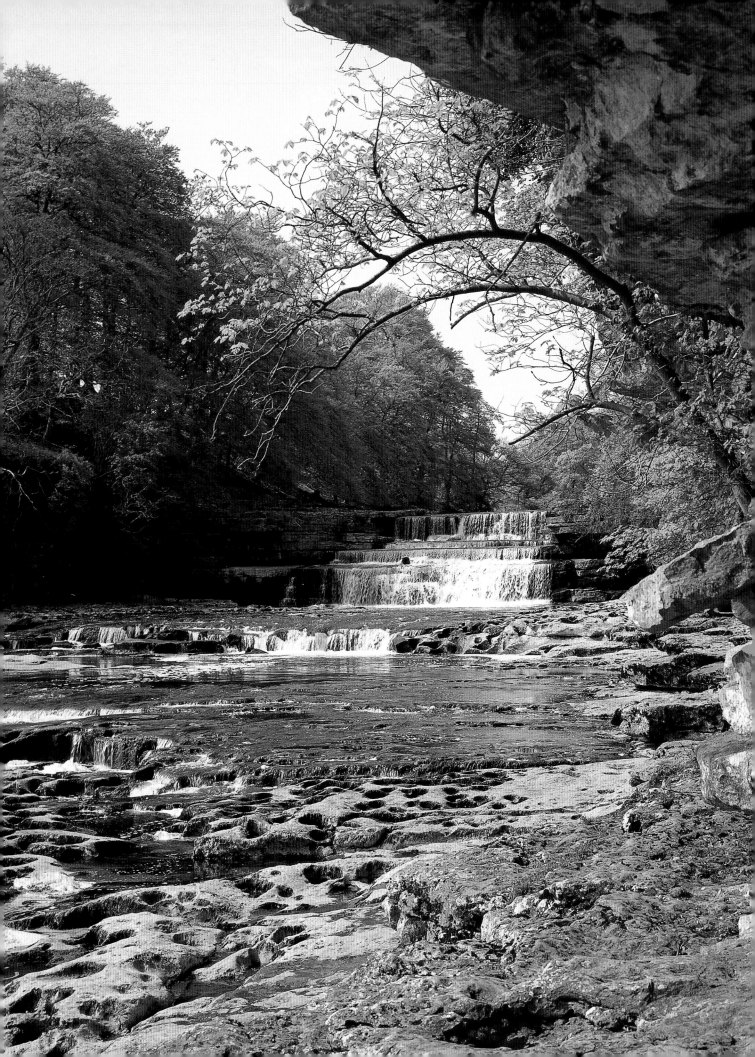

INTRODUCTION

The origin of the seasons

If we are to appreciate the ecology of plants and animals to the full, we must first be aware of the effect on it of the seasonal changes in temperature, daylight and rainfall. This is vitally important to the nature photographer who needs to know what is available in the natural environment during the different seasons.

Seasonal change is largely controlled by three of the Earth's characteristics: its movement around the Sun; its rotation on its own axis; and the tilt of its axis.

The Earth's orbit around the Sun is not quite circular. The maximum distance from the Sun to the Earth is 94.5 million miles, and the minimum distance 91.5 million miles, an average distance of 93 million miles. Although these differences produce a slight variation in the solar energy reaching the Earth, they are not the cause of the temperature changes associated with summer and winter; in fact, the Earth is at its nearest to the Sun in the middle of the northern winter.

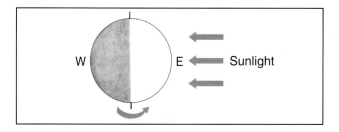

Night and day

The Earth rotates in an anticlockwise direction as seen from the North Pole; thus the Sun appears to rise in the east and set in the west. For just twelve hours each day, any point on the Equator is in sunlight and for the remaining twelve hours it is in darkness.

Aysgarth Falls, Yorkshire Dales, in Spring.

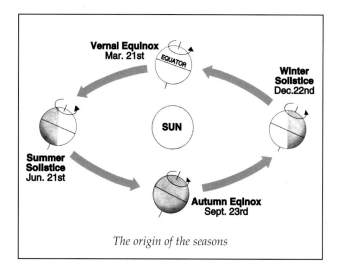

The origin of the seasons

The Earth's tilt

Seasonal variations in light and temperature are the result of the tilt of the Earth's axis of rotation. This is about 23.5° with respect to its orbit round the Sun and this is the key to the seasons.

A person living near latitude 50°N (X on the diagram), which includes such places as Penzance, Frankfurt, Prague and Vancouver, spends more hours in darkness than in daylight in December, because at that time the North Pole is pointing away from the Sun. In June such a person spends more hours in daylight than in darkness, and at the summer solstice (21 or 22 June) experiences the longest day. Half-way between this and the winter solstice (21 or 22 December) are the vernal and autumnal equinoxes, where days and nights are of equal length. Within the Arctic Circle any point is in darkness almost 24 hours a day around the winter solstice, and in daylight almost 24 hours a day around the summer solstice, with equal day and night lengths only at the equinoxes.

Temperature fluctuations

Another result of the Earth's tilt is the seasonal temperature variation. The slow changes in temperature as the year progresses are due chiefly to the varying angle at which the Sun's rays strike the Earth's surface and the length of the day. The diagram on page 10 illustrates what happens when beams of

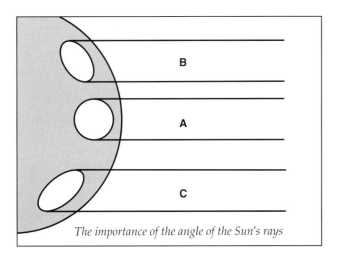

The importance of the angle of the Sun's rays

light of equal width and energy strike the Earth's surface at different angles. Beam A, perpendicular to the Earth's surface, has its solar energy concentrated on a small area, whereas beam B's energy is spread over a larger area. Beam C is highly oblique to the surface, and its energy is spread out very thinly. Thus far less energy reaches the Polar regions than the temperate regions, and the tropics receive most of all. There are several other contributory factors, including altitude, ocean currents, distance from the sea, winds, terrain and cloud cover.

Thus the Northern Hemisphere receives its maximum solar energy between March and September, peaking in June/July, and its minimum solar energy between September and March, with the lowest level in December/January.

Rainfall distribution

The factors controlling the distribution of rainfall are complex. Air picks up water vapour as it passes over oceans (which make up around seventy per cent of the Earth's surface) and is moved around the Earth by changes in air pressure. As moist air rises it expands, cools and precipitates its water vapour as rain. Air rising when it comes into contact with high ground results in 'relief rain'. Air will also rise by convection over hot ground, producing the very heavy rains of the tropics. Finally, cyclonic rain occurs when warm air is forced to travel over cooler air, for example throughout the Doldrums, where the trade winds meet. East Asia, Northern Australia, and Central North America experience most rain during our summer months, whereas Britain, Northern Europe, and the Eastern States of North America have light rain throughout the year. At the extremes, the equatorial regions of Africa, South America, and South West Asia have heavy rain all year round, while the Kalahari, Sahara, Atacama, Asian, and South Californian deserts have little or no rain at any time.

Plant distribution

The distribution of plants is greatly affected by variations in light, temperature, and rainfall. Green plants manufacture their own food by photosynthesis, for which they require water, carbon dioxide, sunlight and a suitable temperature, the required energy coming from sunlight, which is absorbed by chlorophyll in the plant's leaves. Nitrates, phosphates, sulphates and water are taken in through the root system in solution, and are used in the manufacture of plant proteins. Some plants store large quantities of food in the form of starch, and are cultivated sources of food.

Plants produce oxygen as a by-product of photosynthesis, and although they use a small amount for their own respiratory needs, the bulk of it passes out through the leaves into the atmosphere, where it is available to animal life. The carbon dioxide breathed out by animals is used by green plants for photosynthesis, and the life-sustaining oxygen / carbon dioxide balance is thus maintained.

Water is also required to give plants the rigidity essential for cell enlargement during primary growth. The movement of water from the roots up to the leaves is a vital part of the transport system, but loss of water from the leaves is potentially harmful when ambient temperatures are high or water is scarce. Some desert plants develop long root systems to reach deep water supplies, while others (succulents) store water in thick leaves or stems.

Some plants have reduced their leaves to small spines in order to keep down water loss, while others roll up their leaves in dry weather. Plants with unmodified leaves simply shed them.

Plant growth is temperature-sensitive, and usually ceases when the ambient temperature falls below about 6°C. For this reason plant life in certain polar regions is non-existent, while in many tropical regions, plant growth is continuous. Between these extremes are the temperate regions, where part of the year is spent above 6°C and part of it below, resulting in seasonal growth patterns.

Most plants survive the cold winters by producing dry resistant seeds (annuals) or by shedding their leaves and lying dormant (perennial shrubs and

It has been estimated that the large English oak, Quercus robur, gives off several hundred litres of water each day during the summer months. In the cold winter as the temperature falls, the root hairs have difficulty functioning and therefore continued water loss from the leaves would leave the tree water-deficient, so the leaves are shed.

A desert succulent Ferocactus glaucescens which stores water in its well-developed water-proofed stem. The leaves, which would normally give off water vapour (transpiration) are reduced to small spines.

trees). Conifers which have become adapted to cold weather have leaves reduced in size to water-conserving needles which are shed in small quantities all the year round. Forests of evergreen conifers stretch in a large band across Canada, Northern Europe and Russia.

Animal distribution

Animals cannot exist without plants: every food chain has a green plant as its starting point. In isolated regions where plants find it difficult to exist, the animal population suffers accordingly. The photographer who is aware of plant-animal associations and the food chains involved will be in a good position to locate particular animals.

However, where plant life is not a limiting factor, how do seasonal variations in light, rainfall, and temperature affect animal populations? Daylight reduces cropping time in herbivores, also the time available for hunting by some predators. But for many of the smaller nocturnal mammals temperature is probably the controlling factor.

All animals require water to survive. Conservation of water is a problem for most terrestrial organisms.

Water is lost as sweat, during respiration and in urine, and this loss must be replaced by a daily intake. Bird lovers are well aware of this and try to ensure that fresh water is available during dry weather and in freezing conditions.

In hot desert regions, native animals are specially adapted to withstand extreme dehydration (e.g. the camel) or to conserve water to the extent that they can survive without drinking at all (e.g. the kangaroo rat). The camel survives in the desert because of a series of physiological modifications, including the excretion of only small quantities of highly concentrated urine, the production of almost dry faeces, reduction of water loss through the skin, an ability to withstand high levels of tissue dehydration, and the facility to allow the body temperature to rise to 6°C above normal during the day. When water becomes available the camel can consume 70-100 litres of water in minutes without any adverse effects.

The kangaroo rat uses further strategies. It also produces very small amounts of highly concentrated urine and almost dry faeces, and can survive on the small quantities of free water found in seeds and other plant material. It also utilises the metabolic water released when foods are oxidised in the body. These adaptations allow it to survive without drinking at all.

Temperature has a profound effect on the distribution of animal life around the world. Animals are divided into poikilotherms, which have fluctuating body temperatures, and homeotherms, whose body temperatures are high and constant. The former are often misleadingly referred to as 'cold-blooded' animals. Invertebrates, including sponges, worms, shellfish, insects, as well as backboned animals such as fishes, amphibians and reptiles, are poikilothermic; they are active in warm summer weather and lethargic in cold weather. Some aquatic animals survive the winter in the water under the ice; others either hibernate or die.

Birds and mammals, including humans, are homeothermic, with a high, constant body temperature of 37°-40°C. This gives them two great advantages over the poikilotherms: first, it allows the body's chemical reactions to proceed at a brisk rate, making the animals efficient and alert; and secondly, it enables birds and mammals to colonise areas of extreme temperature such as the polar regions and tropical plains and forests. However, in cold regions these animals have to use an enormous amount of energy to maintain their temperature, while in hot

Most people realise that garden birds have great difficulty finding food during the winter, but too few remember to make fresh water available every day, particularly during icy weather.

Seasonal availability of animals and plants — Table 1

	SPRING March-May	SUMMER June-August	AUTUMN Sept-Oct	WINTER Nov - Feb
Temperature range	3°-15°C	8°-24°C	20°-7°C	10°- -7°C
Rainfall per month (cm)	4.57-7.11	4.82-9.90	5.68-14.98	5.59-15.24
Sunshine/day (hours)	3.34-6.80	4.30-7.74	2.75-5.08	0.94-2.83
Microscopic pond organisms	Increase in numbers growth and reproduction	Maximum numbers	Numbers reduce	
Non-flowering plants				
Fungi	Very few except bracket fungi	Numbers increase slightly	Large numbers available. Growth and reproduction	Most die off. Hyphae and spores persist
Mosses and lichens	Persist. Some reproduction	Persist	Persist	Persist
Ferns	Rapid growth	Growth sustained	Growth ceases. Spores produced	Aerial parts die down
Flowering plants				
Annuals	Germination and growth of seeds	Continued growth. Reproduction Plants die down	Production and dispersal of seeds.	Seeds persist
Perennials	New growth. Most trees flower.	Continued growth. Shrubs flower	Production and dispersal of seeds	Plants dormant
Insects	Increase in adult activity. Some eggs hatch	Maximum numbers, growth and reproduction	Numbers decrease	Eggs persist. Few adults survive
Fish	Spawning-egg development	Increase in numbers	Numbers reduced	Numbers reduced
Amphibians and reptiles	Emergence from hibernation. Mating, eggs laid	Development of eggs. Increase in numbers	Numbers reduce. Preparation for hibernation	Hibernation
Birds	Migration to breeding grounds. Residents active-eggs laid	Reproduction. Vigorous growth of offspring	Migration to winter quarters	Residents remain active
Mammals	Increased activity. Emergence from hibernation	Reproduction and growth of young	Reduced activity, leading to hibernation	Some active, some hibernating

A very small mammal such as a mouse, vole or shrew has a large surface area to volume ratio and therefore loses heat rapidly. Its body temperature can be maintained only by a regular intake of energy-rich food, and as a result its 24-hour day is divided into periods of alternate sleeping and feeding.

areas they must expend energy to prevent overheating. In both cases, the methods used to maintain a constant body temperature are both varied and interesting.

Awareness of the effects of light, water and temperature, and the seasonal changes involved, places the nature photographer in an excellent position to predict the subject matter that may be available during any season of the year. Table 1 outlines the availability of a range of plant and animal groups during the seasons in the temperate regions of Britain. This is merely an indication of general trends, with a more detailed discussion in the introduction to each season.

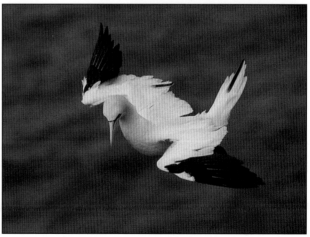

Birds have a constant high body temperature of 40°C (with mammals not far behind at 37°C plus) which makes them fast and efficient. But they must consume vast amounts of food to maintain this high temperature, with the energy requirement at its maximum during wing-flapping flight.

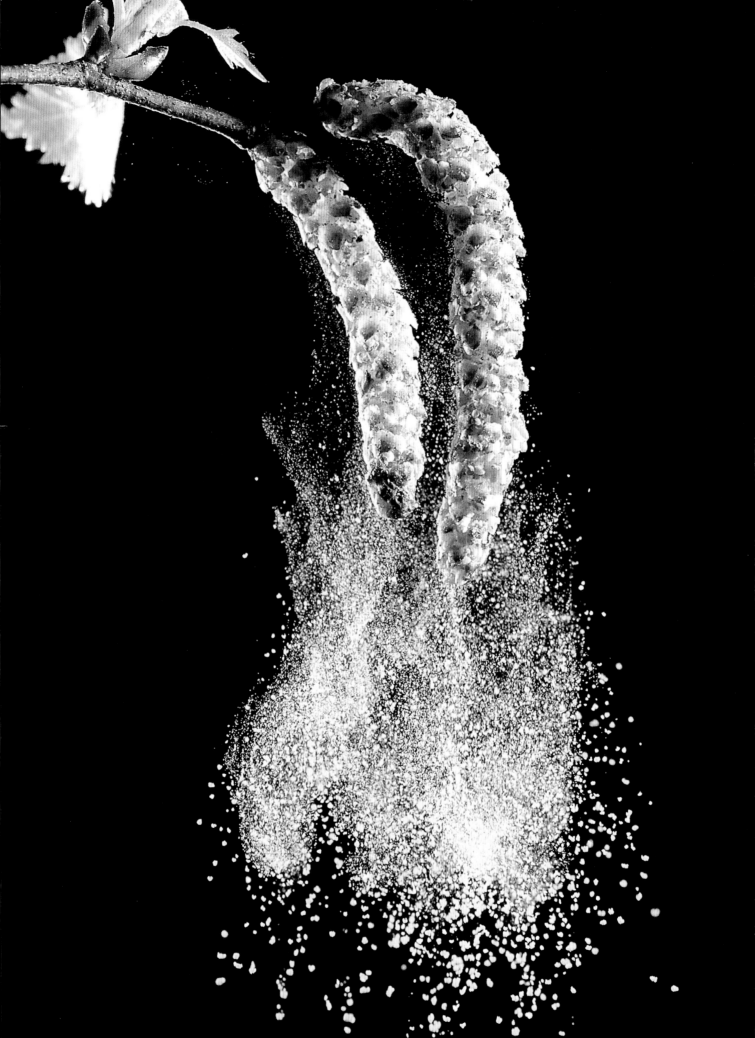

CAMERAS & LENSES

In order to cover a wide range of natural history subjects, you require a good quality camera, not too expensive but fairly light, robust and easy to carry over rough terrain. It should have a bright, accurate viewing system with through-the-lens (TTL) metering. There should be a good range of shutter speeds, from 1s or longer to 1/1,000 s: and the camera should be able to take a cable shutter release. It should be a 'systems' camera, with an extensive range of lenses and accessories available.

Some types of camera can be eliminated at once: compact, studio, twin-lens reflex and Polaroid cameras. This leaves the single-lens reflex (SLR) camera with its interchangeable lenses and readily-available accessories as the main contender for wildlife photography.

You must then decide which of the following formats to choose: 35 mm format (24 x 36mm), 4.5 x 6 cm, 6 x 6 cm or 6 x 7 cm. Almost every camera manufacturer produces at least one 35 mm SLR camera; but when you move up to the 4.5 x 6 cm format, the choice is limited to Mamiya, Bronica and Pentax. The 6 x 6 cm format has always been popular, and a dozen or so manufacturers, including Bronica, Rollei and Hasselblad, produce high quality 6 x 6 cm SLR cameras. The 6 x 7 cm format is available from manufacturers including Pentax, Mamiya and Bronica. Although it is true that larger formats require less enlargement, and thus give better image quality and lower granularity, in practice the differences are less than you might expect.

There are other factors too. 4.5 x 6 cm format cameras cost more than twice as much as 35 mm cameras of equivalent quality, while 6 x 6 cm and 6 x 7 cm cameras can be four to five times as dear. There is also a vast range of lenses and accessories available for 35 mm SLR cameras at prices well below those of lenses for larger formats. Moreover, on the basis of weight and bulk the 35 mm camera wins every time, and as nature photographers may be carrying their equipment long distances, often over difficult ground, this becomes an important consideration, (I am not talking about one camera and one lens, but a bagfull of equipment including telephoto lenses, filters, flash units, perhaps a second camera body and tripod!)

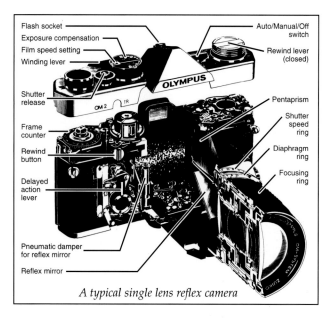

A typical single lens reflex camera

Anatomy of the 35 mm single-lens reflex (SLR) camera

The SLR camera employs just one lens for both taking and viewing. 'Reflex' describes the path of the light: after passing through the lens it is reflected through 90° by a 45° inclined mirror on to a horizontal ground glass screen where the image is formed. With a simple hood to keep out the light we have the SLR camera in its original form. When the shutter is released, the mirror swings up out of the way, allowing the light to fall on the film plane with the image in sharp focus. A focal-plane shutter controls the exposure duration.

The SLR principle has been used in camera design for well over half a century, although the earliest cameras, such as the Thornton Pickard, Ruby Reflex and Graflex, were heavy and bulky and used plates. The German Ihagee company was the first to apply the SLR principle to the 35 mm camera, in 1936. Today this type of camera enjoys a popularity never envisaged by its inventors.

Opposite - Silver birch, Betulina pendula. Taken indoors, flash units at either side and slightly behind were needed to highlight the pollen cloud, while a white reflector lightened the frontal area. A sharp tap on the twig liberated the pollen, and a fraction later the camera and flash units were fired.

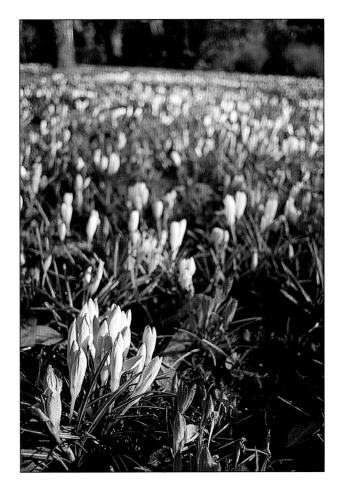

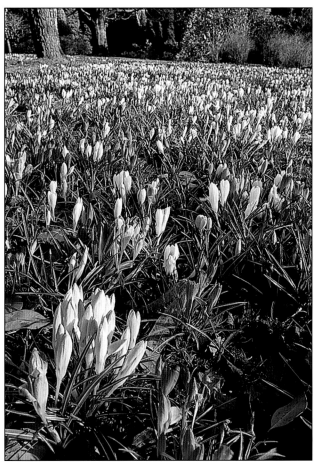

Aperture control

The manual aperture control was later replaced by a semi-automatic and then a fully automatic control allowing focusing to be carried out at full aperture, but with the iris diaphragm closing down to a preset aperture for the actual exposure. However, it is often necessary to be able to judge the effect that closing down the lens aperture has on the depth of field; thus we require a 'preview' button or lever - a feature sometimes absent from modern SLR cameras.

Viewing System

The original optical arrangement of the SLR camera produced an image which was reversed right to left, and the camera had to be used at waist level. In order to provide eye-level viewing with the image the right way round, a 'pentaprism' and eyepiece above the focusing screen were added. This was a tremendous improvement on the original system, although the latter is still supplied as standard on larger-format SLR cameras. On the debit side, the pentaprism is a bulky and expensive addition to the camera.

The focusing screen has been improved over the years by fitting a Fresnel lens above the screen to brighten the image (especially at the corners) and by

Two shots of spring crocuses taken from the same position.

Left - with the 28 mm wide-angle lens fully open (f/3.5) and focused on the nearest cluster of white flowers.

Right - with the lens stopped down to f/16 and focused slightly farther back on the next group of white flowers to obtain the maximum benefit from the greatly increased depth of field.

incorporating a twin-wedge split-image rangefinder or a 'microprism' focusing aid (or both) in the centre of the screen.

With the more expensive SLR cameras a range of special-application units is available, including an all-matt screen for telephoto lenses and astronomical telescopes, a chequer-matt for 'shift' lenses and a cross-hairs clear-field screen for photomicrography. Most modern focusing screens also display information about shutter speed, aperture and exposure compensation, and the reflex mirror includes receptive areas for autofocusing and exposure control systems.

Exposure metering

Although separate hand-held meters are still preferred by professional photographers (larger-format SLR cameras do not usually have built-in

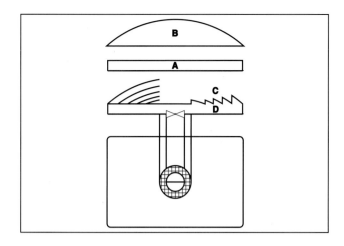

The original focusing screen consisted of a piece of ground glass A above which was placed a plane-convex lens B to brighten up the edges of the field. The modern screen consists of a Fresnel lens C combined with a matte screen D in the centre of which is a microprism collar and range-finder.

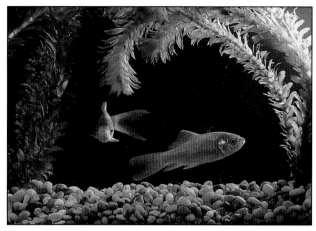

Normal metering, whether manual or automatic, would, because of the black background, give too long an exposure resulting in a greyish background and overexposed fish. For this shot 'underexposure' (downward correction) of one stop was required.

metering), all modern 35 mm SLR cameras have a sophisticated exposure control system as an integral part of the camera design. Over the years the built-in uncoupled meter was replaced by a semi-automatic system linked to the shutter speed and lens aperture settings; but a breakthrough came with the introduction of through-the-lens (TTL) metering, with the exposure determined by sensors located within the camera body, so that only the light reaching the film surface was measured. Exposure problems associated with the use of extension tubes, filters and telephoto lenses were thus solved at a stroke.

As the main subject matter is usually near the centre of the frame, image luminance is usually measured biased towards the centre (centre-weighted metering). Approximately 60 per cent of the final reading is taken from the central area, the remainder from the rest of the field. Centre-spot metering is a useful alternative. A tiny spot representing about two per cent of the total image area is selected for exposure assessment. In experienced hands this gives very accurate exposures. Another method is multi-spot metering, which calculates the mean of a number of readings at points on the image area. These modern exposure controls are battery powered.

Exposure values

Exposure is the product of the intensity of the light reaching the film and its duration. The intensity is controlled by the iris diaphragm and the duration by the opening and closing of the shutter. The iris diaphragm is calibrated in f-numbers (f/nos). These are arrived at by dividing the focal length of the lens by its effective diameter. Thus a lens of focal length

50 mm with an effective diameter of 25 mm has an f-number (relative aperture) of f/2. If the iris diaphragm is now closed down to 12.5 mm the relative aperture will be f/4, and the transmitted intensity will be reduced to one-quarter of its original value. (Not half, as you might expect: the area of the aperture has been reduced by a factor of 4.) An exposure of 1/125 s at f/2 is equivalent to 1/15 s at f/5.6 or 1 s at f/22. These all have the same exposure value (EV). The f-numbers, in ascending order, are arranged so that each transmits half as much light as the previous number, and for the system to work the shutter speeds must be arranged in a similar fashion, each setting being half the duration of the previous one. (In practice the calibration figures are rounded off for convenience in reading.) Over the years maximum shutter speeds have increased from 1/1,000 s to 1/4,000 or even 1/8,000 s.

Exposure modes

Most SLR cameras have a range of exposure modes to satisfy the differing needs of their users. A fully-automatic programme mode allows the camera to select both the aperture and shutter speed. This is of little value to the nature photographer, who needs to be able to preset either the aperture or the shutter speed. Much more useful is the aperture-priority mode where the photographer selects the aperture, leaving the camera to set the appropriate shutter speed. This mode is particularly useful when photographing static subjects or landscapes, as it allows the photographer to select the optimum aperture to achieve an appropriate depth of field. The shutter-priority mode allows you to select a suitable shutter speed while the camera looks after the

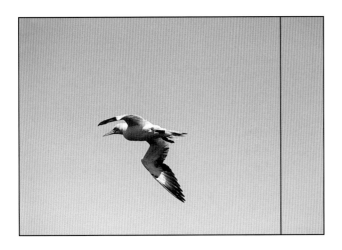

When photographing seabirds in flight the predictive autofocus mechanism on my Minolta 7000i camera occasionally locks on to the bird, as in this gannet photograph, but more often hunts back and forth. When it does finally settle into focus the bird is usually too far away, flying away from the camera.

aperture; this is useful when you are photographing moving subjects where the shutter speed is the prime consideration.

It is also important that the automatic exposure can be modified by the photographer when circumstances require it, and ± 2 stops or more compensation is usually available in 1/3 or 1/2 stop increments. (A 'stop' in photographic parlance means a doubling or halving of the exposure, by any means.)

Finally, most cameras also have a manual mode: the photographer selects both aperture and shutter speed.

Automatic focusing

More than half of the SLR cameras available today have automatic focusing. This facility has been steadily refined over the years so that it is now fast and accurate, and very useful when one is photographing moving subjects.

Predictive autofocusing may also be available. Based on the speed and direction of movement of the subject, focusing continues during the brief period during which the mirror is up blocking the viewfinder. The subject must be located in the focusing area in the centre of the screen, although a focus hold (usually the first pressure on the shutter release button) may allow reframing of the subject for a better composition.

Subjects having exceptionally low or high contrast, or containing a grid of vertical lines (such as a park fence) may cause the system to 'hunt' back and forth. In such situations you may need to switch to manual focusing. Some autofocus cameras lack a depth-of-field preview button, and on many of them the noise

from the autofocus motor may be sufficient to disturb wildlife when working close up. The price of autofocus lenses has fallen so much recently that they are sometimes cheaper than the equivalent non-auto lenses. Of course, if all your subjects are static there is no need for autofocus, and you can simply switch to the manual mode.

In order to achieve the best possible definition from a tripod-mounted camera, you should lock up the mirror before you make the exposure, and use a cable release. Don't buy a camera without a cable release screw socket.

Buying secondhand

When buying an SLR camera always go for the best quality you can afford even if it means having to manage with just the standard lens. Buy additional lenses only when you really need them. It is worth while considering buying a secondhand camera. These cameras have often had very little use and are excellent buys. But check for signs of damage or wear. Also look for burr marks on screw heads (indicating that someone has tampered with the camera), and check the lens surfaces for abrasions and digs. Ideally, you should get an expert to examine the camera before you agree to buy it, unless the vendor is prepared to give you an unconditional guarantee.

Shutter speeds can only be checked accurately electronically, but you can ensure the mechanism is operating smoothly and without hesitancy at all speeds. The mechanism for advancing the film and setting the shutter should operate smoothly and with a minimum of effort. Modern electronically-controlled shutters are usually very reliable, but small faults can prove very expensive to repair.

My own cameras are two Olympus OM2n cameras bought secondhand more than ten years ago and still completely reliable, plus a Minolta Dynax 7000i bought more recently and also performing faultlessly.

Lenses
Standard lens

The standard lens for a 35 mm camera has a focal length of 50 mm, a maximum aperture of around f/1.8, with very good optical correction and containing six or more elements. It is referred to as 'standard' because it gives a normal perspective and angle of view, suitable for a wide range of subject matter from landscapes down to small flowers and insects. Reversed in its mounting it will also function effectively as a 'macro' lens, producing good quality images larger than natural size.

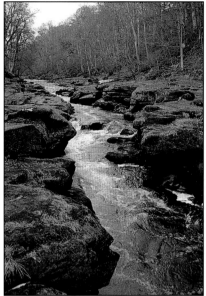 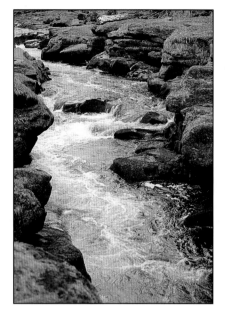 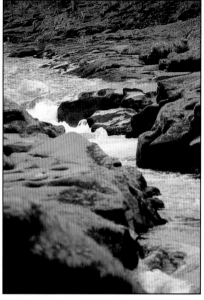

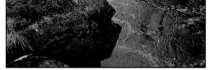

(a) 35mm lens (b) 70mm lens (c) 210mm lens

These photographs taken from the same position to demonstrate the effects of focal length on image size and perspective.

Wide-angle lens

These lenses have short focal lengths, ranging from 38 mm down to a 16 mm 'fish eye'; they have a much wider-than-normal angle of view, and increased depth of field as compared with standard lenses. Lenses of around 35 mm focal length are useful when the subject is part of a larger environment, for example, bluebells in deciduous woodland or heather on an exposed moor. By closing the lens aperture well down and focusing correctly a sharp image can be produced on flowers from 1 m distance or less, all the way to infinity. The most extreme wide-angle lenses (18 mm or less) produce such strong distortions of perspective that the images can dominate the picture to the point of gimmickry: use them with caution!

Telephoto Lens

A telephoto lens is designed physically shorter than its true focal length. This optical configuration is commonly used for long-focus lenses for 35 mm cameras, and the terms 'telephoto' and 'long-focus' are often used as though they were synonymous. A wide range of fixed focal length telephoto lenses is available, the 210 mm being one of the most popular. It has a reasonably large aperture and can be used to single out middle-distance subjects or to photograph small creatures such as butterflies and moths in close-up without the need to approach more closely than a couple of metres. 135 mm is another useful focal length, especially for hand-held shots, being comparatively easy to hold steady. Lenses from 300 - 500 mm focal length are heavier, and have smaller apertures. They are popular with wildlife photographers as they produce reasonably large images of camera-shy animals from a safe distance.

When the animal is either quite small and difficult to approach, or large and impossible to approach, the ultralong-focus lens of 600-1,000 mm focal length comes into its own. A telephoto lens also allows tight cropping of the main subject without approaching it closely, thus giving more impact and better composition.

One effect of using a long-focus lens is foreshortening, distant objects appearing much closer to the foreground than with a standard lens. If you want to suggest closely-packed trees or a dense spread of crocuses, a long-focus lens will produce the desired effect. The disadvantage is that the depth of field is very limited. Also, the risk of camera shake is in direct proportion to the focal length of the lens, and for hand-held cameras a rough recommendation is to select a shutter speed which is not less than the reciprocal of the focal length of the lens. For example, a 200 mm lens would require maximum exposure duration of 1/200 s, and a 500 mm lens no more than 1/500 s; if ambient light levels do not allow these very short exposures you need a sturdy tripod. Use a cable release or the 'self-timer' setting, and if possible, lock up the mirror before exposing.

Long-focus lenses tend to be expensive, with the price rising dramatically as the maximum aperture

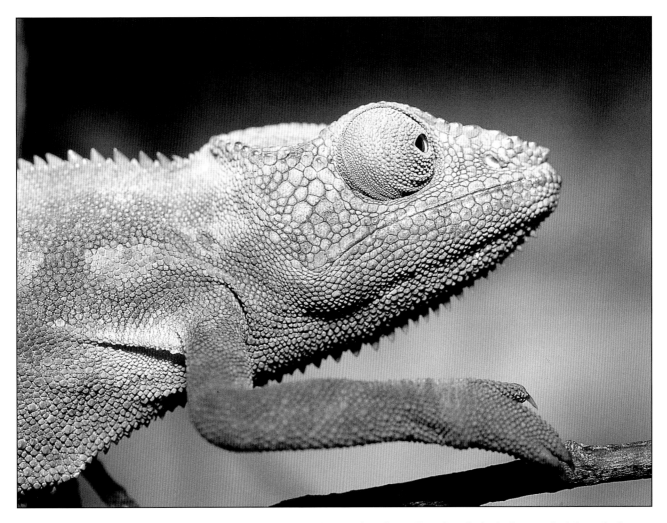

increases. A 500 mm f/7.2 lens would cost around £500 (1996 prices), while a 500 mm f/4.5 lens from the same manufacturer costs just over £3,000! (But it does transmit four times as much light, with a correspondingly brighter viewfinder image.) Such lenses are also very heavy.

As a general rule, optical quality becomes more problematic as the focal length increases, and manufacturers now use extra-low dispersion glasses to produce lenses with better colour correction. These modern lenses also have improved contrast and colour saturation.

Zoom lens

Until relatively recently it was accepted that the image quality of a zoom lens could never match that of a fixed focal length lens - the price you had to pay for the advantage of variable focal length. But today there is little difference in the performance of the best zoom lenses in terms of image sharpness, when compared with fixed focal length lenses, though there is inevitably some geometrical distortion at the edges of the field at the extremes of the zoom.

A chameleon, Chameleon fischeri, photographed through glass using a 90 mm macro lens specially computed to resolve fine detail in close-ups, as demonstrated by the skin detail.

Zoom lenses come into their own when you are working from a fixed position such as a hide or the far side of a river. You can fill the frame exactly as you require to achieve a good composition. Furthermore, two zoom lenses such as a 28-200 mm and a 200 - 500 mm will cover the full range of focal lengths you are ever likely to need.

Zoom lenses tend to be heavy and expensive: they may contain up to 22 glass elements. Most zoom lenses have modest apertures, more so at the long end of the range, where f/4.5 - 5.6 is not uncommon. This can make accurate focusing difficult in dim light.

Mirror lens

As telephoto lenses approach the 500-600 mm focal length mark, they become long, cumbersome, heavy and very expensive. A somewhat cheaper alternative is the catadioptric or 'mirror' lens. This is a combination of lens and mirror elements forming a

Cassegrainian telescope. Light passes through a front corrector element and is reflected from the surface of a concave mirror on to a convex mirror before passing through a further corrector element and imaging on the film.

The benefits of the mirror lens are its compact design, lightness, the long focal lengths available (from 500-2,000 mm) and its low price compared with that of a conventional all-glass lens. A disadvantage is its fixed aperture (usually f/8 for a 500 mm lens) allowing no control of the depth of field. Light intensity is controlled by neutral density filters. Focusing in dim light can be difficult, and exposures may be too long to cope adequately with subject movement. Another curious effect is that out-of-focus highlights appear not as discs but as doughnut-shaped rings.

Macro lens

The standard 50 mm lens is designed to deliver its best performance between infinity and about 3 m distance, whereas a 'macro' lens is computed to give a good performance right down to 0.23 m (about 9 in) for a half-size image. With an extension tube between the lens and the camera body, life-size and larger images are readily available.

Although 50 mm is the standard focal length, macro lenses are also available from 80 to 135 mm focal length, allowing a greater working distance between the camera and the subject. This can result in a more satisfactory perspective and more selective focusing. The only drawback is a more modest aperture than that of a standard lens, usually around f/3.5. In addition, the cost may be two to three times that of a standard lens.

Teleconverter

Why pay a hefty three-figure sum for a 600 mm telephoto lens, when for less than a quarter of the price you can buy a x2 converter, attach it to your existing 300 mm lens and achieve the same results? Teleconverters fit between the main lens and the camera body and function by magnifying the image produced by the lens. They are available in different powers, from x1.4 to x4. So are there any drawbacks?

Well, to begin with, the original manufacturer takes pains to design the best possible performance into a prime lens; adding extra glass elements to one end could well result in degradation of the image. The very best converters, usually with a modest x1.4 magnification, are made by the manufacturers for their own lenses, and perform very well; but they are not cheap. But I wouldn't recommend inexpensive converters made by independent companies to fit any

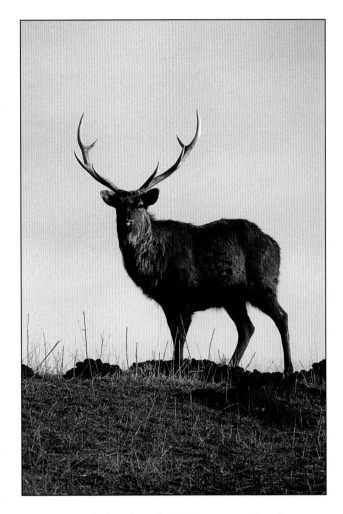

A long-focus telephoto lens of 500-600 mm comes into its own when photographing animals such as the European red deer, Cervus elaphus. Although a resident of a huge deer park I had to stalk the animal very carefully over a considerable distance before I got this shot. Exposure was 1/15 s at f/11 using a tripod-mounted 500 mm telephoto lens.

lens as they may reduce the image quality of the prime lens and introduce optical aberrations.

The other drawback with teleconverters is that they reduce the amount of light reaching the film, because the focal length has been increased without any increase in the lens diameter. The result is a loss of two stops in a x2 converter and 3+ stops in a x3 unit, changing an f/5.6 lens setting to f/11 and f/18 respectively.

The optimum selection of cameras and lenses is always difficult. My own preference for the cameras mentioned earlier has been built up over the years. My personal choice of lenses is a 20 mm (for photomicrography), 50 and 90 mm macro lenses, a 75-300 mm zoom lens and a 500 mm telephoto lens. With this equipment I feel able to tackle most natural history subjects.

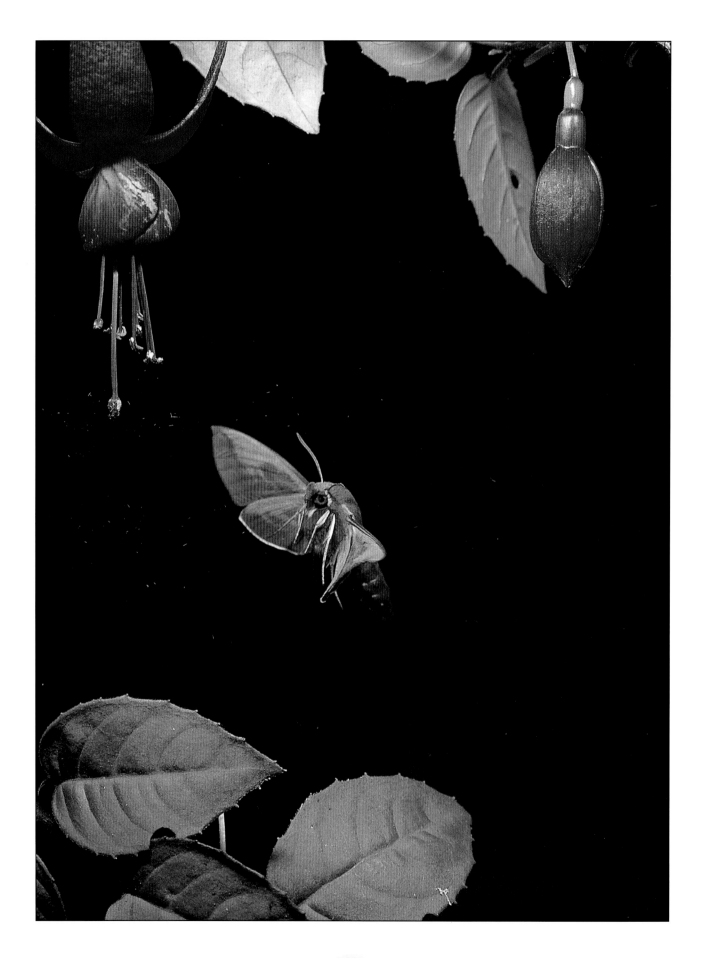

ADDITIONAL EQUIPMENT

Although cameras and lenses form the basis of a nature photographer's outfit, in order to tackle a wider variety of tasks you need some further equipment. When you buy equipment always select well-engineered items, as there is nothing more exasperating than going out on an assignment and finding that something vital doesn't work properly.

Filters

A huge variety of filters is available, but you need to select and use them with caution. For one thing, any filter introduces two further glass-air surfaces in front of the lens to cause internal reflections and reduce the image quality. Again, the natural world doesn't usually require a colour change to make it acceptable.

Let's start with the ubiquitous 'skylight' or ultraviolet (UV) absorbing filter. Salespeople often try to persuade you to buy one on the grounds that if it doesn't do anything else it will protect your lens from damage. This, of course, is nonsense: any sort of trauma that damages the filter is almost certain to damage the lens as well; and as far as filtration is concerned, modern lenses are all opaque to UV anyway. (A good lens hood will go much further in protecting your lens.) They may be useful if you are working on a spray-soaked rocky headland, or in blowing sand, but in most cases you would be far better off with a polarising filter. These have the effect of deepening the tone of blue skies, particularly at right angles to the direction of the sun; and, more important, when used with their polarising axis vertical, they reduce surface reflections from water when you are taking photographs of subjects in rock pools and ponds. When you use a polarising filter, always try rotating the filter in its mount while you study the image through the viewfinder, until you have the best image. A polarising filter can also help to reduce the effects of haze under some conditions. It requires an increase in exposure of about $1\frac{1}{2}$ stops.

An elephant hawkmoth, Deilephila elpenor, in free flight.
The two-flash set-up used in this flight tunnel shot is capable of giving an exposure as short as 1/10,000 s, necessary to 'freeze' a fast-moving insect wing.

Colour-balancing filters are useful when you need to adjust the film's response to the changing colour of daylight from dawn to dusk and during changing weather conditions. Heavy overcast skies often produce a strong blue cast which can be 'warmed up' by using an 81A, B or C amber filter, while cold winter scenes can be made even more atmospheric by using a pale blue 82B filter.

Filters are also available to match the colour sensitivity of artificial (tungsten) light film to normal daylight conditions and vice versa. If you want to use tungsten illumination with daylight-balanced film you will need an 80A (blue) filter. If you want to use a tungsten-balanced film in daylight you need an 85B (amber) filter. (Note: these filters are often designated B12 and R12 respectively.)

A neutral density (ND) filter absorbs light equally across the spectrum; they are useful with lenses such as mirror lenses which do not have an iris diaphragm, or in circumstances where overexposure would otherwise be inevitable. A graduated ND filter is often used to slightly darken bright sky without affecting the lower part of the picture. Graduated filters are also available in a wide range of colours, but these are of use only for special effects that would usually be inappropriate to nature photography.

In black-and-white work a colour filter simply lightens subjects of the same colour as the filter and darkens the rest, particularly complementary colours; deep-coloured filters produce more pronounced effects. For example, a yellow filter will lighten yellow/green grass and will slightly darken the rest of the scene, especially blue sky, while an orange or red filter produces a more dramatic effect, rendering the sky almost black. Colour filters can also be used to increase the contrast between a subject and its surroundings, so that for example, a red rose can be progressively lightened using respectively a yellow, an orange, and a red filter, separating it tonally from its green leafy background.

All filters reduce the amount of light reaching the film, by a factor known as the factor filter. With TTL metering this is taken care of automatically.

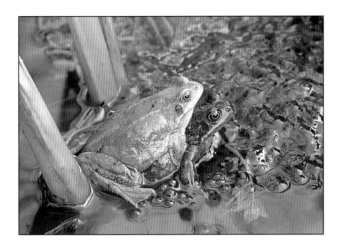

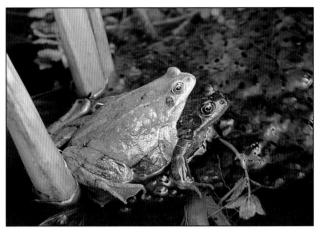

Film types

Whether you work with slide film, colour negative film or black-and-white film depends on the use you are going to make of the result. Colour slides are intended for projection, and until recently were a standard requirement for publishing houses. Slide films can cope with high-contrast subject matter, and they have better colour saturation and higher detail resolution than colour prints. One major drawback is that they require very accurate exposure. Colour negatives produce excellent enlargements, and many prints can be made from the same negative. Prints can be made from colour slides too, but there are inherent inaccuracies in hue and saturation that are doubled in the second-generation image. This is not the case in colour-negative printing, as the negative contains dye images which pre-compensate for these errors, so that very accurate colour reproduction is possible. In addition, colour negative film is much more tolerant of variations in exposure, with up to two stops on either side of the 'correct' exposure often giving acceptable results.

In all areas of photography, black-and-white film is being used less and less, though small bands of enthusiasts continue to produce first-class work. In the absence of colour, you need to concentrate much more on form, tone distribution and lighting. In nature photography the last bastion of black-and-white work is probably landscapes, where good work is still being done.

Film speed and granularity

The speed of a film is a measure of its sensitivity to light, films being classified using the ISO (International Standards Organisation) speed indexes. These are of two types: the arithmetic index, which doubles up for each doubling in film speed, and the logarithmic index, which increases by 3° for each doubling of film speed. These two systems

Left - Two frogs in amplexus. Note the distracting highlights and reflections from the surface of the water and frogs' spawn.

Right - The same shot taken with a polarising filter over the camera lens. Much more acceptable, but the penalty was a loss of 2 stops (that is, four times as much exposure required).

correspond roughly to the old ASA and DIN systems of speed rating. (The equivalence remains the same: ISO 100 arithmetic = ISO 21° logarithmic.) ISO 25/15° represents a slow film, ISO 400/27° a fast film.

The light-sensitive coating of the film is called the emulsion, and consists of microscopic crystals of silver halide dispersed in gelatin. Very small crystals are less sensitive to light and are used in fine-grain films, and the larger crystals form the basis of fast films. During the processing of slide film the silver is replaced by transparent yellow, magenta and cyan dyes in three layers; by overlapping the dyes in various combinations, all possible colours can be produced. At high magnifications you can easily see the granular structure of the image.

When colour-negative material is processed the hues and lightnesses are reversed: blue sky appears reddish (yellow + magenta) while green grass appears magenta and white objects appear black. In the printing process hues and lightnesses are reversed.

Slow fine-grain film is able to resolve minute detail, with more accurate colour rendering than fast film, making it the choice for high quality work. Unfortunately a slow film requires longer exposures, especially if the light level is low. In such situations there is no choice but to use a fast film (ISO 200/24° or 400/27°) which will allow short exposures to arrest movement. The penalty is graininess, somewhat lower contrast, and the loss of very fine detail.

By modifying the processing technique, both slide and negative films can be 'pushed' by up to two stops, allowing an ISO 50/18° film to be rated at ISO

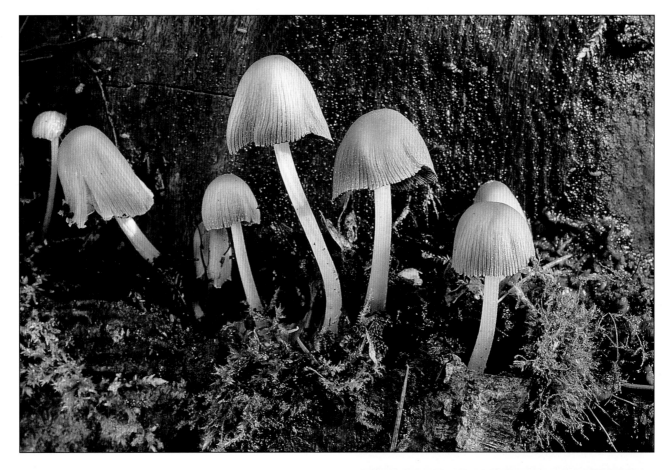

200/24°. The benefits are plain; the drawbacks include some loss of image quality due to increased granularity and a possible shift in colour balance, especially in colour slide materials.

Films differ in their characteristics from one manufacturer to another, so that you may need to try out different makes of film until you find one which suits your needs. Once you have found it, stick to it.

Reflectors and diffusers

The function of a reflector is to illuminate an area which would otherwise be in shadow or inadequately illuminated. The material used in the reflector and the type of surface will determine its characteristics. A mirror is the best possible reflector, but is seldom of use because it functions as a second main light, producing an unnatural effect. A piece of aluminium foil which has been crumpled, then smoothed out and glued to a piece of A4 white card makes a good reflector, producing a more diffused light. You can use the reverse side of the card for a still softer light. The 'Lastolite' is a commercially-available reflector which folds up into a small space for transport. The folded unit is packed into a small lightweight pouch, and when removed it literally springs into action. White, gold and silver surfaces are available.

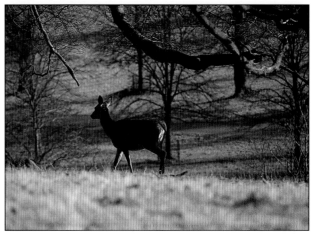

Top - Mycena growing on rotting timber and photographed with a 50 mm macro lens on slow ISO50/18° film. Note the fine detail in the fungi cap.

Above - Fast films are also useful when long (e.g. 500-600 mm) telephoto lenses are being used to photograph animals from a distance. This allows a smaller aperture and shorter shutter speed than a slow film would permit. The deer basking in the late winter afternoon sunshine was photographed using a 500 mm f/7.2 lens stopped down to f/16 with a 1/15 s exposure.

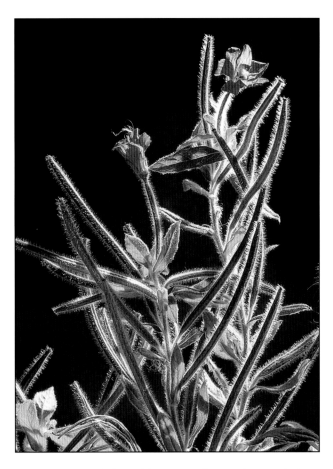

The hairy willow herb, Epilobium parviflorum, photographed outdoors on a summers day. The high sun was shining straight down on to the camera lens, but an efficient lens hood kept the front element in shadow.

A diffuser is used to soften the light source; I often use a white handkerchief. This softens strong sunlight when stretched out between the sun and the subject matter. You can also tie it round a flash unit to produce a soft diffused light.

Lens hood

A lens hood is designed to prevent non-image-forming light from entering the camera lens. Light from outside the picture area can produce 'lens flare' as it reflects off the inside of the barrel and lens elements, causing reduced contrast and possible 'ghost' images if the sun is in front of the lens. Lens and camera body manufacturers go to great lengths to prevent flare by multi-coating lens surfaces and matt-blacking all internal surfaces, but there is still much to be gained by the use of a good lens hood.

In its simplest form a lens hood consists of a ribbed black metal or rubber tube. In a more sophisticated form it is an adjustable bellows unit with an aperture of proportions similar to those of the film format. This type of lens hood can be extended or reduced in length to match the acceptance angles of different lenses. Bellows lens hoods are rarely seen on 35 mm SLR cameras, though they are standard accessories for large-format roll film and sheet film cameras. Most macro lenses have their front element recessed into a ribbed black barrel which acts as a lens hood. Wide-angle lenses often have a protruding front element of large diameter, and a good lens hood is essential.

Camera supports

One does not have to have visibly unsteady hands to produce camera shake, as can be amply demonstrated by tying an electric torch to a hand-held camera and watching the dancing patch of light on a nearby wall!

Before discussing ways of eliminating camera shake let us be clear as to how to diagnose it in a photographic image. Using a hand lens, images of point highlights will appear as short streaks if camera shake is present. The effect is uniform over the whole image area, thus distinguishing it from subject movement (confined to the subject itself) or lens aberrations (confined to the periphery, and occurring only at low f-numbers).

To minimise the risk of camera shake, ensure the exposure is no longer than the reciprocal of the focal length of the lens, as mentioned earlier. For example, you can probably hand-hold a 50 mm lens at 1/50 s, whereas a 200 mm lens demands 1/200 s or less. This applies to the normal range of subject distances. If you are working close to the subject you will need even shorter exposures.

Most camera shake results from rotating the camera axis upwards or sideways during the exposure. Moving the camera bodily (without rotation) has much less effect.

Although I hand-hold my compact camera when taking holiday snapshots, I always use a tripod or some other support when engaged in serious nature photography. Many tripods are too light and spindly to be worth serious consideration. Most wildlife photographers use the British-made Kennett Benbo tripod. This embodies some radical departures from traditional tripod design: the legs can be adjusted for length, but can also be moved independently right up to the vertical position. One lever locks all three legs firmly in place, irrespective of their positions. The tubular extending legs are completely sealed at the bottom end, and slide on the outside of the tube above. This allows the tripod to be stood in up to 46 cm (18 in) of water with impunity.

The Benbo I use regularly has 69 cm (27 in) legs which extend to 117 cm (46 in), and when the reversible centre column is pulled up to its maximum height the

Above - A combined camera clamp, miniature tripod and threaded spike is worth a place in the camera bag.

Right - The Benbo tripod is strong and versatile, and extends up to 1.57 m (62 in). Its unique construction allows it to be used in water.

Left - The Manfrotto handgrip or joystick has a spring-loaded ball and socket allowing the camera to be set in any position

tripod stands 157 cm (62 in) high. Though expensive, it is worth every penny of its cost. A slightly smaller version, the Trekker, is also available.

The two most popular tripod heads are the ball-and-socket and the pan-and-tilt. The former allows the camera to be moved in all directions, and can be locked in any position simply by tightening a thumbscrew. The pan-and-tilt head was originally designed for ciné cameras and allows panning and tilting as separate movements. This was, until very recently, my own preferred way of attaching the camera to the tripod.

I now use a precision-cast hand-grip manufactured by Manfrotto of Italy. This consists of a heavy spring-loaded ball and socket joint at the lower end and a quick-release camera fitting at the top. Gradually squeezing a long lever releases the pressure on the ball-joint, allowing the camera to be set up in any position. The adjustable spring pressure is sufficient to support a heavy 6 x 7 cm camera in any position. Again, this is expensive, but, as with the Benbo tripod, it represents money well spent.

The camera clamp table tripod is a useful little support. It consists of a ball-and-socket head mounted on a G-clamp. You can fix it to a railing or bench where you can't easily use a conventional tripod. The

body of the clamp contains three short legs and a threaded spike. The former screw into the clamp base to form a small table tripod, and the latter, when attached, allows you to screw the clamp into tree trunks and other soft wood.

Although only three legs produce full stability, you should not overlook the monopod, which, is compact and light, and can give additional support when the camera would otherwise have to be hand-held. It is especially useful for panning shots.

A small bean bag is a useful support. You can easily make one by partly filling an old sock with dried peas or beans and tying the end. You simply put the bean bag on a wall or car roof, sit the camera on the bean bag and give as long exposures as you need (using the self-timer delay if you can).

A further method of supporting the camera is with a shoulder pod. This is a rifle butt with the camera attached to the stock, and is useful for photographing moving animals with a long-focus lens.

Flash equipment

One or more flash units will form an indispensable part of your outfit, particularly if you wish to do close-up work, night photography or shots of birds in the

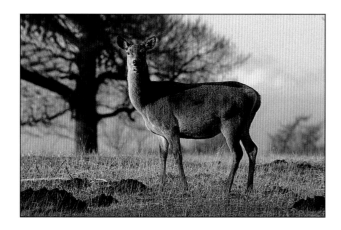

This roe deer, Capreolus capreolus, was photographed using a 500 mm telephoto lens supported on a bean bag on the car roof. A cable release was used. Exposure was 1/15 s at f/11.

garden. Once you have bought your flash equipment the cost per flash is insignificant; and the long tube life (10,000+ flashes), reliable colour balance (close to daylight) and negligible heat production, make it a very useful light source.

The flash is produced by an electrical discharge through a sealed glass tube containing a mixture of gases (chiefly xenon). The duration of the flash varies from 1/500 s to 1/20,000 s. The modern unit is light and compact. It is usually powered by four size AA cells or rechargeable NiCd cells. Using electronic circuitry, one or more capacitors are charged to a high voltage (300+ V). A 'trigger' of several thousand volts is fired by the shutter mechanism, initiating an electrical discharge through the ionised gas, and resulting in a brilliant white flash.

There are three basic types of unit: manual, automatic and dedicated. Most automatic and dedicated flash units have a manual setting. Automatic units provide just sufficient light to correctly expose the film. The better units have a choice of four or more aperture settings, each with a given distance range. A light sensor in the front of the unit measures the light reflected from the subject, and when it reaches a predetermined level it quenches the flash, any unused energy being stored for future use.

Dedicated flash units, as the name implies, are linked to the electronic circuitry of a specific camera, automatically setting the correct shutter speed for flash synchronisation. Some provide viewfinder information concerning readiness to fire, and afterwards indicate whether the exposure was adequate. Independent flash manufacturers produce a range of modules to dedicate their flash units to most SLR cameras.

The most accurate and versatile system for nature photographers has the flash sensor inside the camera

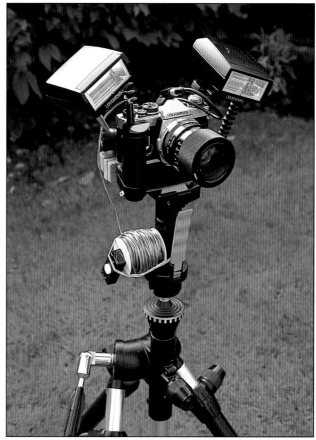

A remote release method consisting of a bobbin of electric flex with a bell-push switch on one end and a 2.5 mm jack plug at the other, located in the inlet socket on the autowinder unit.

body, measuring the light reflected from the film surface (TTL flashmetering); this operates equally well for any lens, even with filters and close-up accessories.

With any type of shutter, it is essential that the flash should fire while the shutter is fully open. This is known as X-synchronisation. (At one time there was also M-synchronisation, used for flashbulbs, but this is now obsolete). Up to a certain shutter speed (usually 1/60 s to 1/250 s, depending on the camera) the leading blind of a focal-plane shutter reaches the end of its traverse before the trailing blind is released, so that the film frame is fully uncovered long enough for the flash to fire (about 1 millisecond).

At shorter exposure times the two blinds form a slit, and only part of the film receives an exposure; dedicated flash units do not allow this to happen. Special 'slow burn' units manufactured by Olympus and Nikon do, however, allow full flash synchronisation at 1/2,000s and 1/4,000s respectively. Leaf shutters can be synchronised at all speeds, as the blades are always fully open for part of the exposure.

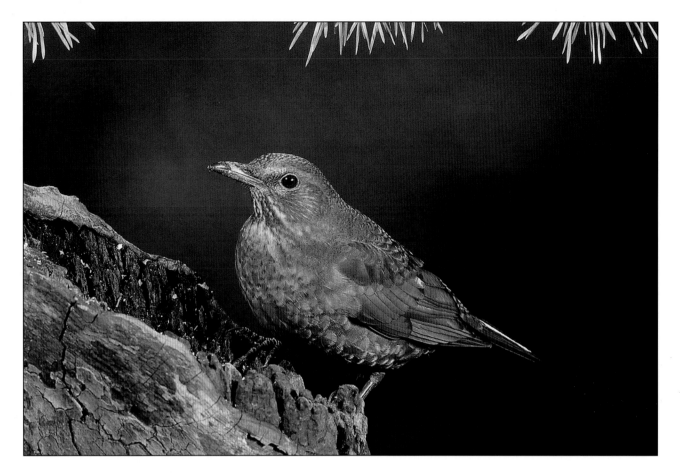

A female blackbird, Turdus merula, photographed using the remote release method. A three flash set up was used.

Remote release systems

On most occasions you will probably be right behind your camera, but there are times when this is not possible. You therefore need to be able to operate the camera remotely, and unless you are prepared to return to the camera and wind on the film after each exposure you need a motor drive as well. Most modern SLR cameras now have a built-in autowind, though some require a separate add-on unit. Such an autowind must have a jack socket so that it can be part of a remote release system. Using an autowind / camera combination operated remotely, you can expose an entire roll of film without having to approach the camera.

Pneumatic release

This system uses a rubber bulb and a length of narrow-bore tubing to move a piston which in turn releases the camera shutter. There is a time-lag which makes the unit rather less useful than it might otherwise be. You can place the rubber bulb between two small sheets of hardboard to make a pressure mat, to be activated by the weight of an animal. The main advantage of the pneumatic release is its simplicity and reliability but the time-lag increases considerably with distance. The maximum is about 10 m (32 ft).

Electrical methods

Several cameras, and most autowinders, are equipped with a 2.5 mm jack socket for a remote release system. Accessory manufacturers produce switches and leads in lengths of 5-10 m but you can easily make one with components from any electrical shop. If the camera and autowinder are mounted on a tripod with the camera prefocused on a spot to which a visiting bird or small mammal is likely to return, you can settle down some distance away and watch through binoculars. At the appropriate moment you can operate the switch to release the camera shutter, fire a flash and wind on the film. The feeding blue tits were photographed using this technique.

Infrared (IR) remote release units

Several camera manufacturers have introduced remote release systems which are either radio controlled (requiring a licence) or are linked by means of an IR beam. The unit consists of a transmitter and a receiver which triggers the camera, flash units and motor drive. Such a unit will operate over some 80 m distance, and is useful for photographing shy animals.

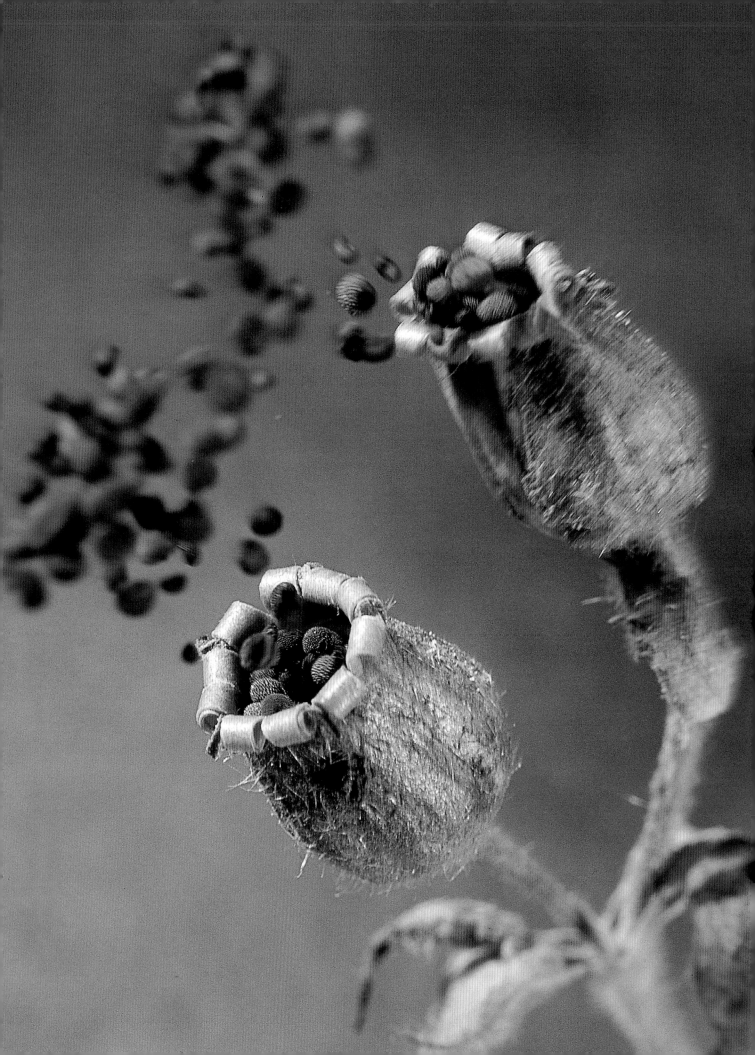

CLOSE-UP TECHNIQUES

Most SLR cameras will focus down to about 45 cm (18 in), covering an area of roughly A5 size and giving a scale of about one-sixth lifesize. But many of the plants and animals are much smaller than this. To produce a reasonably large image on the film you will need some extra equipment.

Basic problems

Close-up photography produces exciting images; but as the magnification increases so do various problems which are negligible at greater subject distances.

Choice of lens

Lenses intended for general photography may not be suitable for close-up or macro work. It may be necessary to employ special optics and/or special lens mountings for this purpose.

Vibration

In extreme close-up work the slightest movement of the camera or subject matter during the exposure can result in a blurred image. To counteract this you need a very heavy, rigid support. If you've seen photographs of the camera rigs and gantries used by the Oxford Scientific Film Unit you will be aware of the kind of equipment necessary for professional-quality work.

Depth of field

When you are operating close up the depth of field is extremely small, sometimes only fractions of a millimetre. This demands very accurate focusing and careful positioning of the subject. Closing down the lens aperture will help, but, unfortunately, below about f/8 image quality becomes limited by the laws of diffraction, and fine detail is progressively lost.

Illumination

In extreme close-up work the subject area is extremely small, often only a few square millimetres. If you are going to produce sufficient illumination over such a tiny area you will need a high-intensity focusing spotlight, pencil-beam illumination or electronic flash.

Seed dispersal in the red campion, Silene dioica. The specimen was very small (approx. 20mm) requiring powerful flash to illuminate it and to 'freeze' the dispersing seeds.

Lenses for close-up photography

If you want to work at a larger scale than about 1/6 with a standard lens, one solution is to reduce its focal length. You can achieve this by fitting a supplementary lens to the front of your standard lens. Such lenses come in 'powers' of 1, 2, 3, etc. dioptres (the reciprocal of the focal length in metres). With a 1-dioptre lens (i.e. a focal length of 1 metre) and the camera lens set at its closest focusing distance (45 cm), you will be in focus at 35 cm. With a 3-dioptre supplementary lens (FL = 1/3 m) the camera will now focus down to 27 cm, covering an area slightly smaller than a postcard.

You can get supplementary lenses of up to 5 dioptres power. These single-element meniscus lenses are inexpensive and give fairly good results, but they are not well-corrected for lens aberrations, and will lower the image quality unless you use a small lens aperture. For this reason it is not a good idea to use two or three together to increase the combined power. However, if you choose to do so, you can find the combined power by adding together the individual dioptre values.

Extension tubes, bellow units and teleconverters

Extension tubes, located between the lens and the camera body, are standard equipment for close-ups. They are available in sets of three, and can be used singly or in any combination to give a continuous range of focusing up to a scale of 1:1. The results are very good (although not up to the standard of a genuine macro lens) but they are fiddly to use as each limits the focusing range of the lens. The most useful extension tubes are those with built-in helical focusing, permitting adjustable extension.

For higher magnifications than 1:1 you need a bellows extension unit; within its design limits any lens-to-film distance can easily be obtained. Most have a rotating mount allowing the camera body to be clamped in any position from horizontal to vertical. The most expensive units tend to be heavy and sturdily constructed so as to keep the lens in correct optical alignment with the camera body.

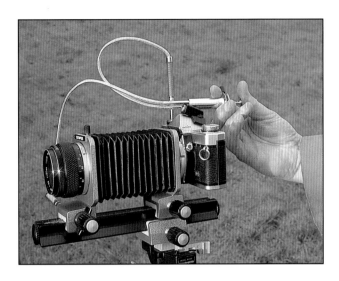

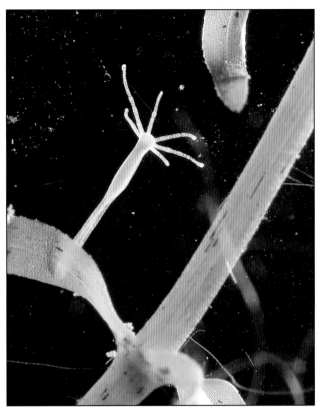

Above - A good bellows unit is very useful when taking close-ups larger than half life size, and essential when using macro lenses which do not have built-in focusing. The Olympus auto-bellows is a very versatile unit and has served me well over many years.

Right - The tiny animal, Hydra vulgaris, is hardly visible to the naked eye, being around 4 mm long when fully extended. It was photographed using a 20 mm f/3.5 macro lens specially designed to produce sharp images at magnifications from x4 to x12, when used with the bellows unit.

With some bellows units you have to stop the lens down manually before exposing; others employ a double cable release to operate the iris diaphragm and shutter release together. Of course, when you have fitted a bellows unit or extension tubes, you can't focus farther away than 10-30 cm depending on the design of the unit.

Another way of enlarging the image in the camera is to use a teleconverter lens. However, the snag with all these methods is that as the magnification increases the effective aperture decreases and the required exposure goes up. For example, a x3 converter gives a linear magnification of 3 to the image, i.e. an area magnification of 9, so that the exposure needs an increase of 9 times, or 3+ stops.

Special lenses for close-up work

The most effective way of maintaining image quality in close-up work is to use a specially-computed 'macro' lens. This focuses directly down to a half life-size image, and with the addition of an extension tube it will go to 1:1 or into true macro mode. For greater magnifications (up to x5) the lens is reversed in its mounting, using an adaptor ring with a bellows unit. The important thing about macro lenses is that they are optically corrected for very short focusing distances. Some standard lenses and zooms have a so-called macro facility, but they are not as well corrected as a true macro lens when used in this manner.

However, you can use standard camera lenses with a reversing ring for macro work and obtain reasonably good results.

Good-quality enlarging lenses are also suitable for macro work, as they are designed to operate at close distances. I have tested a 50 mm Rodenstock Rodagon, using it in the normal position for life-size images and reversing it for magnifications up to 5:1. The definition right across the field was excellent, with particularly good contrast, the only drawbacks being the inconvenience of using the manual diaphragm, and the difficulty of finding suitable adaptors to attach the lens to the bellows unit.

Illumination

Lighting can be either hard and unyielding or soft and subtle, each type producing its own effect on the subject matter. Harsh light is emitted from a small source, producing high-contrast lighting with dark sharp-edged shadows. As the light source is moved away from the camera-subject axis, the shadows become longer and more obtrusive. This kind of lighting is typical of sunlight on a clear cloudless day, and of the light from a slide projector or a spotlight. It is seldom used as the sole source of illumination as the shadows are devoid of detail.

As the light source increases in diameter, the shadows become more soft-edged. You can achieve this effect

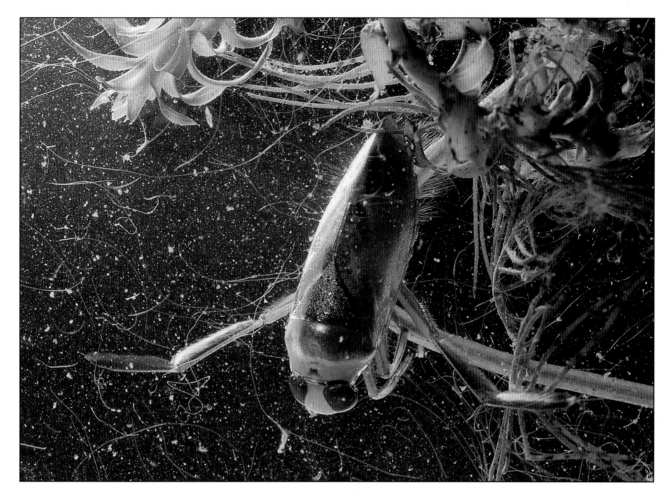

A water boatman, Notonecta glauca, lit by two flash units, one to the left and slightly behind and a less powerful one to the right. The result is a solid-looking three-dimensional insect.

by increasing the size of the reflector. The 'brolly' flash is a convenient way of converting the tiny light source of a flash unit into a large diffused light equal to the area of the white or silver umbrella. If the area of diffused light is large enough the illumination will be very soft, giving flat shadowless lighting. This type of illumination is well illustrated by the light on a completely overcast day, when the sky is a whole hemisphere of fully diffused light and there are no shadows at all.

In close-up photography you can still apply the principles of illumination you would use in portrait photography, with the main light positioned in the 45° frontal position, i.e. 45° above the subject and 45° to one side. This produces good modelling, and gives an adequate three-dimensional effect when you are photographing small animals and plants. If the lighting is undiffused the shadows tend to be very dark, and you will need some 'fill-in' light. This can be either a simple reflector or a low-intensity light which partially illuminates the shadows and produces an acceptable balance between highlights and shadows. Such lighting is a basic arrangement to produce an acceptable (though not very exciting) result.

Other possible lighting arrangements include grazing (or low oblique) illumination and backlighting. To be successful, these set-ups require some skill, but the results can be very satisfying. Grazing illumination emphasises surface texture.

This technique is not unique to close-up photography, of course: it is a much-used cliché in landscape photography. Backlighting is a form of illumination favoured by many nature photographers (including myself). It can produce exciting effects, and can transform an average scene into something special. Any animal or plant fringed with delicate hairs or fine bristles is likely to benefit from backlighting. As the light is shining almost directly into the camera lens, you need to use a good lens hood. You may also need to hold a piece of card (or your hand) just out of the picture area, shading the lens from direct light.

Sources of illumination

The chief types of illumination for close-up work are daylight, electronic flash and tungsten lamps.

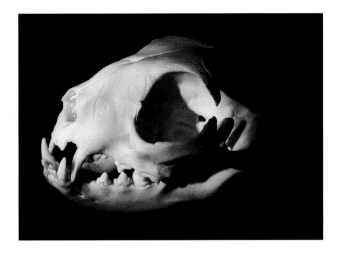

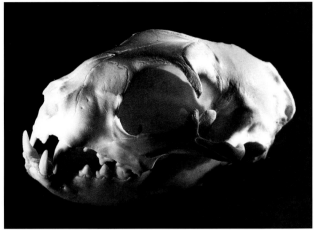

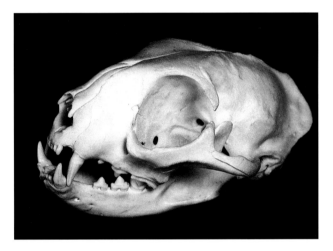

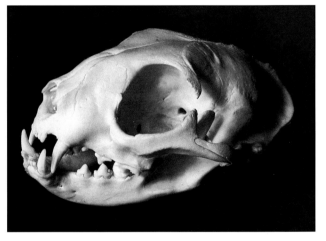

Daylight

Most field work is done by daylight. On a clear, cloudless day the light is highly directional, as the sun subtends less than 0.3°, and is thus effectively a point source. A lightly overcast sky produces a more diffused light which softens the contrast. Clear sunlight with white clouds as 'fill-in' gives yet another quality. You can't control the weather, and you may as a result have to spend many hours waiting for the appropriate light quality to arrive.

Although sunlight may look bright, it is often insufficiently powerful to provide enough light when you are taking close-ups at a scale of 1:1 or greater. This is due to the Inverse Square law, dealt with on page 40: a life-size image requires a fourfold increase in exposure.

Colour temperature

Another important characteristic of sunlight is the way it changes its colour during the day. This is of no small importance to the nature photographer. The overall hue of daylight, and of many other light sources, can be defined in terms of colour

Illumination for close-up work using a cat's skull as the subject.

Top left - single 45° frontal spotlight resulting in dark shadows.

Top right - two spotlights placed to the left and right of the skull, which emphasises the surface texture.

Above left - soft diffused frontal lighting which is rather flat

Above right - a 45° frontal light and a small fill-in light, set up as in human portraiture and producing good modelling.

temperature. The unit is the kelvin (K), the fundamental SI unit of temperature. A temperature interval of 1 K is the same as 1°C, but 0 K is the same as -273°C (absolute zero). The colour emitted by a hot non-reflective object (a so-called black body) bears a simple relation to its temperature in kelvins. As the temperature rises the body emits first red, then yellow, then white, then bluish light. The colour of spring sunlight with white clouds at midday closely matches that of a black body at a temperature of 5,500 K, and this is the standard to which daylight colour films are balanced. Any hue that can be visually matched in this way is said to have a colour temperature of x kelvins. With incandescent sources such as tungsten filament lamps, the colour temperature is close to the actual temperature. Thus a photographic floodlamp of the

large type has a colour temperature of 3,200 K, and a tungsten-halogen lamp is 3,400 K, whereas a domestic long-life filament lamp is roughly 2,800 K, much redder. Some 'cold' sources, which do not produce a continuous spectrum, nevertheless produce light that can be closely matched visually by black-body radiation, and are allotted an equivalent colour temperature (6,000 K for electronic flash). Other sources (such as fluorescent lamps) which have an irregular spectrum cannot be matched by a black-body, and need CC filtering (see below) before they can be used with colour film.

The colour temperature of daylight varies. Sunlight itself varies from 1,000-3,000 K at sunrise and sunset to 5,400 K at midday, while clear blue sky (which, on a clear day, illuminates the shadows) can have a colour temperature as high as 20,000 K (almost violet).

Daylight colour film is balanced for 'photographic daylight' (5,500 K), so that when the light approximates to this temperature you will obtain an accurate colour record on slide film. If, however, the colour temperature falls in the evening to around 3,000 K, the photographic image will show a strong orange cast. If you want a slide to give a very accurate colour record, you need to measure the colour temperature of the illumination with a meter, and, if necessary, to add the appropriate correction filter to the camera lens. These filters are designated according to their mired shift. A mired is 1 million divided by the colour temperature in kelvins, so that, for example, 10,000 K is 100 mireds. Blue filters have a negative mired shift and amber filters a positive shift. The standard correction filters by Kodak are shown in Table 1. Other manufacturers produce filters designated in decamireds, e.g. B1.5 (= -15 mireds) and R3 (= +30 mireds), etc.

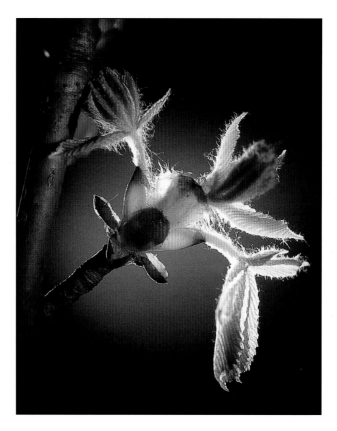

Developing leaves of the horse chestnut Aesculus hippocastanum strongly lit from behind, highlighting the delicate hairs and 'fluff'. A weak frontal light was used to avoid the specimen appearing as a silhouette.

There is also a series of filters produced by Kodak for correcting colour balance for untypical sources such as fluorescent lamps. These are identified by the code CC, followed by the density (05 = D 0.05, 10 = D 0.10 etc.) and the hue (R = red, G = green, B = blue, C = cyan, M = magenta, Y = yellow), so that, for example, CC30M represents a magenta filter of density 0.3. These filters are also necessary when very long exposures (more than about 5 s) are needed, to correct colour balance errors due to an effect known as reciprocity failure.

For many photographers a redder-than-normal sunset is quite acceptable. Some may even want to increase the colour bias by adding a 'warm' filter, say an 81B or 81C. Similarly, you might want to make a cold winter morning scene look even colder by adding a negative mired shift of about the same amount.

Daylight colour film balanced for 5,500 K illumination, when used in artificial light, produces an unpleasant overall orange cast. An 80A (-125 mired) correction filter can be used, and with tungsten filament floodlamps this yields completely accurate colour rendering, but the filter factor is around $3\frac{1}{2}$, nearly two stops extra exposure. Colour film is available

Table 1 Kodak correction filters

Amber		Blue	
Kodak No	Mired Value	Kodak No	Mired Value
81	+10	82	-10
81A	+18	82A	-18
81B	+27	82B	-32
81C	+35	82C	-45
81EF	+53	80D	-55
85C	+86	80C	-81
85	+112	80B	-110**
85B	+127*	80A	-125***

* Floodlamp (tungsten) to daylight

** daylight to tungsten-halogen

*** daylight to floodlamp

Above - When dealing with living organisms in close-up the only satisfactory form of lighting is flash, because of its high intensity (when used close to the subject), colour temperature and very short duration (1/1,000 or less). The set-up shows two powerful flash units used to photograph pond animals in a small glass cell.

Right - To preserve the black background and prevent over exposure of the catkins, minus 1$\frac{1}{2}$ stops exposure compensation had to be given.

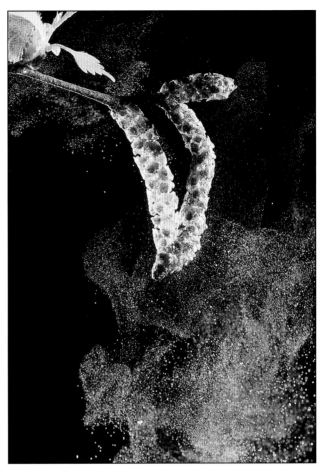

balanced for tungsten light at 3,200 K. This is an exact match for the large floodlamps used by professional photographers, and is close to the 3,400 K halogen lamps that are becoming increasingly popular. Ordinary domestic lamps (2,800 K), however, need further filtration of -45 mireds (Kodak 82C filter).

Electronic flash

A small electronic flash unit can be a useful light source, and has aptly been called 'portable sunlight'. Its characteristics make it the best source of illumination for close-up work. Its high intensity allows the use of a small lens aperture, with a corresponding increase in depth of field. The flash duration is sufficiently brief to 'freeze' the movement of most wildlife. The close match to daylight allows you to use daylight-balanced film without filtration.

You can operate two or more flash units simultaneously, either linked by electrical leads or triggered by slave units. If the subject is static you can use the same unit several times in different positions, building up a two or three flash effect on a single frame.

You can use electronic flash in the field either as the main source of illumination or as a fill-in light. In the latter role you need to work with the flash at one-half or one-quarter power. If the flash is the main source, with a leaf shutter you can use the fastest shutter speed and still have full synchronisation. The ambient

light will then play a negligible part in the illumination. However, focal-plane shutters can be synchronised only at longer exposure times (1/60 s to 1/250 s depending on the camera model), and in bright light it is possible to register ghost images of a moving subject in addition to the main image illuminated by the flash.

Because it can be very difficult to place the flash units close enough to the camera axis when working very close to the subject, a 'ring-flash' is often useful. This fits round the lens and gives shadowless illumination, with a somewhat flat effect.

Tungsten filament lamps

The third source of illumination is the tungsten filament lamp. There are many different types, from the 100 W domestic lamp to the overrun 'Photoflood' and the high-intensity low-voltage halogen lamp. As the colour temperatures of these sources are different from daylight, you need either correction filters or tungsten-balanced film if you are working with

The studio set was used to show spore dispersal in the common puffball, Lycoperdon periatum. The two flash units were sufficiently powerful to provide a very short flash exposure to freeze the cloud of spores.

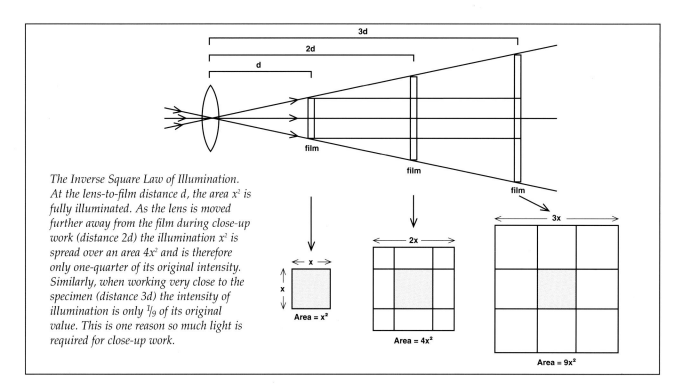

The Inverse Square Law of Illumination. At the lens-to-film distance d, the area x^2 is fully illuminated. As the lens is moved further away from the film during close-up work (distance 2d) the illumination x^2 is spread over an area $4x^2$ and is therefore only one-quarter of its original intensity. Similarly, when working very close to the specimen (distance 3d) the intensity of illumination is only $\frac{1}{9}$ of its original value. This is one reason so much light is required for close-up work.

incandescent sources. In practice neither domestic lamps nor photographic floodlamps are suitable for extreme close-up work, because they don't concentrate the light on to a small enough area. Photographic spotlights do achieve this, by the use of an optical system in front of the light source. If you don't possess a spotlight you can produce the same effect with a slide projector. Remember, however, that most of the energy output of a tungsten filament is in the infrared region, so you must have a heat filter (IR-absorbing glass) incorporated in the light source.

In the tungsten-halogen lamp the filament operates at a very high temperature. The envelope is made of fused quartz in order to withstand this. These lamps have the same colour temperature (3,400 K) as the old Photofloods; but unlike those, the tungsten-halogen lamp has a very long life and is resistant to shocks. In addition, the filament can be made very compact, making these lamps particularly suitable for applications that call for something approaching a point source.

Although tungsten lights are satisfactory for close-up photography of static subject matter, when movement is involved there is no substitute for electronic flash.

Exposure determination

In day-to-day photography, using a compact camera loaded with colour negative film with an exposure latitude of two stops or more, automatic exposure control provides negatives that produce prints of fairly satisfactory quality under most circumstances. It is a different story when you are working in close-up using slide film with very little exposure latitude.

All exposure meters are calibrated to produce a correctly-exposed image when the subject matter is of average reflectance and contrast. 'Average' is defined as 18 per cent mean reflectance, with a contrast from brightest highlight to deepest shadow of 32:1. measured in lumens. Most everyday subjects - buildings, landscapes, people - do reflect about 18 per cent of the light falling on them. However, a scene of high reflectance such as a snow scene will cause the meter to read high, indicating what is in fact too short an exposure and resulting in an underexposed image. On the other hand, an overall dark scene with few highlights will read low on the meter, indicating too long an exposure and giving an overexposed result. Both situations require some exposure compensation even on colour negative film, if you are going to obtain the best results. Experience shows that the former situation requires an increase and the latter a decrease in exposure of up to two stops in order to obtain a correctly exposed image. You can achieve this by using the '+' or '-' override control on the camera (if it is equipped with one).

A good method of obtaining a truly correct exposure estimation is to use a Kodak Neutral Density card. This is mid-grey in tone, and reflects 18 per cent of the light falling on it. To use it, you place it at the subject (or in the same lighting as the subject) so that it fills the field of view of the camera, and take an exposure reading from it.

The other side of the Kodak card is white, and reflects 90 per cent of the light. This can be useful if the ambient light is too dim for the meter to register. However, as the reflectance is five times that of the 'average' grey side, you need to give five times the indicated exposure (2$\frac{1}{4}$ stops). You can, of course, use any white card, even a white handkerchief.

You can buy grey cards from Kodak dealers. However, you can get a fair approximation to a grey-card reading by centring the metered area on a mid-tone such as a tree trunk, grass or even the palm of your hand. Use the spot-metering programme if it is available.

These methods are particularly useful if you are photographing a high-contrast scene with very bright sunlight and dense shadows, especially if you are working with colour slide film and are unable to use incident-light measurements (see below).

Incident-light metering

So far, the techniques of exposure estimation have all been based on measuring the light reflected from the subject. Another way of estimating exposure is by measuring the light illuminating the scene. This is called incident-light measurement. Many photographers use this method exclusively. The receptor cell of a hand-held meter is covered by a shaped diffuser, which collects light from all forward angles. The meter is pointed away from the subject towards the camera; the diffuser integrates all the light falling on it. Again, the meter is calibrated on the basis of an average subject, but it gives a more accurate result than a reflected-light reading, because the tone of the subject matter doesn't influence the reading.

Incident-light metering is a very useful technique for normal-distance photography, particularly colour-slide work, but it is of less use in close-up photography, where through-the-lens metering is almost mandatory.

Exposure determination with flash

Whereas automatic and dedicated flash units will monitor the light, and quench the flash when the film has received sufficient exposure, there are times when you may wish to adjust the exposure yourself (for example, when using flash as a fill-in light). You then need to set the unit to 'manual', and work out the exposure yourself. You need to do a simple sum using the guide number, which is a figure depending on the speed of your film and the power of the flash. The amount of light produced by an electronic flash is quoted in terms of the electrical energy stored in the capacitors, and is measured in joules (J). A joule is a watt second. This represents the electrical input. (The actual light output is much less in terms of energy, and is measured in lumen seconds.)

The guide number is a more practical way of specifying this. The guide number GN = f/no x flash-to-subject distance in metres. Thus if the GN for a particular combination of film and flash unit is 18, at a distance of 3 m (10 ft) the aperture would need to be f/6; at 6 m (20 ft) it would be f/3.

Flash illumination obeys the Inverse Square law, which states that for a small source the illumination is inversely proportional to the distance. Thus when the flash distance is doubled the illumination is divided by four. A portable flash unit with a GN of 32 for ISO100/21° film has a usefully large output for nature work.

Exposure problems in close-up work

Strictly, f-numbers are correct only when the lens is focused on infinity. In close-up work its distance from the film may be two or more times its focal length, with a dramatic fall-off in the illuminance on the film due to the Inverse Square law. This effect can be allowed for, if the effective f-number is taken as the extension (i.e. the lens-film distance) divided by the diameter of the lens aperture. You can calculate the effective aperture for any given magnification by applying the following formula:

Effective f/no = Marked f/no x (Magnification +1).

Thus in photomacrography, where magnifications of X4 and more are not uncommon, a marked f-number of f5.6 becomes an effective f-number of f5.6 x (4 + 1) = f/28.

The increase in exposure required for a stated magnification will be the square of the aperture factor, as shown in Table 2.

Table 2		
Image scale (magnification)	Multiply f/no by	Realtive exp. increase
1/20	1.05	1.1
1/10	1.1	1.21
1/5	1.2	1.44
1/2	1.5	2.25
1	2	4
2	3	9
4	5	25
10	11	121

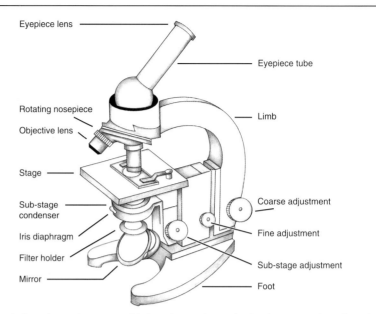

*The equipment used to produce the photographs in chapter 6 (Summer). Note the half-silvered mirror at **A**, the electronic flash **B**, and the microscope's own lighting built into the base **C** with the camera and flash lead firmly attached to the top of the microscope via the adaptor tube.*

A typical student microscope with focusing optics and a fixed stage. Light reflected off the mirror up through the condenser lens, through the specimen on the slide, up one of the objective lenses and through the eyepiece lens into the eye of the viewer.

At magnifications smaller than 1/5, there is no significant increase in exposure; but at larger scales the required exposure may be considerable, as Table 2 shows. At large magnifications you may find it far from easy to throw sufficient light on the subject matter to produce a reasonably short exposure.

The increased exposure required in close-up work may not be too much of a problem with tungsten filament lighting, as the camera's TTL system will take care of it; but with flash, exposures may be difficult to calculate unless the camera has off-the-film (OTF) flash metering. Automatic or computer flash is of little value because the flash sensor unit is unaware of the increase in exposure required as the magnification increases. It is preferable to use the flash on 'manual' setting, and make trial exposures. I have used flash extensively for close-up work, from lifesize up to x450 through a microscope and I strongly advise anyone interested in this area of nature photography to buy a camera with OTF flash metering.

Depth of field and focusing problems

As the camera moves closer to the subject, the magnification increases and the depth of field becomes increasingly shallow. A 50 mm lens set at f/4 and focused at 25 cm (10 in) gives a depth of field of only 9.5 mm (0.37 in), but when the same lens is focused to produce x5 magnification, the depth of field is reduced to a mere 0.07 mm (0.002 in) at f4 and is still only 0.23 mm (0.01 in) at f/16. Critical focusing is therefore essential.

At high magnifications it is often easier to focus if you set the bellows to the magnification required and then move the entire camera system until the subject is in focus. You can then fine-focus by using the bellows movement, or even screwing or unscrewing the lens.

Photomicrography

The ultimate magnifier is the microscope. Any competent nature photographer can make photomicrographs of living organisms from a pond, river or seashore.

Although a microscope may appear complicated, it is optically fairly simple. It consists basically of a magnifying system, an illumination system, and a focusing mechanism.

The magnification is obtained using two separate lens systems: an objective lens close to the specimen, which produces a magnified real image, and an eyepiece which magnifies this image further. The total magnification is the product of these two magnifications (which are engraved on the lens mounts). The objective is the main magnifier, and is available from x2.5 to x100, those most useful to the nature photographer being at the lower end. You can do much interesting work using only a x6 objective. The diameter and thread are standard, and products from different manufacturers are fully compatible.

Eyepieces are simpler in construction than objectives, and are much less expensive. The two most popular eyepieces are the x6 and the x10.

Illumination

The simpler microscopes have an adjustable mirror under the stage to reflect light through the specimen, via the aperture in the stage, up into the optical system of the microscope and into the viewer's eye. Although daylight can be used to illuminate the specimen, it is common practice to use a small lamp. This can be either a separate unit or built into the base of the microscope, in the latter case making a mirror redundant. A further refinement is a substage condenser lens to concentrate the light on the specimen. Depth of field and light intensity are controlled by an iris diaphragm under the stage. Such a basic microscope costs only a few hundred pounds, but is capable of much good work.

Basic photomicrography techniques

The SLR camera is ideal for photomicrography because you can easily attach the camera body to the microscope eyepiece and focus the image in the camera viewfinder. The only additional piece of equipment is a simple tube connecting the camera body to the microscope eyepiece. It is worth while replacing your focusing screen (if you can) with one specifically designed for the job, with a very fine matt surface and a central clear patch with cross-hairs.

A small part of the wing of a small tortoiseshell butterfly, Aglais urticae, magnified 5x life size. With the 20 mm macro lens set at f/16 (relative aperture) the working aperture (effective aperture) comes out at 16 x (5 + 1) = f/96. Hence the need for high power flash lighting to shorten what would otherwise be very long exposures, unusable with living organisms.

Although any form of tungsten lighting can be used, the illuminance will be low and the exposure will probably be too long to arrest the movement of living organisms. The best solution is to use tungsten lighting to view and focus but change to flash when taking the photographs. You can do this by using a half-silvered mirror set at 45°, in the position normally occupied by the microscope mirror. The arrangement works well, despite much of the flash output being lost through and around the mirror. The flash duration is sufficiently short to 'freeze' movement in the organisms and to eliminate the effects of vibration, which are greatly increased at high magnifications.

You can also use flash for incident illumination, by placing a flash unit on either side of the microscope just above the stage. Exposure problems do not exist with a camera equipped with TTL metering; without it the only way to establish the correct exposure is by trial and error, logging every exposure as you go and assessing the results when the film is processed.

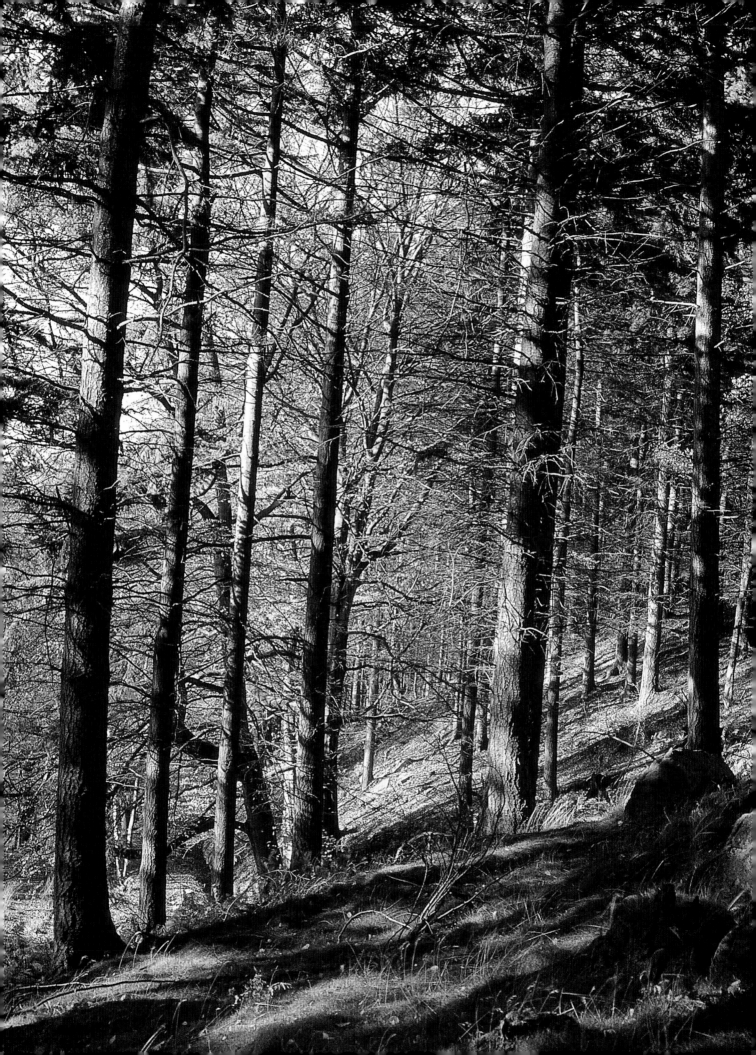

COMPOSITION

Composition refers to the way we visually arrange the component parts of the subject matter harmoniously within the image area. The final image might be dramatic, moody, pastoral or even jarring, but as long as you are content with the arrangement of the elements and the treatment you have given them, you have achieved a satisfactory composition.

The discussion of composition in absolute terms is unprofitable: there are many imprecise factors to consider, and every individual has different sets of priorities. Composition is thus a very personal concept; but if you want your efforts to be appreciated by a wide audience, then to some degree you must arrange and light your subject matter in accordance with guidelines accepted as fundamental. Fashions may change, but the basic concepts of composition are timeless, as can be seen from the paintings of Rembrandt and Turner, and no less, the photographs of Karsh, Cartier-Bresson, Beaton and Lichfield, or of wildlife photographers such as Stephen Dalton, Heather Angel and Laurie Campbell. It is also worth studying the camera work in TV dramas, particularly when the camera comes to rest after a slow panning shot - the composition of the final frame is often excellent and has plainly been carefully planned.

It is often said that rules are meant to be broken. To some extent I would agree, provided you are familiar with the rules in the first place.

Picture format and boundaries

Your first decision (unless you are working with 6 x 6 cm equipment) is whether the picture will be in a horizontal or vertical format. As a general rule the horizontal or 'landscape' format is, as the name suggests, appropriate for landscapes, or any image intended to convey peace and tranquillity, whereas the vertical or 'portrait' format suggests (apart from formal portraiture) imposing subjects, such as stately buildings or tall natural objects such as a thicket of silver birch or a group of conifers. Close-ups of stationary animals often look more dramatic in

Imposing buildings or tall natural subjects such as conifer trees are often shown to advantage in 'portrait' format, which concentrates the eyes (and the mind) on the tall trees rather than the overall horizontal landscape of which they are a part.

portrait format, whereas animals moving across the field of view will usually look better in landscape format.

The boundaries of the picture are important, because in a composition without a 'frame' the eye tends to wander out of the picture. It is good practice to frame a picture by selecting a viewpoint which includes overhanging vegetation, or the bough of a tree, or even an area of dark sky. A graduated neutral density filter is often useful for darkening the upper edge of the picture.

Subject positioning, size and colour

Although it is tempting to position the main subject in the centre of the frame, the resulting picture will lack interest. One way to avoid this is to apply the 'rule of thirds', in which you mentally divide the picture into thirds using imaginary horizontal and vertical lines. Their intersections form the 'strong' points at which the main subject matter should be located. It is also good practice to have animals (including birds) looking into the area of greatest space as this 'looks right' and suggests the space into which the animal will move.

The relative size of the animal or plant is also important. Large size does not always produce the greatest impact. On the other hand, there is a minimum size below which the subject loses significance.

The colour of the main subject in relation to the background will also affect the impact of the final image. By using contrasting colours the main subject can be quite small and still make an impression. When you include an artificial background you should consider the possible colours carefully, in terms of what you are trying to achieve.

The relationship of the various components in a picture can be affected greatly by the camera position: a low camera angle will not only enhance the immediate foreground and reduce the middle distance but will also make small subjects stand out more dramatically. A high camera angle expands the middle distance, often pushing the horizon into the top third of the picture, and can be achieved simply by standing on portable steps, or climbing a nearby

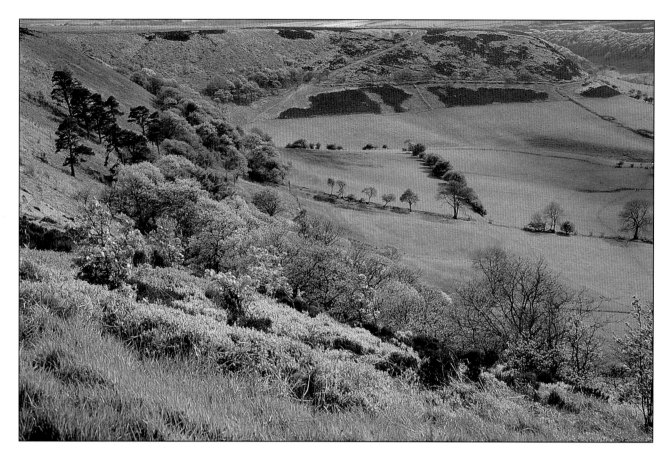

building or hill. The highest viewpoint, i.e. the camera pointing vertically downwards, can be useful when photographing, for example, crocuses on a garden lawn or barnacles attached to a seashore rock. Correctly set up and focused, the subjects should be critically sharp right across the frame.

Linear and pictorial balance

A composition in which the main subject resembles a triangle suggests solidarity and stability, while a diagonal line implies motion and dynamism. An 'L' configuration is often used to frame a landscape: the vertical component might be a tree and the horizontal component a dark foreground. An inverted 'U' is also frequently used, in the form of an arch or overhanging foliage framing a scene.

To conclude, the picture should feel balanced. This is not too difficult to achieve in black-and-white work, where the size and density of the different tones is easily handled. With colour the problem is more difficult, although the principle is the same: any areas of colour on one side should be balanced by something smaller and more dense, or larger and lighter, on the other side.

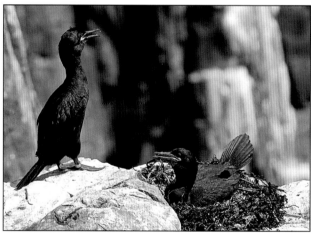

Top - A horizontal format is often used for landscape photographs to suggest peace and tranquillity. It also represents the normal field of view for a pair of human eyes.

Above - The nesting shags illustrate the 'rule of thirds': both birds are located at the 'strong' points where the four imaginary lines intersect.

Opposite - The sunset-over-a-lake picture is framed by a tree at either side and the dark grassy bank along the bottom edge. This concentrates the eye on the sunset reflections on the water and on the two ducks.

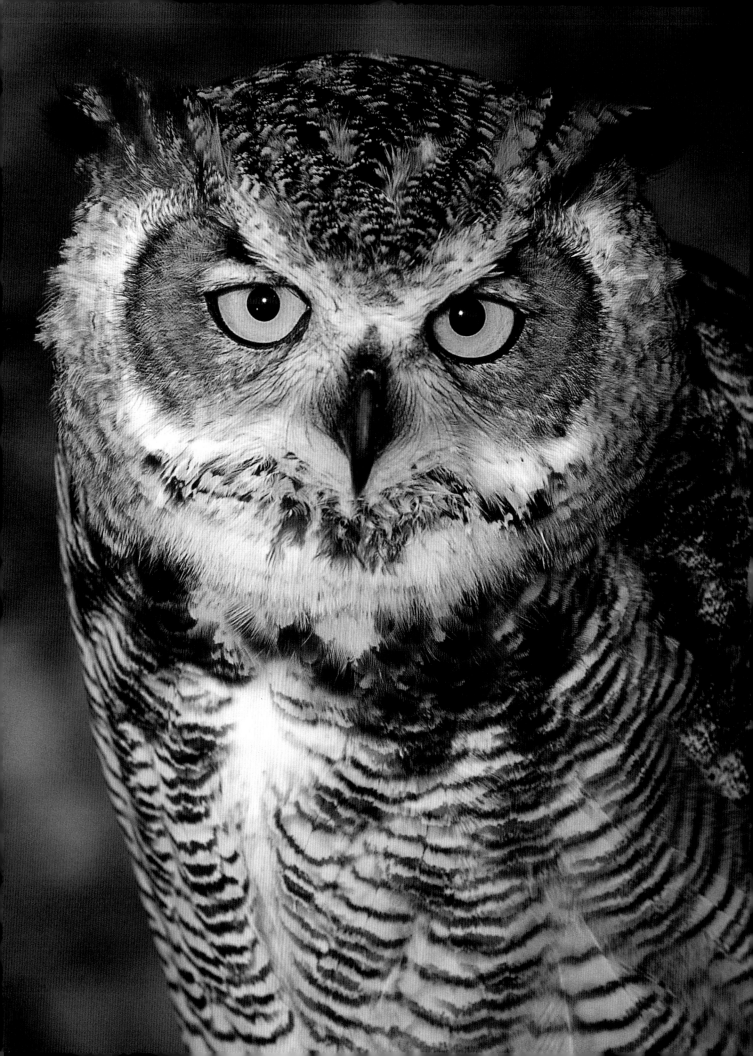

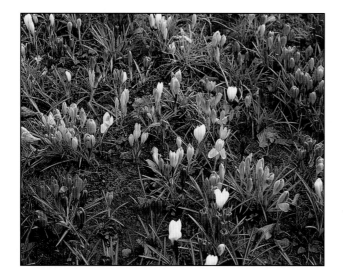

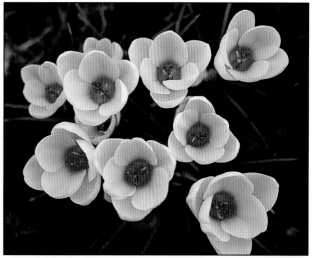

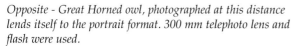

Opposite - Great Horned owl, photographed at this distance lends itself to the portrait format. 300 mm telephoto lens and flash were used.

Above left - 'Largeness' does not always produce the greatest impact, and in this carpet of spring crocuses it is the tiny group of four yellow flowers that forms the centre of interest.

Above right - A cluster of crocuses photographed with the camera pointing vertically downwards. The stamens and pistils were kept in sharp focus, allowing the background of green leaves and grass to stay softly out of focus and therefore not a distraction.

Right - Beech leaves, beginning to turn in the autumn, strongly backlit by the sun, against a suitably dark natural woodland background. This form of lighting is a favourite of many nature photographers, myself included.

Patterns and symmetry

Some patterns, as for example those seen in a layer of frogspawn or the end of a pile of newly-cut logs, are repetitive. There is something predictable and even restful about this type of arrangement. Other patterns, such as the bark of a tree, are random and non-repeating; but when an area is carefully selected it too can be attractive, well composed, and balanced for both colour and tone.

Other patterns are based on radial symmetry, with the elements spreading out from a central point, as in daisies, primroses and dandelions, or aquatic invertebrates such as sea anemones, starfish and sea urchins. When you photograph them from above you can really appreciate the symmetry. The arrangement is important: most photographers would (rightly) place the centre of the pattern at one of the intersecting thirds positions. But occasionally you can place the centre of symmetry right in the centre of the frame, emphasising the symmetry of the subject.

Lighting

The atmosphere of a picture is influenced greatly by the lighting. I suggested earlier that sunrises and sunsets produce interesting colours and low-angle lighting emphasises surface texture, resulting in patterns of light and shade not seen as a rule. Backlighting can also have a dramatic effect on the impact of a picture.

I have already emphasised the importance of using a tripod to avoid camera shake; but the use of a tripod also allows you to study the composition of the picture in the viewfinder. A small change of position or angle can radically alter the relative positions of near and far objects, completely altering the composition. Releasing the shutter should be the culmination of concentrated effort, involving a search for the best viewpoint, followed by adjustment of the final composition in the viewfinder. With practice and an analytical eye, good composition will become second nature.

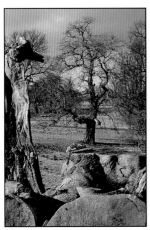

Above - A sweet chestnut tree 'L', framed by a rotting vertical trunk with sawn off stumps forming the base of the L.

Above right - Oblique or grazing lighting, even diffused as in this photograph of sweet chestnut bark, will always highlight surface texture.

Right - A regularly repeated, symmetrical pattern engenders a feeling of peace and organisation.

Opposite - Irregular, colourful, non-repeating patterns, seen in the crumbling remains of a long-dead sweet chestnut tree.

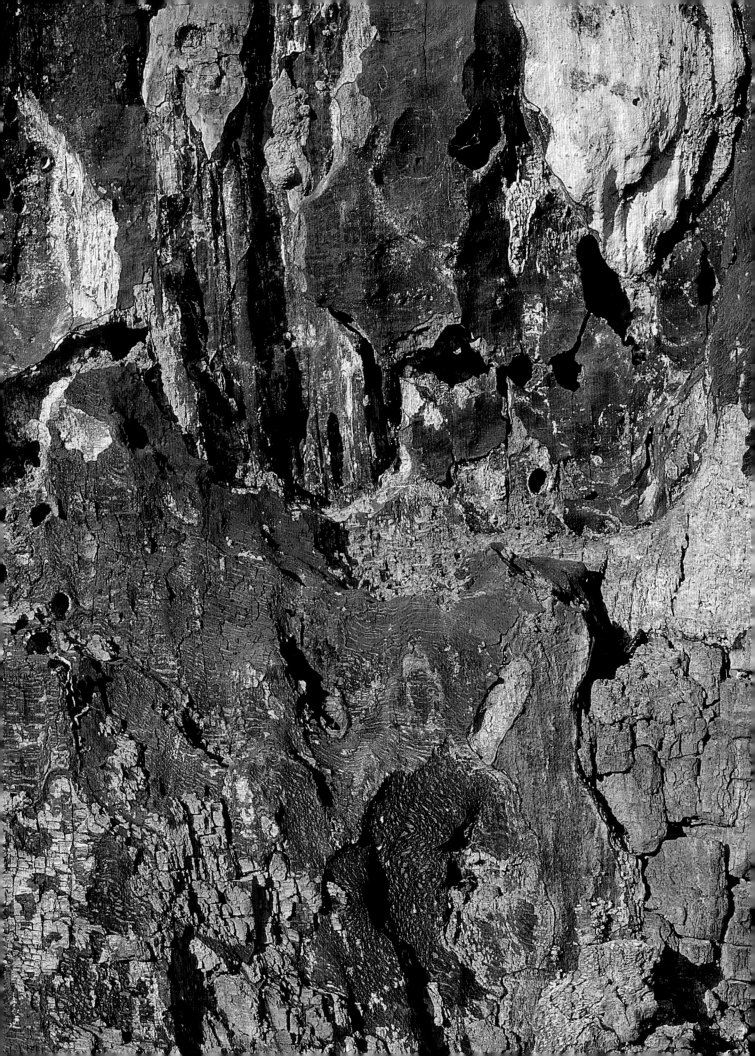

SPRING

And the Spring arose on the garden fair,
Like the Spirit of Love felt everywhere;
And each flower and herb on Earth's dark breast
Rose from the dreams of its wintry rest.

SHELLEY

The two main factors which trigger the great burst of activity across the plant and animal kingdoms at the onset of spring are light and the rise in temperature.

As winter turns to spring, the day length increases, resulting (in Britain) in approximately 14 hours of daylight by the middle of May. The buds begin to swell and finally burst, liberating the new leaves; catkins appear on pussy-willows and silver birches; moths begin their search for nectar, and insect eggs laid the previous autumn begin to hatch, as food for the caterpillars becomes available. Birds that have wintered in warmer climates return to Britain, and join the resident population in nest-making and egg-laying. The cuckoo, recently returned from its winter quarters in tropical Africa or southern Asia, can be heard for the first time.

The temperature begins to rise, promoting plant growth and flowering, and bringing dormant and hibernating animals back into full activity. The store of fat laid up by hibernating hedgehogs has been used to provide energy to keep their vital processes ticking over during the long winter months. Once awake and active again their thoughts turn to food, which is now becoming abundant. Badgers do not hibernate, but are less active during the winter when food is difficult to find. The fox, which has spread into most rural areas, remains fully active during the winter, often raiding dustbins and rubbish tips.

With the passing of winter and the gradual rise in temperature the aquatic environment revives, too. Frogs loudly herald their return to water to reproduce. In Britain there are three species of frog: the common frog, which, owing to drainage of marshy ground, is becoming less common; the edible frog (introduced into Cambridgeshire some 200 years ago), and the

The hedgehog, Erinaceous europaeus, must feed regularly in the autumn to build up a fat store to see it through the period of winter hibernation. 90 mm macro lens, daylight.

marsh frog, brought in from Continental Europe in 1935 and still thriving in the Romney and Walland marshes of Kent. The common toad is widely distributed, while the smaller natterjack, a protected species, is very much limited in its distribution in southern England and south-west Ireland. The remaining amphibians are the three species of newt: palmate, smooth and great crested. All amphibians hibernate, often at the bottom of a pond or under damp stones, logs or heaps of vegetation. With the coming of spring they all require water to lay their eggs in.

As the temperature rises, plant and animal life in ponds and rivers begins to re-emerge: floating plants such as duckweed, water ferns, frogbit and waterlilies, and submerged plants such as Canadian pondweed, water starwort and hornwort, plus a host of microscopic algae and diatoms, all burst into growth. These and several of the animal pond dwellers are discussed in the 'summer' section.

Spring landscapes

When you think (in photographic terms) of spring landscapes, you probably think of woodland landscapes. Unfortunately, many well-established woods are often marred by heavy undergrowth, with lanky saplings springing unchecked from the

Path through a bluebell wood. Tripod mounted camera, cable release, 1/8 s at f/16. A medium speed ISO100/25° film was used.

53

Above - The ideal combination of daffodils, old stone bridge and a river. This shot had to be taken in the early morning before the sun moved round to put the whole bridge in dark shadow.

Above - Melting ice and snow flooded the lake, partially submerging many bushes and tree bases. The camera lens had to be put into shadow by holding my hand just out of frame. I used a tripod mounted Mamiya 645 camera and standard 80 mm lens.

Right - Woodland stream photographed in bright but not direct sunlight. A small aperture (f/16) was used to produce a good depth of field and the longish exposure (¹/₂ s) has 'smoothed out' the water.

woodland floor, and by the ugly remains of elms. Commercial conifer plantations tend to be regimented and boring. Some trees such as beech, silver birch, field maple, hornbeam and oak are particularly attractive just after the young leaves have developed, when their delicate green translucency can be seen with the sun shining through.

If you include spring flowers such as wild garlic or bluebells they will add interest to a woodland scene. Bluebells, incidentally, reflect a good deal of violet and near-UV radiation, which affects the colour rendering in transparencies so that they appear pinkish (the latest films cope somewhat better). These scenes are best photographed with dappled side or backlighting by the sun. A zoom lens will come in handy here, as it increases the range of possible compositions.

Another attractive feature in a spring landscape is water: streams, rivers or lakes. The composition is usually more satisfactory if the stream or river runs diagonally across the frame so that the eye is led across and up into the picture. By using a fast shutter speed (1/250 - 1/1,000 s) the rushing water can be 'frozen', every droplet clearly visible; selection of a slow speed (around 1/4 s) smoothes out the turbulent water, often producing an almost surrealistic effect. Still water generates interesting reflections, as illustrated above, which shows a flooded lake in early spring with the setting sun directly in front of the camera (with my hand shading the lens). The daffodil is a harbinger of spring, and a combination of daffodils, water and trees makes an attractive picture.

Buds and flowers in close-up

When buds burst in spring, the first structures to appear are the leaves, which quickly unfold and increase in size. They are followed by the inflorescence, which although small at first, soon develops into well-defined flowers. The horse chestnut is probably the best-known example, with its large sticky buds, its fluffy first leaves, and ultimately its superb cluster of white flowers rising from the dark green leafy background like a Christmas candle. Young developing sycamore leaves, too, are attractively translucent, with the flowers hanging like Christmas tree decorations. But for sheer enchantment the leaves of the common beech are hard to beat. The slender cigar-shaped buds give rise to delicate green, symmetrically veined hair-fringed leaves. Male willow flowers consist of a mass of yellow-headed

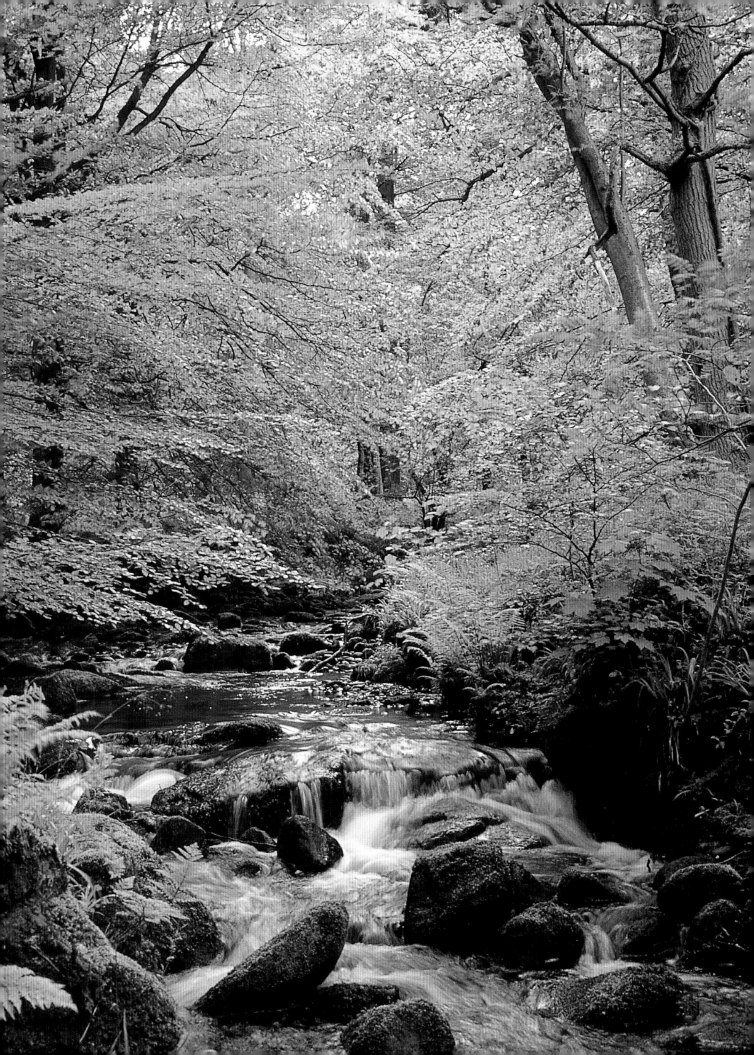

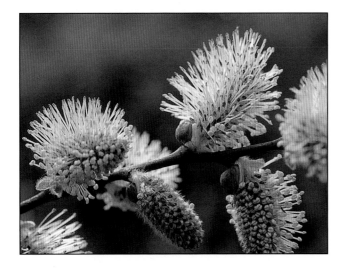

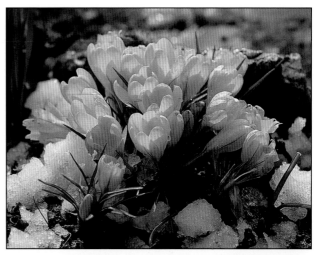

Above left - Male flowers of the pussy willow, Salix caprea, each flower consisting of a mass of pollen-producing stamens. Note the harmonising out-of-focus green wooded background.

Above right - A group of crocuses, Crocus purpureus, photographed on a spring morning after a light overnight fall of snow. Backlighting was provided by the early morning sun.

Left - Horse chestnut, Aesculus hippocastanum, bud about to open. Taken outdoors in natural sunlight with a white reflector acting as a frontal fill-in light. I used a 90 mm macro lens on a tripod-mounted camera.

Right - Goose-grass, Galium aparine, photographed in close-up using a 50 mm macro lens. The tiny hooks are present not only on the fruits but also on the stems and margins of the leaves, hence the nickname 'Sticky Jack'.

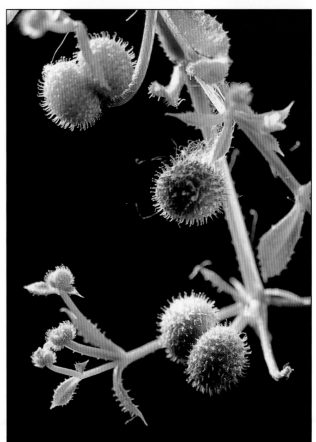

stamens but the female flowers, borne on another tree, are comparatively inconspicuous. After fertilisation a mass of downy seeds is produced; this, too, is well worth photographing.

The male catkins of hazel and silver birch are efficient pollen generators, and as the wind shakes them the pollen is liberated in clouds.

Everyone looks forward to the emergence of spring flowers, providing a dash of colour in a world awakening from its winter sleep. There are plenty to choose from: snowdrops, crocuses and daffodils, then primroses, campions, celandines, tulips and wood anemones, not forgetting early-flowering shrubs.

Crocuses come in a variety of colours, and when nestling in snow they make an appealing photograph. As the petals are translucent, backlighting by the early morning sun can transform a routine scene into an attractive picture. You may need to remove dead leaves and twigs from the foreground, or melt some of the snow immediately behind the flowers to make them stand out better. Tulips are easy to photograph,

but for something different try photographing them during a spring shower, if possible with the sun shining through the petals. The length of the exposure will determine whether the rain is recorded as small droplets or six-inch nails!

If you are interested in photographing spring flowers and shrub blossoms in a more controlled indoor environment, I suggest you work with daylight as the main source of illumination, and a portable video light to highlight features or provide backlighting or

fill-in. When daylight is the main source of lighting you don't really need to use a blue correction filter on the video light as the yellow cast is not noticeable, but if artificial light predominates you will need the filter, unless you are already using tungsten-balanced film.

Working indoors allows you to experiment with different coloured backgrounds, bearing in mind that you can vary the overall tone of the background according to where it is relative to the light falling on it. Use a Kodak grey card for estimating the exposure, and a cable release (or the self-timer) for the exposure.

Frogs and toads in the field

Frogs and toads are well camouflaged in their natural environment, as their skin changes colour according to the background. Occasionally you may be startled by the discovery of a frog or toad as you tidy up the compost heap, and if conditions are favourable and you are quick off the mark, you may get a good photograph.

During the breeding season frogs, newts and toads return to water to lay their eggs, revisiting the same pond year after year. The male develops a nuptial pad on the first digit of each forelimb in preparation for gripping the egg-laden female. When a large female arrives in the pond, the male climbs onto her back, grasping her tightly with his forelimbs (amplexus).

Top - Tulips, Tulipa, Darwin group, in a spring shower. The length of exposure will determine whether the rain registers on the film as droplets or streaks. The exposure was 1/8 s at f/16.

Above - A chance encounter with a common toad, Bufo bufo. I had the camera to hand and the light was good, with a picture there for the taking. Hand-held camera, 90 mm macro lens.

Right - An American green tree-frog, Hyla cinerea, photographed indoors using two flash units, a main one above and a fill-in to one side.

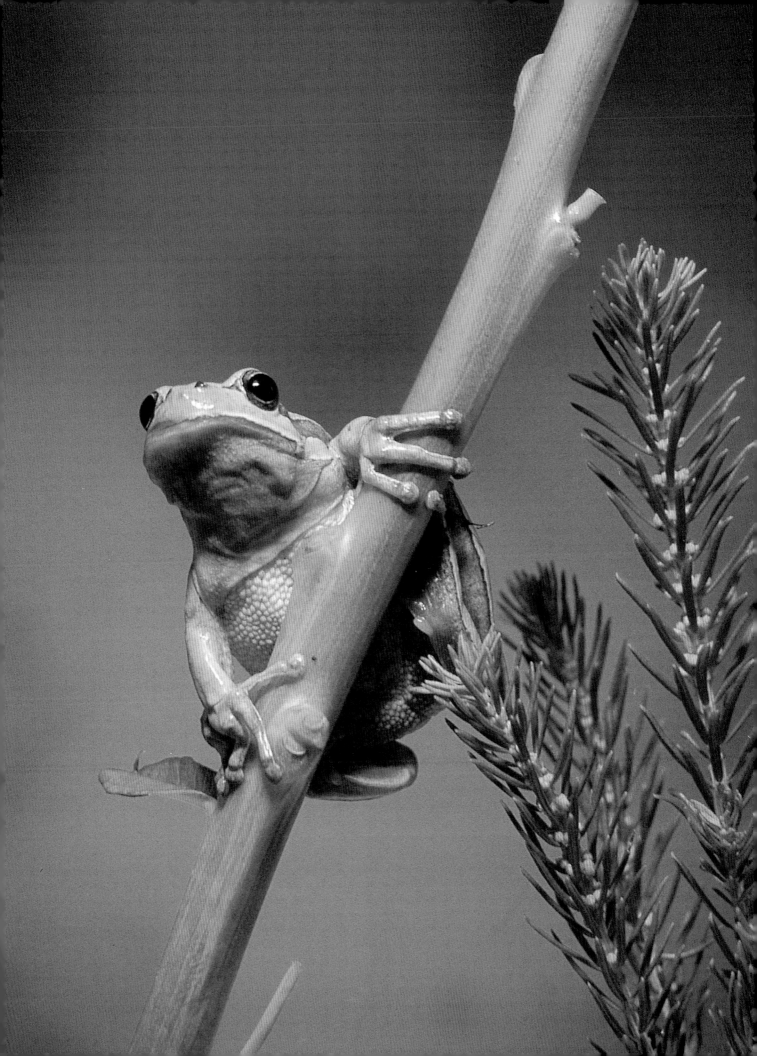

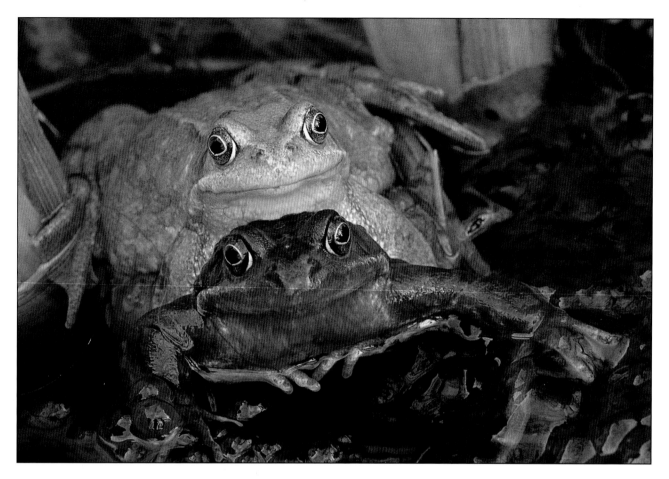

Top - A pair of frogs head-on. I set up the camera with the film plane parallel to the two pairs of eyes, ensuring that all four were sharp. I used a 75-300 mm zoom lens set at maximum extension.

Above - Underside lighting allows you to see through the tadpole with the well-developed hindlegs and the young four-legged frog. The skeleton, eyes and parts of the digestive tract are clearly visible.

The eggs are released by the female and immediately fertilised by the male, who sheds sperm over them, after which the frogs separate. The photograph above shows a pair of frogs in amplexus surrounded by a mass of frogspawn. It was taken with a polarising filter over the lens with its axis vertical, to reduce unwanted reflections from the surface. The camera was angled so that both pairs of eyes were equidistant from it and in sharp focus. Eyes are an important centre of interest, so provided they are rendered sharp, some lack of definition on other parts of the frog's body is acceptable.

Photographing amphibians indoors

When you photograph amphibians in the controlled environment of a studio you can arrange the lighting as you need, and are not limited by the uncertainties of natural sunlight. You can control the environment, and the animals, being in a relatively small space, are easy to handle, and to arrange for photographs. Illustrated is a late stage in the development of frogspawn, which begins with the beautifully symmetrical eggs at Day 1 and ends with the free-living tiny-tailed frogs at Day 30. The set-up is illustrated on page 61. Most of the water was removed just before taking the photographs, so that the spawn

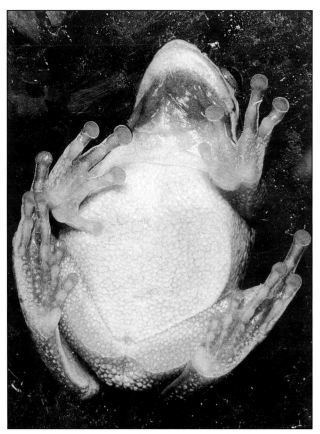

Top - Arrangement for photographing the underside of animals.

Above - Set up for photographing developing frog spawn.

Right - The underside of a tree-frog photographed through glass. The adhesive pads on the digits are clearly visible.

lay in a fairly thin layer on the bottom of the dish. This allowed most of the eggs and tadpoles to be seen with minimum overlap.

The undersides of animals are sometimes worth studying. For example, a photograph of the ventral surface of a tree frog shows very clearly the adhesive pads at the ends of the digits. This type of photograph employs a set-up such as that illustrated above.

Newts begin breeding about two months later than frogs, and as they spend most of their time under water, coming to the surface only occasionally for air, they are very difficult to photograph in the field. You will find the task a good deal easier in the controlled environment of an aquarium. (You will find more about this on page 91.)

Bird photography

During spring population increases as the summer visitors begin to join the resident population. Birds such as puffins, gannets and guillemots winter far out in the Atlantic, returning each year to Iceland, Norway and Britain to breed, while swallows, house martins, sand martins and swifts winter in equatorial and southern Africa and fly thousands of miles north to breed in Britain and Northern Europe.

These often very long migratory flights are simply for the survival of the species. The Atlantic seabirds require solid ground to nest on and a plentiful supply of food for the developing young, while birds which migrate from African countries move from areas where competition for food is great to northern latitudes where the onset of spring yields an abundant food supply.

Birds at the nest

In the early days of bird photography most photographers portrayed birds at the nest. There were two reasons for this: firstly, the bird must return to the nest to incubate the eggs and to feed the young; this guaranteed that the bird would be available for photography. Secondly, a mother bird incubating her eggs or feeding her offspring made a very attractive photograph!

In Britain some of the rarer birds are listed under the Protection of Birds Act of 1981 which makes it an offense to disturb any listed bird while it is on or near a nest containing eggs or young (see Appendix 2). However, you should treat all birds with respect, and if there appears to be the slightest chance of the eggs or young being abandoned by the parents, you must cease all photographic activities forthwith.

Locating the nest

Finding a nest can be difficult, requiring patience and a good knowledge of bird ecology. Locating a swallow's nest in an old barn is easy because the parent birds visit it frequently; also, the nest itself is obvious, and the pile of 'droppings' on the floor is a give-away. Unfortunately for the photographer, most nests are carefully concealed, and the parent birds are often very clever in the way they enter and leave the nest. The coot, for example, makes its nest of reeds and grasses in shallow water among reeds and overhanging branches of trees. It is well camouflaged and very difficult to spot. When a stranger is in the vicinity of the nest, the parents cruise about on the open water, acting as decoys, trying to draw attention away from the nest.

Bird watchers in north-east England are fortunate to have colonies of nesting seabirds on Bempton Cliffs, a few miles north of Bridlington, and on the Farne Islands off the Northumbrian coast. Between April and August, these birds are much too occupied with the business of nest building or feeding the hungry family to be concerned about photographers, and you can work without a hide, as the birds are some distance away on rock faces inaccessible to humans. Your main photographic requirements are a good quality long-focus lens (300-600 mm) and a substantial tripod. As the depth of field is very small and camera shake a strong possibility, you need a medium fast film (around ISO200/24°) and high ambient light levels to achieve the best possible aperture shutter speed combination.

Most birds are suspicious of humans and if you want to approach them closely you will certainly need some form of hide. Depending on the circumstances and the type of terrain this might be a commercial tent-like structure, camouflage netting, a heap of twigs and branches, or even an old door and pieces of corrugated sheeting.

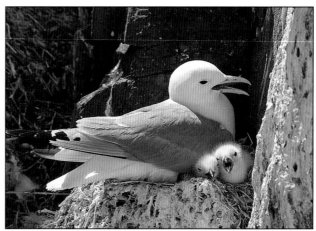

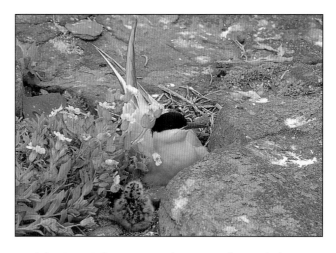

Top left - Coot, Fulica atra. I used a 300 mm lens with the camera mounted on a monopod for extra stability.

Top right - Puffins, Fratercula arctica. I used a 500 mm telephoto lens set at f/11.

Above centre - A kittiwake, Rissa tridactyla, with young. Tripod-mounted camera with 500 mm telephoto lens.

Above - Arctic tern, Sterna paradisaea, with young, 300 mm lens.

Right - The swan's nest was on a small island some 10 m from the edge of the lake. A tripod-mounted camera with a 500 mm telephoto lens set at f/11 secured this photograph.

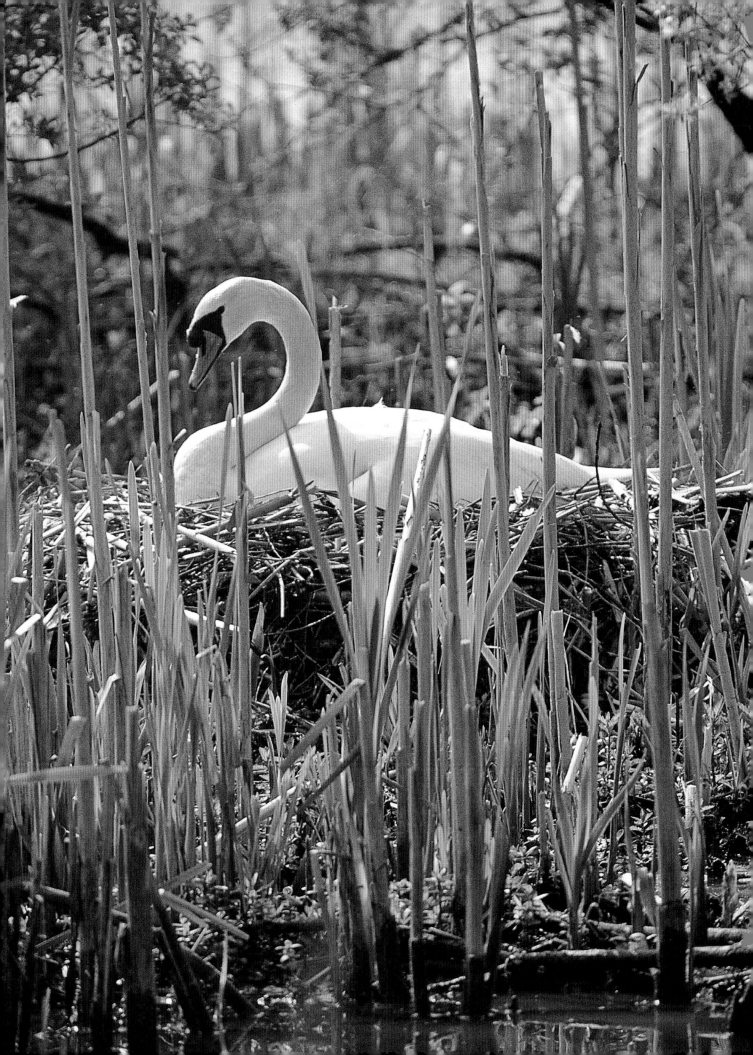

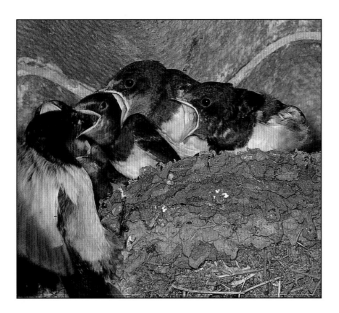

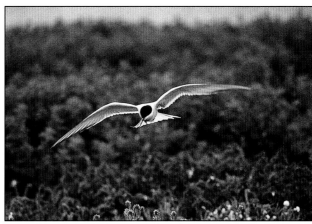

Left - Swallow, Hirundo rustica, feeding young. The camera, with a 75-300 mm zoom lens, autowinder and two flash units (all tripod mounted) was operated remotely from behind a makeshift hide in the corner of the barn.

Above - Arctic tern flying towards the camera supported on a monopod. To allow the best combination of a short exposure and a reasonable depth of field the ISO200/24° was pushed 1 stop (that is, set at ISO400/27°).

To obtain the photograph of the swallow feeding its young I set up the camera (complete with autowinder) and two flash units on a fully-extended tripod which was itself standing on a large wooden hopper. The camera was prefocused and triggered via a long electrical lead attached to the autowinder through a miniature jack plug, with a bell-push switch at the other end. I built a hide across the corner of the old barn using an old wooden door and some pieces of timber that were lying around. After observing the parent birds visiting and feeding their young several times without attempting to take any photographs, I chose my moment and pressed the bell-push switch. The two flash units fired, the exposure was made and the film wound on. Some three hours later I emerged, having exposed half a roll of film. The whole operation was repeated on two further occasions, from which I obtained two or three satisfactory photographs: a fair percentage in this type of work.

Stalking methods

Stalking birds has advanced in popularity in recent years, owing to the availability of compact, lightweight equipment. Locations such as mud flats, swamps, woodland and the seashore are popular with enthusiasts in this branch of bird photography. You should be inconspicuously dressed, and move about in a slow deliberate fashion. Where possible use natural cover such as bushes, shrubs and small hillocks. You must be prepared to travel long distances on foot, in return for perhaps no more than one or two good photographs.

Again, you need a long-focus lens (300-600 mm). Some photographers find a shoulder-pod useful, while others prefer to work near ground level with a large beanbag on a rock or other solid material.

Camouflage netting spread loosely over your camera and shoulders can be useful, and can allow you to get closer to the bird.

Birds in flight

The development of 35 mm SLR cameras with automatic exposure control, autofocus and high-speed, high-resolution film gives you the opportunity to take excellent photographs of birds in flight, even though this is by far the most difficult branch of bird photography.

Suitable lenses

The small size of a bird suggests the use of a long-focus lens. For some work a 210 mm focal length is satisfactory, although many photographers use 400 mm or 600 mm lenses. The shorter focal length enables you to follow the bird more easily in the viewfinder, but with the penalty of a smaller image. Whichever lens you use, camera shake can be a problem. Two possible aids are the rifle grip and the monopod. I favour the latter, using it with a ball-and-socket head slightly tightened to firm up the camera without locking it solid. I always try to shoot in bright light, using fast film (ISO400/27°) and a shutterspeed of 1/500 s with the camera set on shutter-priority auto-exposure. Compensation of at least one stop underexposure is often required, particularly when you are photographing light-coloured sea birds against a dark sea background.

Photographs of birds in flight are usually taken by

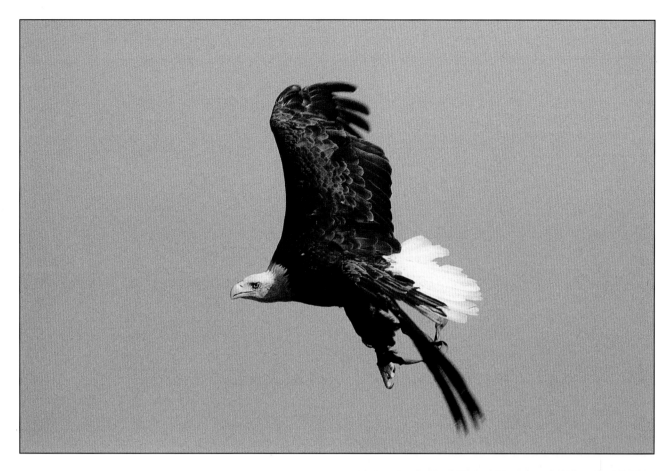

'panning' the camera, i.e. swinging it with the movement of the bird, so that it remains relatively stationary in the viewfinder. Although the bird's body will be rendered sharp, the background will be blurred. The most rapidly moving parts of the bird are the wingtips, and though panning will render most parts of the bird sharp on the negative, the wingtips will often be blurred. This is visually acceptable, and often gives the picture an extra feeling of movement.

Focusing on a moving object is not easy, and many photographers use the prefocus technique. This involves focusing the camera at a certain distance and following the bird in the viewfinder until it comes into the zone of focus, at which point the shutter is released. Other photographers prefer to maintain focus on the bird as it flies past. This works reasonably well with seabirds hovering almost motionless on an off-sea breeze at the top of a cliff.

In recent years the autofocus SLR camera has come into its own, and sharp images should be possible every time, in theory at least! In practice this is not always the case: the focusing mechanism on my Minolta 7000i camera often 'hunts' before settling accurately on the subject, which by then has usually flown past.

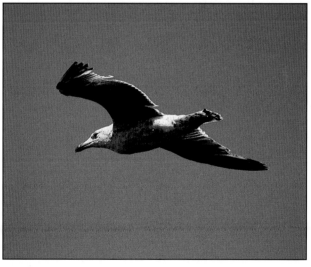

Top - Bald eagle, Haliaectus levocephalus, emblem of the United States, photographed using a 400 mm lens focused manually. The film was ISO 400/27° and exposure 1/1,000 s at f/8.

Above - Panning shot of young herring gull using autofocus 210 mm lens with a 1.4 converter on it. Film was ISO 200/24° pushed to ISO 400/27°.

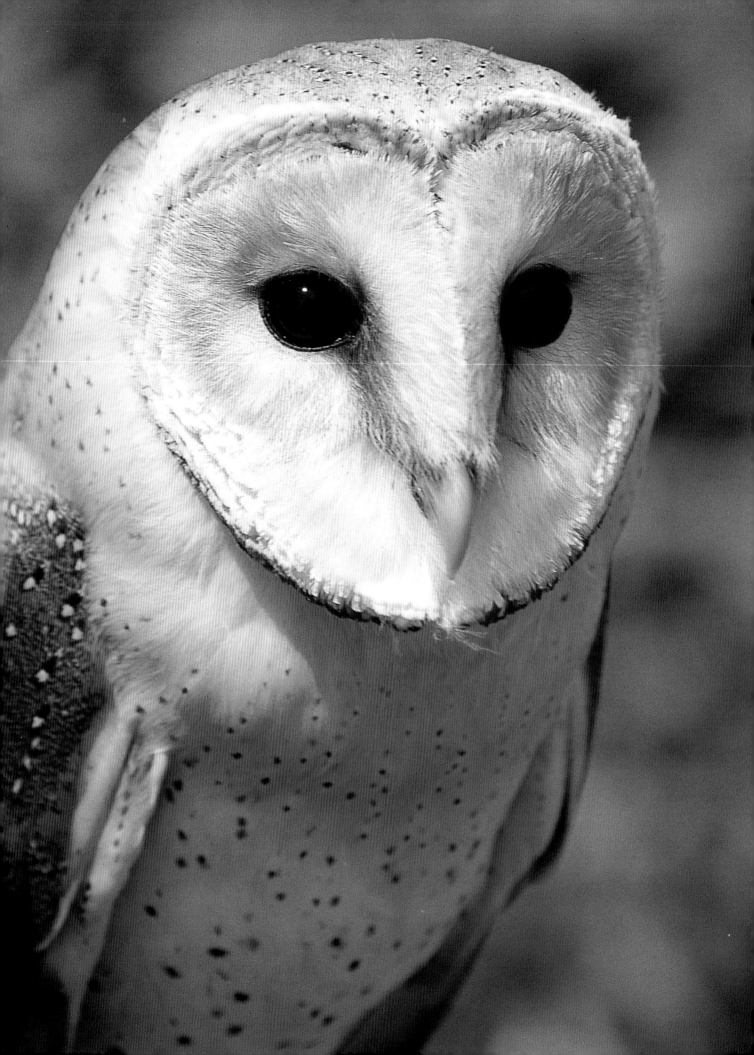

Birds of prey

If you do not have the time, expertise or special equipment needed to photograph birds of prey in the wild, an alternative approach is to visit a falconry centre. Most of the raptors will be on small round perches with jesses (leather thongs) around their ankles, making the setting look artificial. However, close-ups of the heads and shoulders provide natural-looking photographs. Don't attempt to pass them off as photographed in the wild. Someone will rumble you, and your reputation will suffer.

Several times during the day the birds are flown by experienced falconers, providing an excellent opportunity for some in-flight photography. Food is either hand-held or fixed in a lure at the end of a length of cord and swung around by the falconer. Large birds such as vultures or eagles circle the area then fly in low and take the food, smaller birds like falcons and kestrels dive in a fast 'stoop' to capture the prey in their talons. Photographing these birds in flight calls for skill and patience. For the photograph of the eagle I used a Minolta autofocus camera on a monopod, using both auto and manual focus. The shot illustrated was focused manually.

Top left - Close-up of eagle owl. The eyes must be critically sharp with the catchlights adding life to them.

Bottom left - The profile shot of the bald eagle allows both the beak and the piercing eye to be in sharp focus.

Above - Very young downy-feathered great horned owl shortly after a cooling bath. 300 mm lens and flash were used with the lens stopped down to f/11.

Opposite - Close-up of a barn owl, Tyto guttata, photographed at a Falconry Centre using 90 mm macro lens. This shot looks natural because the leather jesses on the ankles are not visible.

Photographing mammals in the field

Although mammals can be photographed during much of the year, I have included them in this chapter because there are so many other living creatures to concentrate on in the summer and autumn months. Photographing mammals in the field can be difficult because British mammals are in general small, secretive and largely nocturnal. Even finding them presents a problem: you may have to work in poor light or even total darkness. Your quarry's hearing is acute, and a clumsy approach usually results in failure. The slightest sound is often sufficient to send it scurrying for cover.

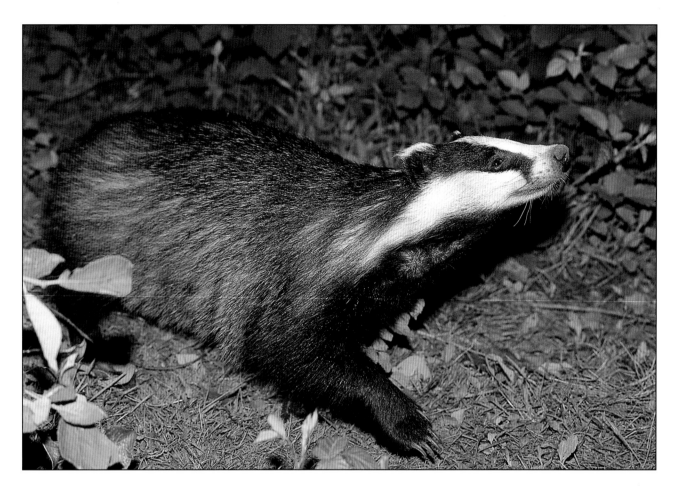

Most mammals have a highly-developed sense of smell, and human scent carried on the wind is sufficient to keep the animal at a safe distance. This is particularly important when stalking woodland deer, which also have acute hearing. Fortunately for the photographer, most mammals, particularly small ones, have poor eyesight, though they are sensitive to changes in light intensity and can quickly detect movement.

Badgers are interesting to watch and photograph, and can sometimes be observed at dusk, although they are usually more active after dark, when you need a red-filtered torch to see them. The adults may be wary of the red light, but the cubs can be brought up to accept increasing strengths of white light. Badgers have a keen sense of smell and should always be approached from downwind. Any human scent carried by the wind to the set is picked up by the boar, who is usually first out, the others remaining in the set until the air has cleared. Badgers are short-sighted, but can pick out areas of dark tone, and as the boar emerges he surveys the area looking for unfamiliar silhouettes.

To photograph badgers, I would set up one or preferably two flash units to illuminate the feeding area, and prefocus and operate the camera remotely.

Top - A badger sniffing the air as it emerges from its set.

Above - The Longworth small mammal trap is ideal for catching live mammals such as mice and voles. The animal enters the tunnel in search of food, activating a trap door, while the main chamber contains food, water and bedding.

Right - The long-tailed field mouse, Apodemus sylvaticus, photographed through the side of an aquarium set up to replicate the natural environment. Two flash units were used.

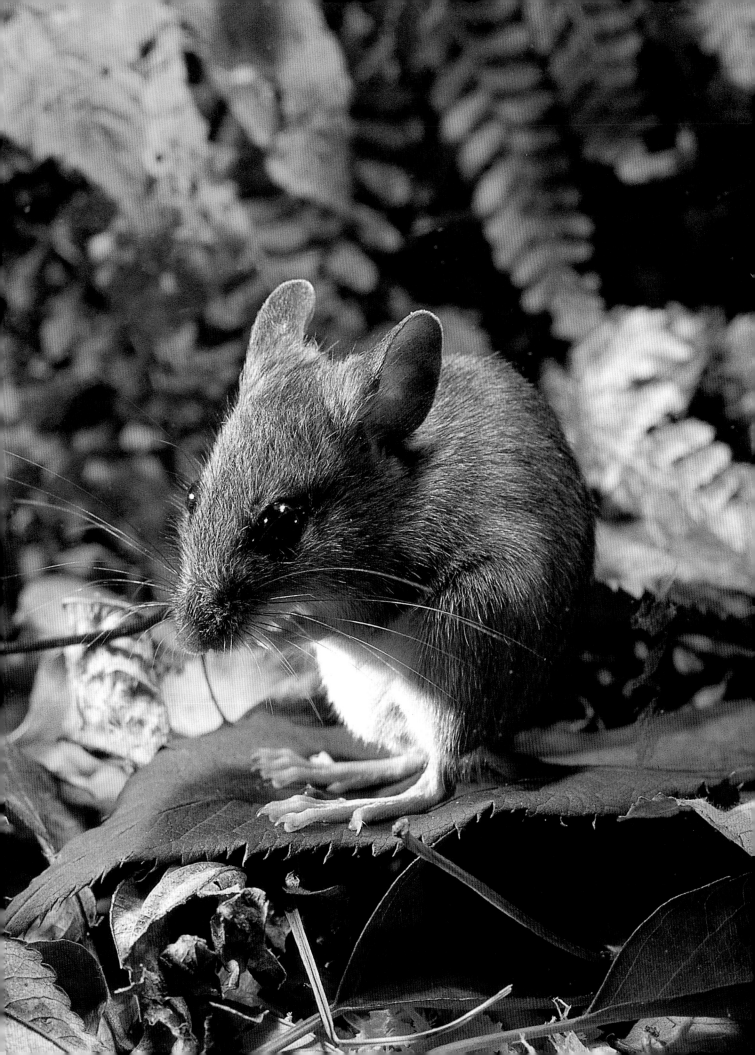

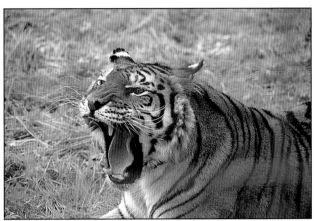

Above - An Asian tiger, Panthera tigris, photographed through the wire perimeter fence using a standard 50 mm lens set at f/4 - obviously a tiger in captivity.

Right - Tiger photographed using a 300 mm lens at f/4. A slight distortion of the background, vertically just in front of the tiger and horizontally at eye level, indicates the position of the wire mesh - but you have to look really closely to see it.

Some photographers prefer to use a telephoto lens and stay with the camera. An autofocus SLR camera with an IR illuminator will focus in total darkness up to 9 m (30 ft) and when coupled to a dedicated flash unit could make a very useful outfit.

Squirrels are not difficult to photograph, because they are active during the day and live above the ground. They are found chiefly in woodland areas and it is possible to photograph them in the trees using a 'wait-and-see' approach. However, only rarely do you get an uninterrupted view, and there may be little control over the light. A more successful technique is to put down bait in an area frequented by squirrels, particularly during the winter months when food is scarce. The food could include acorns, sweet chestnuts, peanuts, beech mast, pieces of apple, cereals such as wheat, and sunflower seeds (page 128).

Photographing small mammals indoors

If you want to photograph small mammals indoors, you need an efficient means of catching them alive. In Britain the Longworth trap is universally accepted as an easily operated and reliable piece of equipment. The original trap was designed by D. H. Chitty and D. A. Kempson of the Bureau of Animal Population in Oxford, and is now manufactured by Philip Harris Ltd. of Shenstone, Staffordshire. The complete trap, which is about 28 cm (11 in) long, consists of a tunnel with a flap door leading to a nest box. As the animal enters the tunnel to reach the food in the nest box it depresses the trip-bar, which closes the flap door. The animal then finds its way into the cosy box which is supplied with food, water and bedding. It is normal practice to check the trap every few hours, because small mammals such as mice, voles and shrews have a large surface area relative to their size and can lose heat rapidly.

Larger traps are available for rats, squirrels, hedgehogs and weasels. The Forestry Commission publishes a leaflet entitled 'Traps for Grey Squirrels'.

Housing small mammals

If a live mammal is to be kept for only 24 hours or so for the purpose of photography, some temporary housing, such as a ventilated metal biscuit tin containing suitable bedding and a supply of food and water, is appropriate. If, however, the animal is to be a long-term resident, you need to provide more suitable accommodation. You can find cages for mice and hamsters in pet shops, and you can set them up to replicate the natural environment, using moss, dead leaves, dry grass and twigs, or furnish them with straw, wood shavings or other insulating material. If you decide to keep a small mammal, it is good policy to visit a pet shop and purchase a booklet on its care.

Photography

As many small mammals are fast movers and good jumpers, the best place to photograph them is in an empty aquarium set up to replicate their natural habitat. For example, a typical environment for a wood-mouse, vole or shrew would include pieces of bark, moss, bracken and leaves, seasonally adjusted and spread up the rear of the tank. Photographic floodlamps are not recommended as they run hot, and their intensity is too low in most cases for short exposures. Electronic flash is mandatory here. Set up a main unit above and slightly in front of the housing, and a second, less powerful unit at subject level as a fill-in light. Cut a piece of black card about 30 cm (12 in) square with a hole in the centre for the lens, and fit

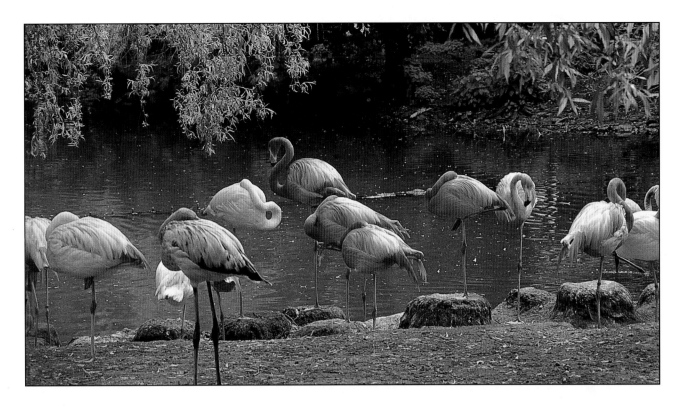

it over the lens barrel. This will block out any reflections from the front glass of the aquarium.

Photographing animals in zoos and wildlife parks

Even though many zoological establishments are open throughout the year, spring is a good time to visit them, largely because there are fewer visitors around. Photographing animals behind wire fencing raises some difficulties, depending mainly on the type of mesh and how close you can get to it. If you can touch it, and the size of the mesh is sufficiently large to allow the camera lens a fairly unrestricted view, there shouldn't be any problems. Don't let the camera rest against the wire, as it might be vibrating; instead, hold it a centimetre or so away. When you can't get close to the mesh the situation is more difficult. With big cats, for example, it is standard practice to have a high wire fence round the enclosure, surrounded by a low fence set back from the main fence. For the best results you need to be as near as possible to the main fence, and the subject as far away as feasible. The standard 50 mm lens is useless: fit a 300 mm telephoto lens. Keep the depth of field small by working at a large aperture, and you may get something like page 70 top right. Both photographs were taken from exactly the same position at an aperture of f/4, but the first exposure was made with a standard 50 mm lens, and the second with a 300 mm telephone lens.

Flamingoes, Phoenicopterus ruber, with their long, pink, matchstick-like legs photographed through wire fencing, where the mesh size was sufficiently large to allow an accurately set up camera an almost unrestricted view.

Wildlife parks tend to be larger than traditional zoos, and the animals can roam over a much greater area. Two types of park exist: one contains lions and other dangerous carnivores, and the second, which usually covers a much greater acreage, houses fairly harmless mammals such as bison, wild goats, deer and antelope. The lion parks allow cars to travel round a fixed circuit with the occupants in their cars behind closed windows. Under these circumstances you need a telephoto lens, and although you can take photographs through the car windows you should use only the flat glass areas of these. Position the camera at right angles to the window glass, otherwise you may get distortion and double reflections. A finger wedged between the glass and the lens mount will help to steady the camera if the car is moving.

The more open types of park housing harmless animals represent a much better prospect for the photographer. If you are restricted to the car but allowed to open the windows, you can support the camera on a beanbag resting on the window ledge. If you are allowed to get out of the car then the camera equipped with either a 75-300 mm zoom lens or a fixed 500 mm lens supported on a tripod or by a beanbag resting on the roof, will ensure you get at least some sharp photographs.

SUMMER

The evening comes; the fields are still,
The tinkle of the thirsty rill
Unheard all day ascends again;
Deserted is the half-mown plain,
Silent the swaithes! the ringing wain;
The mower's cry, the dogs' alarms,
All housed within the sleeping farms,
The business of the day is done,
The last-left hay-maker is gone.

MATTHEW ARNOLD

During the summer months Britain enjoys the highest temperatures of the year, 20°-25°C being fairly common during July and August. There are many hours of daylight, although the days begin to shorten at the end of June. The average monthly summer rainfall is little different from that of the spring. Three factors - higher temperatures, longer day length and a good supply of water - combine to produce ideal conditions for growth and reproduction in plants and animals. The whole range of flora from mosses, lichens and ferns to flowering annuals and perennials exhibits steady growth, while the microscopic organisms in ponds and rivers proliferate, reaching a peak by midsummer. Both insects and vertebrates increase dramatically in numbers. The only group which does not respond to summer conditions is the fungi, most of which wait until cooler, wetter autumn weather arrives, when their fruiting bodies appear almost overnight.

There is much to photograph during the summer months, but I shall concentrate on flowers of the field, hedgerow and garden; insects; seashore, pond and river life, concluding with an introduction to photomicrography. I discussed some aspects of bird photography in the 'Spring' section; but some species build their nests, lay their eggs and raise their young throughout the early summer months.

My summer equipment for nature photography consists of a pair of Olympus OM2n 35 mm SLR cameras (occasionally a Mamiya 645 SLR camera),

A woodland path carpeted with last year's fallen leaves. The sun was not excessively bright, and an aperture of f/16 produced a good depth of field, but a rather long exposure of 1/8 s.

complete with 50 mm and 90 mm macro lenses plus a 75-300 mm zoom lens and a 500 mm telephoto lens. For in-flight bird photography I have also used a Minolta autofocus SLR camera. A Benbo tripod (occasionally the smaller Manfrotto unit), a cable release, a small video light and an Olympus T32 flash unit are my constant companions, and on several outings I have been carrying most of the above equipment at one time; it becomes steadily heavier as the day progresses!

Summer landscapes

Everything I wrote earlier about spring landscape photography is equally valid in the summer months. However, the high-contrast lighting of the midday summer sun can produce a brightness range too great for prints and even transparencies. This is noticeable in photographs taken in dense deciduous woodland. Although the eye quickly adapts to large variations in brightness, the film may have a hard task to record an acceptable image. Most photographers prefer a slightly overcast sky, or shoot only in the early morning and late evening.

Although seascapes are available at any time of the year, summertime has the advantage of being warm and more pleasant to work in, while the brighter light permits shorter exposures on medium-speed film.

Although seascapes can be taken at any time of the year, the bright summer light allows a reasonable depth of field to be coupled to a short (1/250 s) exposure particularly important when photographing sea birds (oystercatchers) in flight.

73

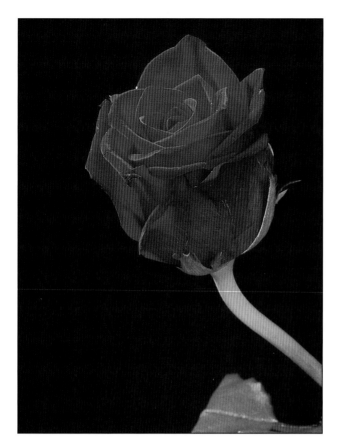

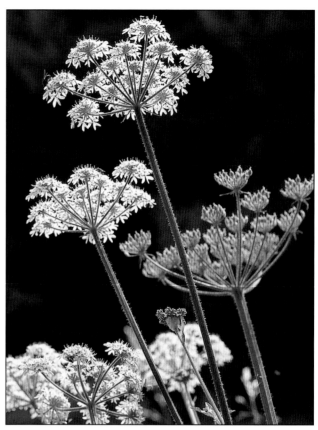

Colour filters are becoming increasingly popular, but they can often mar an otherwise good photograph. I prefer to limit their use to slightly 'warming' up a scene with an 81 series amber filter, and to use a polarising filter to enhance the blue sky and - where appropriate - to reduce reflections from horizontal surfaces.

Flowers of the garden, field and hedgerow

It is not difficult to take a colour photograph of pansies and snapdragons that compares favourably with the picture on the seed packet. But if you intend to produce something more interesting and aesthetically pleasing, it is worth concentrating on the lighting, composition, tone distribution and background, spending some time studying each factor in relation to what you are trying to achieve.

One or two examples will illustrate these points. A rose garden is a joy to behold, though roses en masse do not translate well into a two-dimensional photograph. Try photographing one or two flowers in close-up instead. After all, one may begin by admiring a whole rose bed, but one then bends down to smell and examine individual flowers. The ideal illumination is diffused sunlight; you can decide whether the illumination is to be a frontal, side or

Above - Cow parsnip or hogweed, Heracleum sphondylium, photographed outdoors in natural sunlight. The contrast was produced by the strong backlighting against the dark woodland background.

Above left and opposite - A single rose against a black nonreflecting velvet background can make an attractive picture. The example shown was lit by natural sunlight with a white reflector to fill in the shadowy areas. Exposure compensation of -1 stop ensured that the background registered as jet black.

backlight, remembering that frontal lighting is safe but not very exciting, whereas sidelighting will emphasize surface texture. Backlighting (rim or profile lighting) is worth experimenting with, and the results can often be exciting, but remember to use your lens hood.

As an alternative to working out of doors, why not take the flower indoors and photograph it in a controlled environment? In a conservatory or living room the composition, lighting, tone balance and even the background are all under your control.

During the summer months the hedgerows of country lanes are full of hogweed (cow parsnip). It is so widespread as to be almost unnoticed, yet while walking along the edge of a wood I spotted one backlit by a low sun, the white flowers luminous against the dark green woodland background. Even

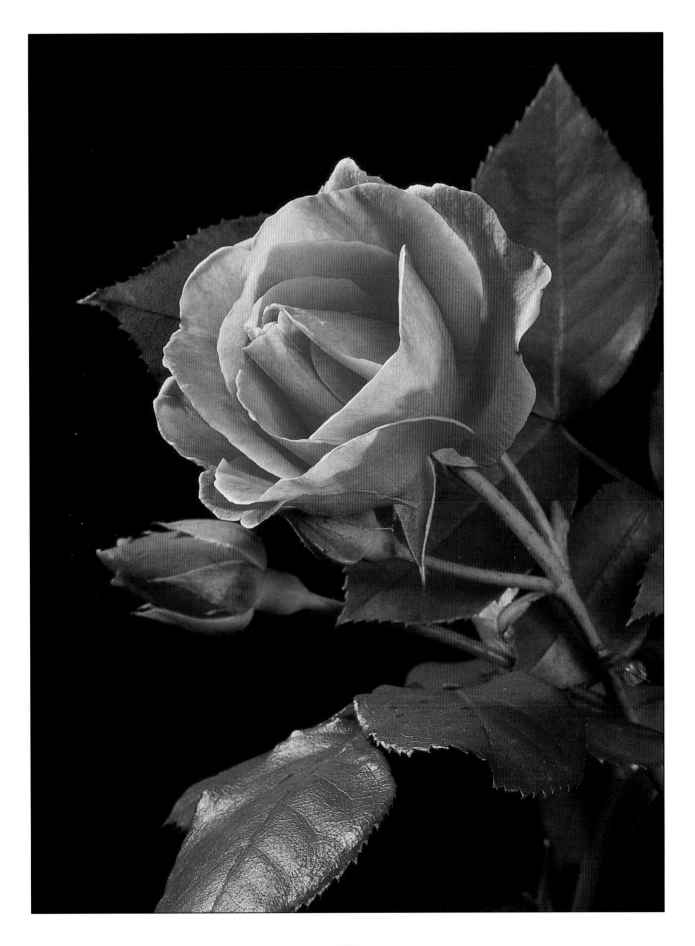

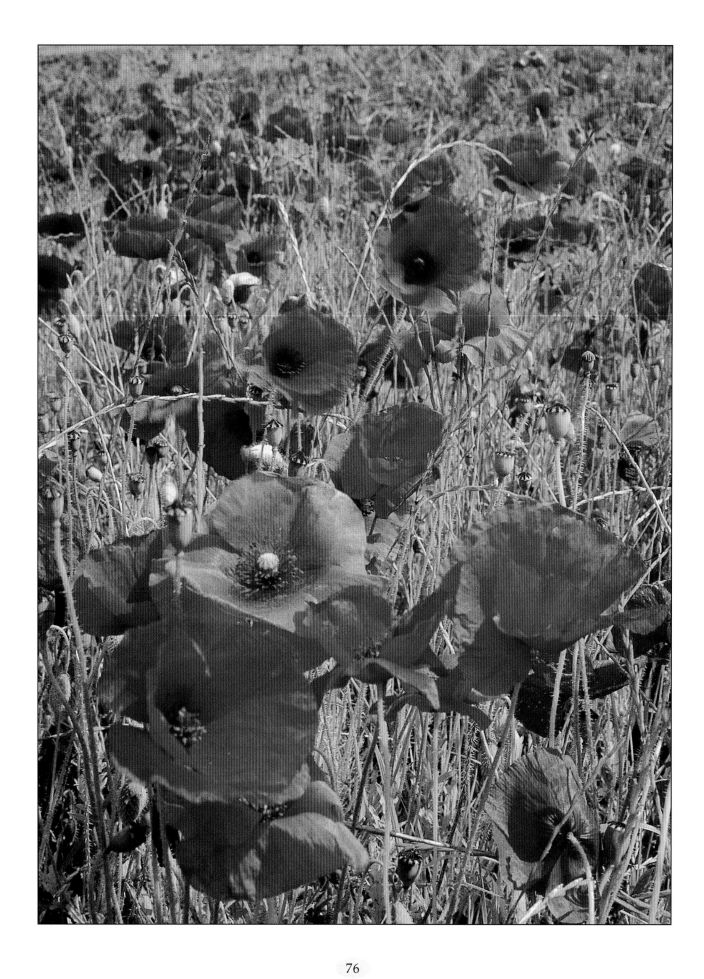

Above - Opening flower bud photographed at ground level using a 90 mm macro lens on tripod-mounted camera. A largish aperture (f/5.6) allowed the background to remain out of focus.

Right - A still-life study of the capsules of the smooth headed poppy, Papaver dubium. Taken indoors using three small spotlights, one of which was used to brighten the lower part of the almost black background.

Opposite - I saw a field of poppies, Papaver rhoeas, en route to the coast to photograph sea-birds. Shortest lens was the standard 50 mm but when stopped down to f/16 it produced a reasonably good depth of field. As usual a tripod was employed.

the short hairs on the stem were highlighted by the sun, and on this occasion I merely had to choose a suitable viewpoint and operate the shutter.

Poppies scattered along the hedgerow are eye-catching, but a field full of these flowers is a joy to behold. Taken from a distance the image is often disappointing, but a camera position low down amongst the flowers can yield a much more attractive picture. If you can get even closer to the ground with a macro lens, a picture showing a close-up of a bursting flower bud can be yours, but use a tripod and cable release, as focusing is critical and the exposure may need to be quite long. To complete the poppy sequence I collected some dry capsules and leaves and arranged them as a still life study lit by three spotlights against a plain green background.

Insects and arachnids

There are more than 850,000 named species of insect; probably more than three times that number remain undescribed. They have been in existence for around 270 million years, and fossil evidence indicates that the largest was a dragonfly-like creature with a wing span of some 3 m (10 ft). Over this time-span insects have become extremely well adapted to all environments (except the sea). The smallest insects are less than a millimetre in length; the largest beetles

(such as the Rhinoceros and Hercules) can exceed 15 cm (6 in) in length, and tropical swallowtail butterflies and the Atlas moth of the Far East have wingspans up to 20 cm (8 in).

Insect bodies have three sections: head, thorax and abdomen. Their mouthparts are adapted for chewing, piercing or sucking, and they breathe through a system of tiny air tubes (tracheae) which permeate the entire body and open through small holes (spiracles) on the sides of the thorax and abdomen. Spiders are not insects but arachnids; they have four pairs of legs rather than three, no antennae or wings and up to eight simple eyes, unlike the compound eyes of insects.

Many insects, for example butterflies and moths, have a four-stage life cycle: egg, larva (caterpillar), pupa (chrysalis) and imago (adult), while others such as grasshoppers, cockroaches and dragonflies have only three stages: egg, nymph and adult. Some insects such as aphids can give birth to live young.

Photographing insects in the field

Photography of insects such as butterflies in the garden or hedgerow is not too difficult provided you bear a few points in mind. The standard 50 mm lens is not ideal because working distances are too short (the insect will fly away as you try to approach). A 90 or

105 mm macro lens or a 75-300 mm zoom with close focusing facilities is far better, but you need to remember that a longer focal length goes with more critical focusing and restricted depth of field. Give the shortest exposure you can get away with, commensurate with a reasonably small aperture, and remember that subject movement is magnified when close up. The requirements are therefore bright sunlight (or flash), medium speed film, and a monopod for steadiness.

After locating your insect move in very slowly taking care not to cast any shadow on it. Make the first exposure before you reach the ideal distance, so that at least you do get one shot; then make several more exposures as you approach more closely. For subjects close to the ground a waist level finder is useful. You can use a small flash unit if the subject is in dark shade or the weather dull and overcast; otherwise natural sunlight is best. With flash illumination the background may register as black, which looks unnatural when the subject is a diurnal insect. You can reduce this effect by selecting a background which is close to the insect, or by illuminating the background with a separate low-power flash unit or a white reflector. If the subject is completely static you can give a longer exposure to allow the background to

Peacock butterfly, Inachis io, resting on dead heads of various species of thistle. The camera film plane was parallel to the wings to achieve maximum definition across the whole wing area. The shot was taken using flash with the background sufficiently close to avoid a 'midnight' effect.

register, but it is not easy to get the exposure and light balance correct, so if you can, bracket your exposures both up and down. As a last resort you can always try holding a suitably-coloured background card behind the subject, but you are then faced with the problem of the subject itself casting a shadow on the background.

Some butterflies, such as the large white, hold their wings vertically while at rest and are best photographed from the side, while others such as the small tortoiseshell and red admiral, as well as most moths, stretch out their wings horizontally and should be photographed from above. Try to set up the camera so that the film plane is parallel to the insect's wings, in order to have the entire wing area in sharp focus. A close-up of an insect feeding will often produce an interesting photograph.

You can apply the same principles to the photography of bees on their daily round of pollen collection. Bees should, of course, be treated with respect. They may be very active during warm sunny weather, but they

become slower and more docile if the temperature falls. Under these conditions the bees' flight muscles may not be warm enough to operate the wings, so that it is reduced to crawling round on the flower head until the warm sun reappears.

Photographing spiders' webs

Most spiders do not spin webs, though they depend on silk for making snares, tying up victims, travelling, and spinning cocoons to protect their eggs. The common house spider produces the familiar untidy maze, while the large garden spider makes a complex and beautiful web. Silk is exuded as a liquid from tiny finger-like spinnerets on the spider's abdomen.

Spiders' webs are most easily seen after overnight mist when tiny water droplets deposited uniformly across the web make it stand out from the background. A wood spider's web spun across the head and upper stem of a dead hogweed, was photographed under these conditions with an exposure of 1/2 s at f/16. The slightest air movement caused the web to tremble, and several exposures were made in the hope that one at least would be fully sharp, while a hand-held video light added some sparkle to the water droplets. I returned to the same site later in the day when the mist had given way to

Spider's web after heavy overnight mist. The tripod-supported camera with a 90 mm macro lens was set up parallel to the web and stopped down to f/16. A hand-held video light added a little sparkle to the water droplets.

bright sunshine, to discover that the web, still intact, was almost invisible now the water droplets had evaporated. If the weather is dry, you can deposit water droplets on a web as a fine mist using a small plant sprayer, but you need to direct the spray above the web so that it drifts gently on to it: direct spraying will damage it.

Photographing insects indoors

Photographing insects indoors ranges from working with completely static subjects such as eggs and pupae to the adults in free flight. Eggs, larvae and pupae should be photographed on or near to the host plant appropriate to that stage of their life cycle. Natural daylight is best, with highlights added as appropriate using a hand-held video light.

Active insects such as butterflies, moths and bees can be slowed down by chilling them in a domestic refrigerator. This is not harmful to them: on many summer and autumn nights the air temperature falls to 8°C or less. These insects can cope with such falls in

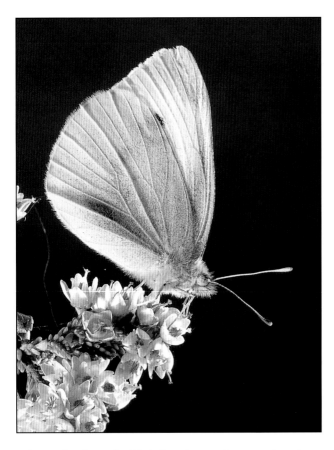

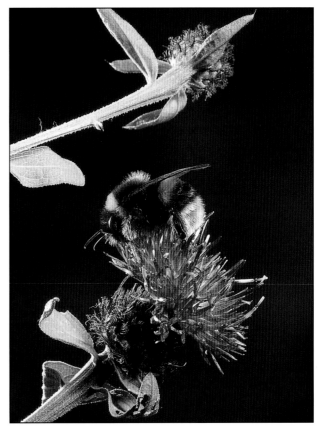

A large white butterfly, Pieris brassicae, resting on a piece of flowering heather. A two-light set-up was used, including a strong backlight, and the 90 mm macro lens was stopped down to f/22 for maximum depth of field.

Bumble-bee, Bombus terrestris, on knapweed. The bee was easy to handle after 10 minutes cooling in the fridge. Shortly after taking this photograph the bee took flight and escaped through an open window.

temperature because they are poikilothermic. (Never try chilling mammals such as mice, hamsters, etc!).

I have used the chilling technique with bumble-bees and butterflies which become fairly easy to manage after about ten minutes in the fridge; within minutes of being back in the warm atmosphere they return to their normal active state.

Insects in free flight

This is a very specialised branch of insect photography, calling for considerable patience, and the knowledge to operate electronic equipment.

The task was first tackled in the mid 1970s by naturalist and photographer Stephen Dalton, who after much experimenting and many setbacks, produced a collection of in-flight insect photographs which to my mind have never been surpassed for their beauty, technical excellence and composition. A selection of them was published in his book Borne on the Wind. The basic idea is that the insect flies along a flight tunnel, breaking a light beam which triggers the operation of the camera shutter and flash units. Thus

the insect takes its own photograph. This is not an easy technique: for every roll of film you expose (around six hours of concentrated effort) you may get one or two acceptable photographs, with luck. Like Stephen Dalton, I designed my own equipment using readily-available materials and components. Electronic light beam switches are now available commercially (see Appendix 1).

One of the many problems with this technique concerns the unpredictability of the insect flight path, and I have used sugar solution and an additional light source to encourage the insect to fly along the tunnel towards the camera. I have also increased the changes of a photograph being taken by a factor of three by introducing a small adjustable mirror at either side of the tunnel so that the very narrow beam of light zigzags across the tunnel. A sharp image of the flying insect is difficult to achieve, as after breaking the light beam and triggering the shutter it can take 1/30 s for the focal plane shutter to traverse the film, by which time the insect may have moved out of focus. Some photographers use specially-designed fast-acting leaf shutters to reduce the time lag, but I use an

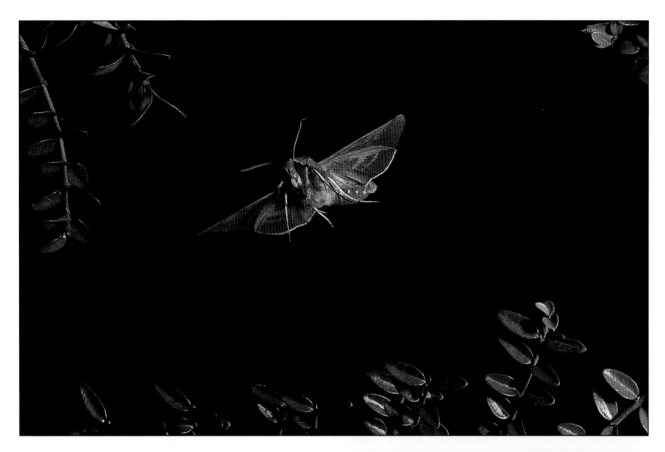

unmodified camera and make allowances for the time delay. The camera is focused approximately 2 cm in front of the light beam, the distance varying slightly, depending on the average flight speed of the insect, and established by trial and error. If several dedicated flash units are used, exposures as short as 1/10,000 s are possible, sufficiently brief to 'freeze' the wing movements of most insects.

In my own studio the flight tunnel is a wooden-framed cardboard-clad enclosure 60 cm (24 in) long, 30 cm (12 in) square at the front rising to 45 cm (18 in) high at the rear. A cardboard-framed acetate sheet with a central hole for the camera lens is located at the front, and a selection of coloured background cards can be slotted into the rear of the tunnel. The light source is a 12 V 100 W halogen lamp operated from a variable output power pack, with a 120 mm lens focused on a pinhole drilled in a metal plate attached to an opening in the side of the housing approx 4 cm in front of the lamp. This produces a pencil beam some 5 mm in diameter 2 m from the lamp. The photoelectronic switch unit is provided by RS Components Ltd with their light-activated switch LAS15. This is a combined photodiode and integrated circuit, designed to operate over a range of 11-20 V. There are two modifications to the circuit: transistor TR2 is included as a logic converter, because LAS15 is

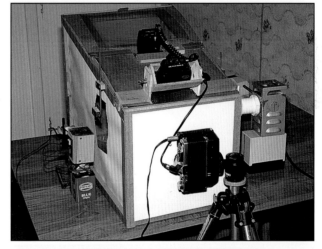

Top - Home-reared elephant hawkmoth, Deilephila elpenor, photographed in the flight tunnel. The moth flies towards the light at the camera end, interrupts the light beam and triggers the camera and flash units, taking its own photograph.

Above - The homemade flight tunnel has been used over several years to take photographs of butterflies, moths, damselflies and bees in flight. Success rate is only about 5 per cent, but one good photograph justifies all the time and effort involved.

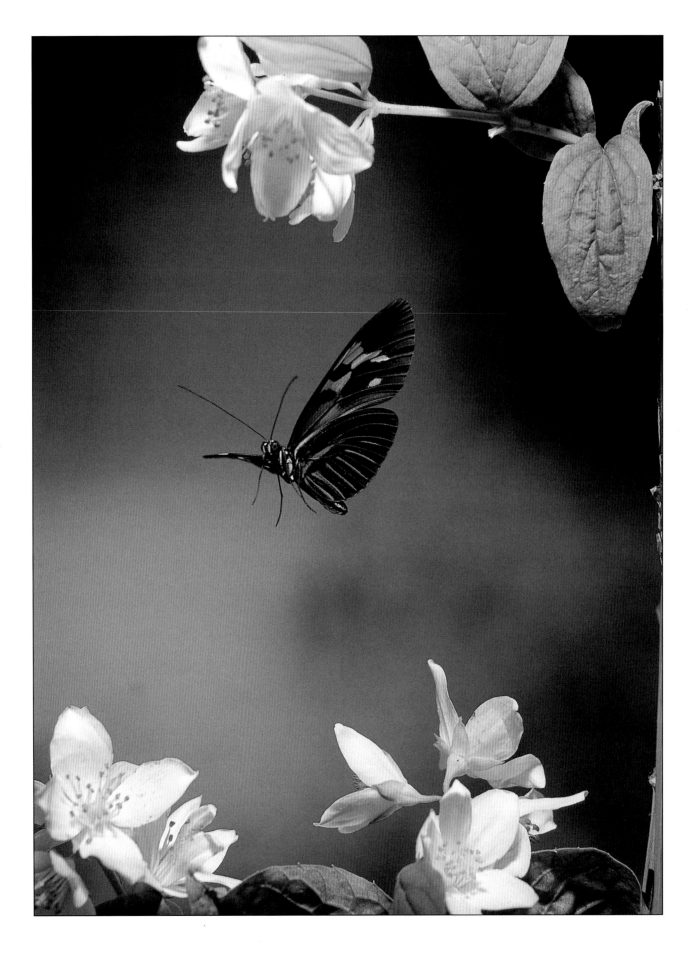

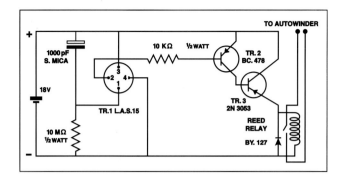

Circuit diagram of the main electronic components used in the interrupted light beam triggering unit. The photodiode switch L.A.S.15 is available from RS Components Ltd. (see Appendix 1).

Opposite - A Zebra butterfly, Heliconius melpomone, photographed in free flight using the flight tunnel and the interrupted light-beam triggering device.

light-activated and the unit must be dark-activated; also, the output, based on RS Components's specifications, is approximately 120 mW using a 15 V input, and this is insufficient to drive the 12 W solenoid. To increase the output, TR3 is included in the circuit.

When the beam of light shining on the photodiode LAS15 is interrupted, the voltage from pin 2 drops and switches on the second transistor TR2. The current from its collector goes to the base of TR3 and switches on this transistor, which in turn operates the solenoid unit. When the light beam to LAS 15 is restored, the above sequence of events is reversed and TR2 and TR3 are switched off again. The diode BY127 is included as a protection device, to prevent the induced voltage produced by the collapsing magnetic field in the solenoid from damaging TR3. The power to the circuit is supplied by two PP4 dry batteries linked in series to give 18 V. When the equipment is on standby the current consumption is approximately 2 mA, allowing the unit to be in use for several hours without unduly draining the batteries.

In the original unit, designed some fifteen years ago, the output from the switch unit activated a fairly large 12 w solenoid when the light beam was interrupted by a flying insect. The moving soft iron core released a spring-tensioned arm which pressed the camera cable release and triggered the shutter and flash units. The unit was built when autowinders were not available for the SLR camera I was using at the time. I have now dispensed with the mechanical release unit and solenoid, and feed output from the unit through a 12 V reed switch relay which, via a length of twin flex and a miniature jack plug, operates the autowinder attached to my Olympus camera. This has allowed me not only to photograph a range of insects in free flight

but to capture on film a small green tree-frog as it leapt through the air towards a nearby twig.

Photographing insects in free flight is one of the most rewarding areas of insect photography. The flight tunnel and light beam unit are inexpensive and not too difficult to make, the winged insects are easy to find throughout the summer and early autumn.

The seashore

The seashore is an area of great photographic potential, yet this unique environment is largely neglected by nature photographers. Most of the plants are seaweeds, and are not found elsewhere, though a few species may penetrate several miles up tidal rivers. Most of the invertebrate groups are represented on the seashore, and several creatures including sea urchins, starfish, sea-squirts, jellyfish, sea anemones and limpets are unique in this area.

There is a high and a low tide twice every lunar day (24 h 50 min). Superimposed on this daily rhythm is a longer rhythm of alternating spring and neap tides, two of each per lunar month (28 days). The maximum tidal range occurs approximately two days after a new and a full moon, while the minimum tidal range occurs two days after the first and third quarters of the moon. There is also a seasonal rhythm consisting of large-range spring tides around the vernal and autumnal equinoxes, with smaller-range tides between them.

The area below extreme low water is known as the sublittoral zone and represents the beginning of the truly marine environment.

Types of shore

There are four kinds of shore: rock, shingle, sand and mud. Any particular shore may be a combination of these. Each category of shore has its own special characteristics, but rocky shores are the ones of greatest photographic interest. The rocks form a solid substratum to which seaweeds become attached, resulting in a luxuriant plant population which can support a wide variety of animal life. Rock pools are a distinctive feature of rocky shores, possessing a rich variety of flora and fauna. They are the most pictorially rewarding of the shore habitats.

Photography on a rocky shore

Most seaweeds can be readily photographed out of water, draped over rocks; the only problem likely to arise is drying out. Dried-out fronds look dead, whereas wet specimens recently exposed by the outgoing tide look healthy and attractive. You need to watch out for unwanted highlights caused by

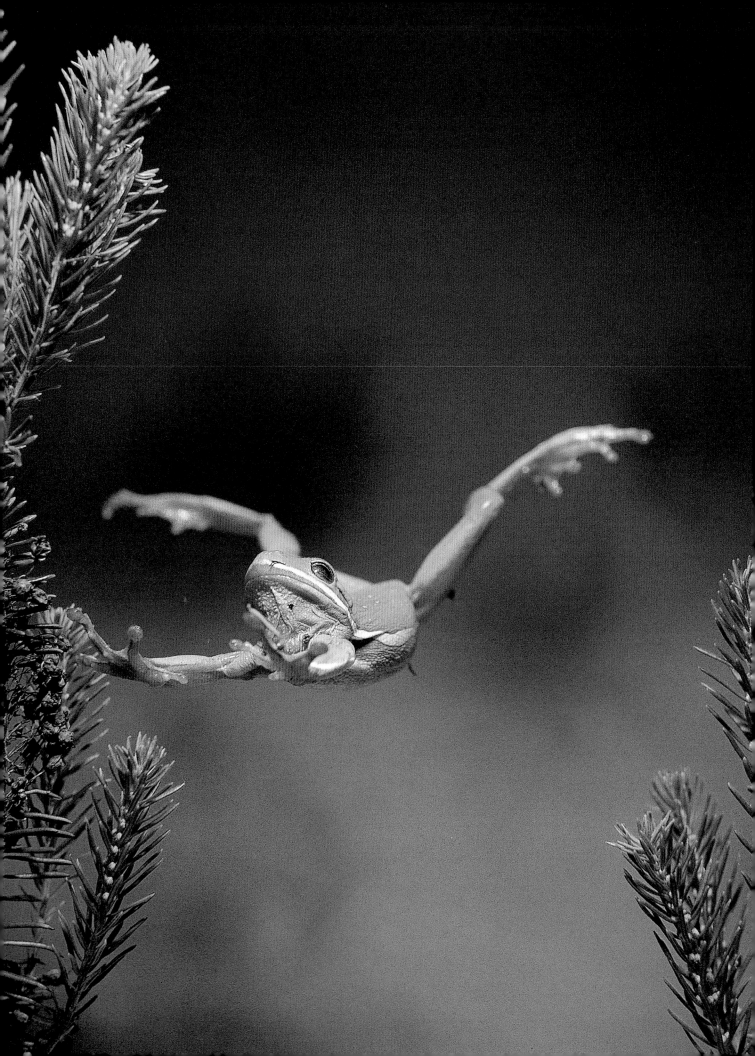

reflections from the wet fronds. Diffused sunlight produced by thin cloud, or by interposing stretched muslin or a large cotton handkerchief between the sun and the specimen can soften distracting highlights. Plan your visit to the shore to coincide with low water at a spring tide so that you can explore the strange and eerie region inhabited by the huge Laminaria seaweeds and the sea urchin. Tide timetables are available from angling shops in towns around the coast, while daily newspapers list the times of high water at key ports around the British coast.

Barnacles and limpets abound on rocky shores. When the tide is out, barnacles batten down their hatches, and limpets pull their shells close to the rock surface. There is sufficient oxygen in the small volume of trapped water to satisfy their respiratory needs until they become submerged at the next high tide. When covered again by the incoming tide, the barnacle opens up its four opercular plates and begins to feed by waving its fronds in this water, catching food in the process. When covered with water the limpet relaxes its grip on the rock and moves about rasping tiny algae from the rock surface. As the tide comes in the limpet returns to its home and settles down in its exact former position. This feeding process can be

Top - A growth of bladderwrack, Fucus vesiculosus, exposed by the outgoing tide and still wet. A wet frond and diffused sunlight are the two requisites for this type of photograph. A 50 mm macro lens on a tripod-supported camera was set parallel to the bladderwrack surface.

Above - The flatwrack, Fucus spiralis, an inhabitant of sheltered and semi-exposed waters, photographed from above in bright but overcast conditions. 50 mm macro lens stopped down to f/16.

Opposite - An American tree-frog, Hyla cinerea, leaps from the far end of the flight tunnel and lands on a twig near to the camera. The adhesive pads on the fingers and toes enable it to cling to almost any surface.

Above left - Underside of the common limpet, Patella vulgaris, showing the large muscular foot surrounded by the gill, with the head, open mouth and tentacles clearly visible. Photographed attached to a piece of glass in a shallow rock pool. A tripod-mounted camera and 50 mm macro lens were set up horizontally.

Above right - A sea urchin, Echinus esculentus, photographed near the surface of a deep rock pool at extreme low water of a spring tide. The rows of tube feet are just discernible between the spines.

Left - The common barnacle, Balanus balanoides, filter feeding by waving its appendages through the sea water. I used a 20 mm macro lens attached to a bellows unit to produce the required magnification, and flash illumination.

photographed only when the limpet is submerged. The trick is to allow the limpet to settle first on a piece of glass approximately 8 cm square. Once the foot has become attached to the glass you invert the limpet and glass and place them just below the surface of a shallow rock pool. You can then photograph it, taking care to avoid any unwanted reflections.

Many animals, in an attempt to avoid drying out, or to hide from predators, secrete themselves in holes and crevices. As this is their natural habitat when the tide is out, you should photograph them in this position. The light intensity in the crevices is often low, and you may need flash illumination. Overhanging rocky ledges are often inhabited by large numbers of beadlet anemones, best photographed in water when their tentacles are fully extended.

A very curious animal group found only in marine environments is the Echinodermata. The word means 'hedgehog-skinned', and the group includes starfish, brittle-stars, sea-urchins, sea-cucumbers and feather-stars. The interest lies in their five-point radial symmetry and the water circulatory system which operates five rows of suckers, called tube-feet.

Starfish are very common on the lower shore and below extreme low water. They have the ability to wedge themselves in narrow crevices, twisting their bodies to fit the space available. You can make an interesting photo-study showing the changes in body shape and position which occur when a starfish is placed upside-down in a shallow pool. Watch (and photograph) the way it uses its tube-feet as it rights itself. The sea-urchin lives in cool water amongst the rocks and oar weeds in the sublittoral zone. Without using subaqua equipment you can find it by visiting a rocky shore at extreme low water of a spring tide, when you may discover one or two in the deeper rock pools and crevices. A photograph of the sea-urchin should show its tube-feet extended, and this can only be achieved by photographing the animal in water, as once it is removed the tube-feet are withdrawn. The urchin has only a small mouth but it possesses a complex five-toothed apparatus called 'Aristotle's lantern' which it uses for browsing on encrusting vegetation and for assisting in its slow locomotion.

NB Don't try to pick up a sea-urchin with your bare hands. The sharp spines easily penetrate wet skin and break off, causing painful sores.

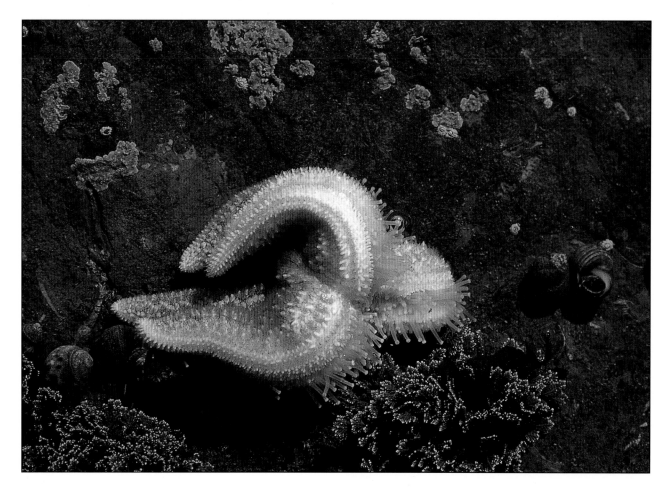

Rock pool photography

Rock pools also have their own permanent residents, including sessile creatures such as limpets, barnacles and encrusting algae and free-living animals including fish, side-swimmers, shrimps and crabs.

The first barrier to photographing life in a rock pool is the surface of the water. On a fine sunny day it acts like a mirror, producing a perfect reflection of the cliffs, clouds and sky above it; under windy conditions refraction distorts the image of the subject matter to such an extent that photography becomes impossible. Surface reflections can be largely eliminated by selecting an oblique angle of between 35° and 40° to the surface, and fitting a polarising filter with its axis vertical. The required exposure increase is $1\frac{1}{2}$-2 stops.

Photographing small aquatic organisms on the shore

Marine organisms do not travel well, and are best photographed on the shore and returned to the sea afterwards. I have assembled an outfit consisting of a very small cell (two pieces of 2 mm picture glass measuring 10 x 12 cm, separated by a curved piece of

Starfish, Asterias rubens, can often be found wedged in crevices at low tide. As they become submerged by the incoming tide they free themselves and with the help of their tiny tube feet, right themselves again and start looking for food. The photograph was taken in a shallow rock pool using a 90 mm macro lens.

clear plastic tubing and held together with elastic bands), two Olympus T32 flash units with extension leads, the OM2n camera, a bellows unit and a 50 mm macro lens, all supported on a tripod and a bench stand. You can use the cell as a miniature aquarium, with sand or tiny pebbles in the bottom and a little seaweed, such as Corallina or Enteromorpha, arranged as required. Small animals such as flatworms and bristle worms, side-swimmers such as Gammarus, and the small crustacean Idotea, can be collected from rock pools using a wide-ended pipette or a fine net, then transferred to the prepared cell. After you have completed your photography, you can return the small creatures unharmed to their homes.

Other interesting organisms include the sea mats which grow on seaweed fronds, and Pomatoceros triqueter, a small sedentary polychaete worm living in

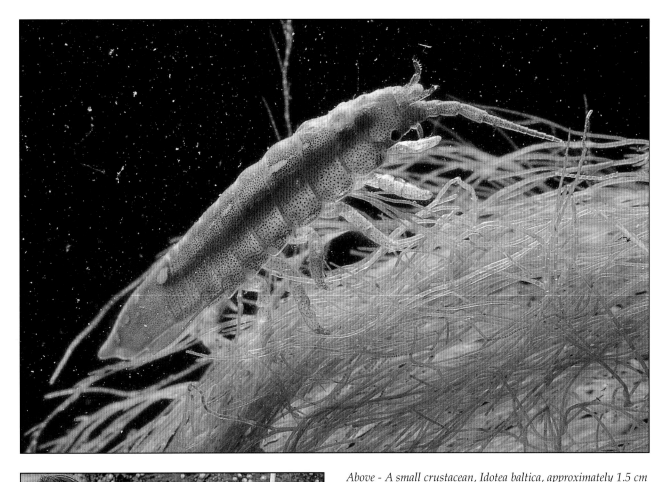

a triangular greyish tube attached to the surface of a rock. If a small piece of rock containing a few worm tubes is placed in the cell you may be lucky enough to see a crown of barred red and white tentacles emerging from one of the tubes. You can set up barnacles in a similar manner, and photograph their filter mechanism.

Ponds and streams

A healthy pond containing plenty of plant material and surrounded by flowering plants is also likely to be home for a host of animals and insects at various stages in their life cycle. Around the pond you will discover a variety of adult insects, including stoneflies, damselflies, caddis flies and dragonflies, which spend their larval stages in the water and often stay around the pond as winged adults.

The metamorphosis from the aquatic larva or nymph to the terrestrial adult usually takes place on the upright stems of plants growing out of the water near the edges of the pond. Using the damselfly as an example, you can take a set of photographs showing the nymph in the water, the adult emerging from the nymph case, the winged adult in free flight, and the

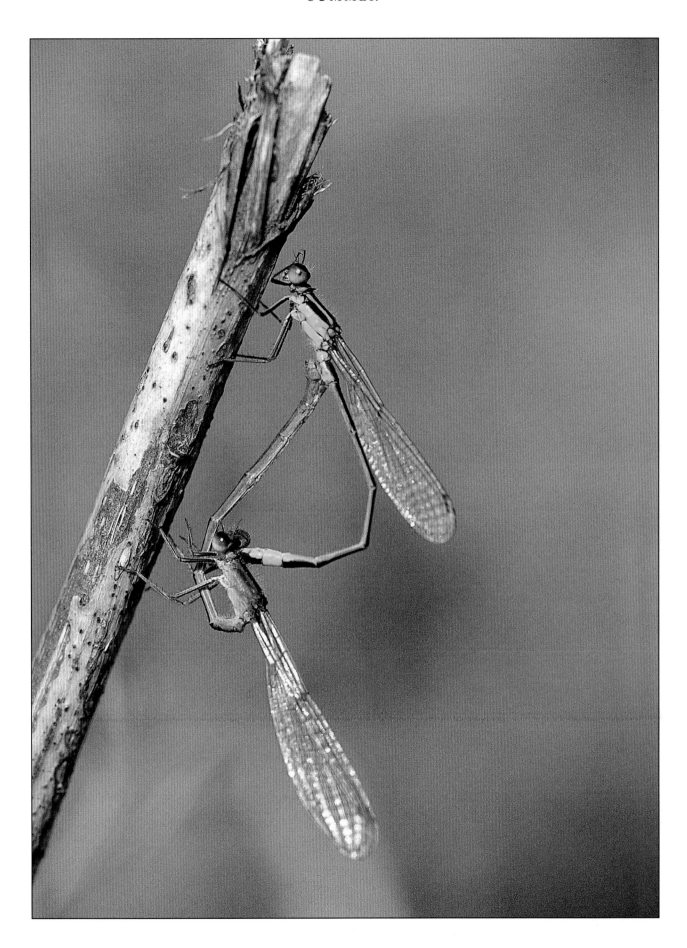

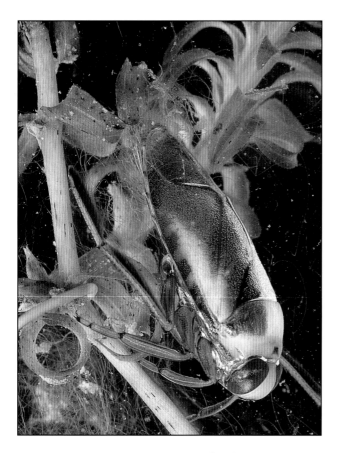

Above - Damselfly nymph photographed in the small homemade cell using the 50 mm macro lens and a bellows unit. The backlighting produced by the flash unit has highlighted the fine particles in the water, which should have been filtered out.

Left - The common water boatman, Notonecta glauca, is an aggressive destroyer of tadpoles, small fish etc., with a powerful and oar-like third pair of legs giving the impression of a tiny boat being rowed along. I took this photograph indoors in the tiny 'aquarium' with a 50 mm macro lens attached to a bellows unit. Lighting was provided by two flash units.

mating process which produces fertilised eggs, thus completing the life cycle. The photograph of the aquatic nymph was taken indoors using the small cell described earlier, while the emerging adult was photographed at the edge of the pond with electronic flash as the main light.

It is fascinating to watch a pair of mating damselflies in the 'heart' or 'wheel' position taking off from a plant and flying in tandem with both insects playing their part in keeping the partnership airborne and intact. These insects can feed on the wing by holding their legs forward to produce a scoop to trap small gnats and midges, which are then pushed up into the mouth. However, they do much of their feeding by simply crawling along a plant stem and picking up small insects on the way.

If the pond is large there are likely to be one or two dragonflies around. They can be distinguished from damselflies, as the dragonfly holds its wings open when at rest, whereas the damselfly keeps them folded. Dragonflies are usually larger than damselflies, and spend more of their time in flight. They are great predators and feed on the wing too.

Various insects, including whirligig beetles, pond skaters and water gnats, are found on the surface of the water, held up by surface tension, which behaves like a delicate elastic membrane allowing the creatures to skim over the surface without sinking through it. Whirligig beetles spin around in groups, describing tight circles like dodgem cars. The water-measurer or water gnat is a very slender creature which paces across the pond as if measuring its width.

Several insects make use of surface tension to hold them on the underside of the surface. In this group are water boatmen, various types of water beetles and the larvae of mosquitoes and crane flies. All come to the surface for air. Some, including water beetles and water boatmen, push the tip of their abdomen through the surface film into the air; others, such as mosquito and gnat larvae, have a tube-like extension at the rear end which they push up into the air. These organisms do not possess gills, and must return to the surface at frequent intervals for air.

Below the surface we find free swimmers including water boatmen, several species of water beetle, different species of newt and, of course, fish. There are also several very small crustaceans such as Daphnia and Cyclops, and a whole host of microscopic animals and plants known collectively as plankton.

Photographing pond life is not easy. Most creatures are well-camouflaged and difficult to spot. The main exception is frogs in the mating season (discussed earlier). Silt-laden streams may contain interesting animals, but these are also difficult to see and almost

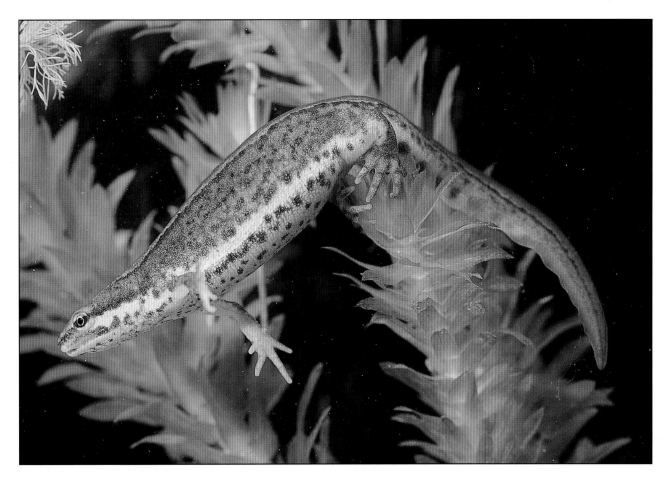

impossible to photograph in situ. The solution is to collect them and photograph them back at home in an aquarium.

Photography of pond life in an aquarium

Collecting material

A useful piece of equipment is a strong fine-meshed nylon collecting net with a plastic glass test tube attached to the bottom. You trail this through the water, particularly among the pondweed. Collect a liberal supply of pondweed, as it will contain a variety of small creatures such as pond snails, flatworms and insect larvae. It will also help to oxygenate the water in the aquarium. Empty each netful either into an 8 x 10 in developing tray or on to a large piece of PVC or polythene sheet. This will enable you to sift through the material and pick up any concealed pond life. Use a pipette for the smallest and a small spoon for the larger animals. Return any surplus pondweed to the pond. Transport your booty in screw-top jars. Broad-based honey jars are better than tall jam-jars, which tend to fall over. Polythene containers with snap-on lids are also good.

A smooth newt, Trituris vulgaris, with its hind legs clasped around some pondweed leaves, depositing eggs. Two flash units were used. Aperture f/16 with 1 stop underexposure.

Collect several litres of pond water if you can. If you have to use tap water for topping-up purposes, let it stand for 24 hours first, to disperse the chlorine. On returning home, separate the carnivores (dragonfly larvae, water boatmen, diving beetles) from the herbivores (pond snails, caddis larvae, etc.). White developing trays are ideal for this purpose.

Setting up an aquarium

An aquarium can be anything from a small glass jar housing a few tadpoles to a two-metre tank holding a wide variety of plants and animals. In general terms, the larger the aquarium is, the more satisfactory it is likely to be. It should be set up to replicate the natural environment as closely as possible, although it is acceptable to use washed pebbles and gravel rather than the silt or mud that was probably present in the original pond. The various pond weeds should be sorted out and the fresher specimens carefully washed free of silt. Each piece can then be attached with cotton to a suitable pebble and placed in the bottom of the aquarium.

If the aquarium is to be used for photography you should filter the water before pouring it into the aquarium, otherwise the fine particles of debris will appear as distracting points of light, particularly against a black background. An aquarium which is to be kept in use for several weeks will require filtration and additional aeration of the water. Most pet shops and many garden centres stock the necessary equipment, together with literature on aquarium management.

Photography through the front of the aquarium

Methods of restricting the movements of fish and other pond animals, lighting the aquarium, getting rid of unwanted reflections, etc., are discussed later. The photograph of the smooth newt laying eggs was taken with a Olympus OM2n camera and a 90 mm macro lens set at f/16, underexposure by 2/3 stop. Illumination was provided by two flash units, one at each end of the aquarium. A piece of black card with a lens hole was attached to the camera to prevent unwanted reflections.

If the creatures to be photographed are small, you can limit their freedom by placing them in a small rectangular cell similar to (but larger than) the one described earlier for photographing small marine organisms. This set-up was employed to photograph the pond snail, illuminated by two electronic flash units, with the more powerful one positioned high and just behind the cell while the smaller one was used as a fill-in light. The camera was an Olympus OM2n, equipped with a 50 mm macro lens and bellows unit. Flash exposure was automatic, using the OTF flashmetering facility of the camera. When a black background was used, exposure compensation of minus one stop was necessary.

To check the lighting set-up when using flash, hold a portable video light in the same position as each flash unit in turn. Any reflections from the front surface of the aquarium, or shadows cast on the background by the ends of the aquarium, will be immediately obvious, and you can reposition the lights as necessary. Finally, ensure the front glass surface of the aquarium or miniature cell is absolutely clean and free from scratches or manufacturing blemishes.

Microscopic pond life

Collection and examination

The first method involves dragging a very fine net with a test tube at one end through the water, particularly among the weeds. The technique concentrates the organisms from many litres of pond

Live Volvox colony surrounded by filamentous green algae. The colony consists of many hundreds of bi-flagellate cells whose movements cause the colony to rotate and roll. The colony is beginning to break up and release the daughter colonies.

water into the volume contained in one glass tube. It can be supplemented by filling a small jar with pond water and filamentous alga (which look like green cotton wool). Together they will provide sufficient material for many hours of microscopic work.

Examination of the material under the microscope is both exciting and time-consuming. The technique is to remove a small piece of filamentous alga and spread it out on a slide. Add a drop of pond water and protect the preparation with a cover slip, then examine the slide methodically. Use the lowest power available initially, as this takes in a large field of view but allows you to pick out moving organisms.

A common ramshorn water snail, Planorbis complanatus. The tentacles and head are clearly visible as the animal grazes unicellular algae from the surface of pondweed leaves. Two flash units were used to illuminate the miniature aquarium with the one behind being more powerful and shining through the snail and its shell.

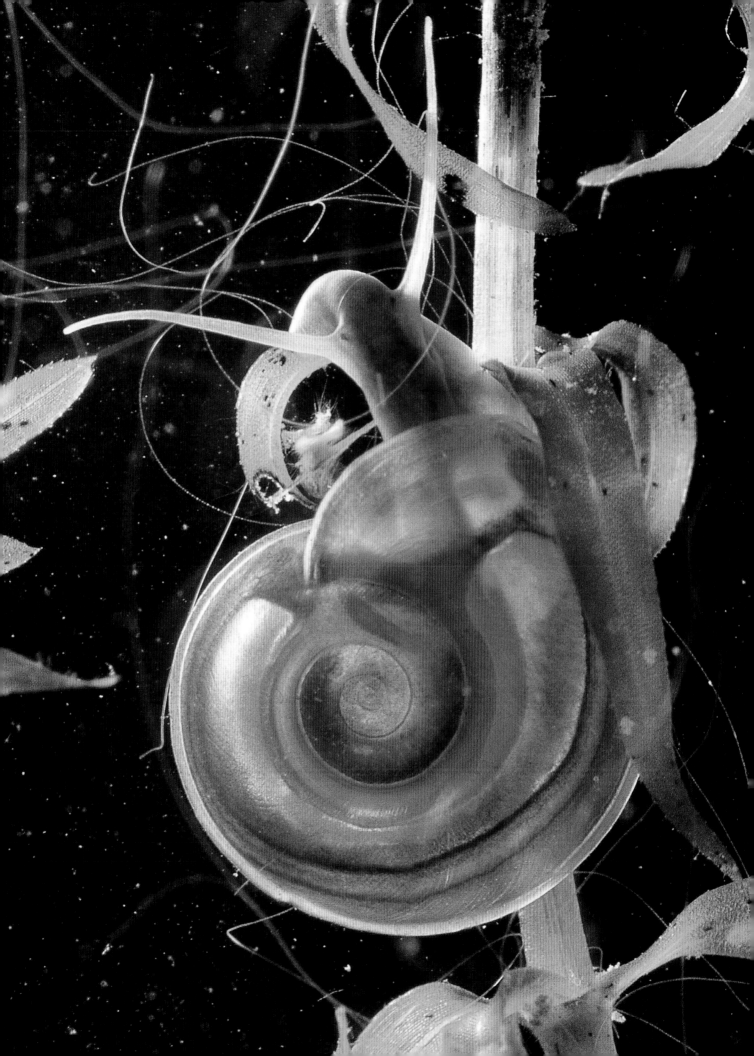

Microscopic plants

In this drop of pond water, the most conspicuous plants are the filamentous green algae. These look like tufts of delicate green cotton wool, but under the microscope their true beauty is revealed. They vary in size and structure, but all of them consist of repeating units or cells joined end to end to form a long filament. Each cell holds several chloroplasts which contain the green chlorophyll pigment required by the plants for photosynthesis. Common examples include Spirogyra which has a spiral chloroplast, a large branched alga called Chaetophora, and Batrachosperum, which looks just like a fluebrush. Chlamydomonas is a single-celled green alga containing two whip-like flagellae, and forms the basic unit from which several interesting colonial forms have arisen. These include Gonium, a 16-cell raft; Pandorina, with its 16 cells forming a sphere; and Eudorina, with up to 64 cells arranged in a spherical or ellipsoidal colony. The ultimate development in this line is the magnificent Volvox colony, containing between 100 and 60,000 individual biflagellate cells, symmetrically arranged to form a large rotating colony. It is propelled through the water in a rolling motion by the constantly-beating flagellae. If you are fortunate enough to find Volvox colonies, then it is worth observing them in detail.

Live filamentous green alga with the green chloroplasts clearly visible. On the outside are several pill-box shaped diatoms sculptured with fine lines and pits (magnification x400).

One striking feature is the presence of daughter colonies within the parent colony. These are liberated when the ageing parent breaks open.

Desmids are single-celled green algae which are common in ponds on peaty soil, though scarce in limy waters. Probably the best known are the numerous crescent-shaped Closterium species. Diatoms are exquisitely beautiful; their shells consist of flinty material elegantly sculptured with fine lines, pits and projections. An individual diatom resembles a microscopic glass container, date-box shaped in the pennate type and pill-box shaped in the centric type.

Microscopic animals

Pond water teems with a great variety of microscopic animals, so this section is necessarily very selective. The group of Protozoa contains over 30,000 species of microscopic animals which perform the functions of feeding, digestion, absorption, excretion and reproduction within the confines of a single cell. The Sarcodina are a group of protozoans which possesses pseudopodia (false feet), used for locomotion and food capture. Amoeba proteus is probably the best-

known member of this group. It consists of a naked piece of protoplasm without any obvious body shape. It is found among plant debris. Its most striking features are the constant production and extension of pseudopodia during movement, and the rhythmic filling and emptying of the contractile vacuole as it discharges water from its body.

The Flagellata are an interesting group, on the borderline between plants and animals. Each individual possesses one or more whip-like flagellae which assist in movement (an animal characteristic). Some possess chlorophyll and manufacture their own food in a similar manner to green plants; others have no chlorophyll and feed on organic matter.

Members of the Ciliata possess tiny cilia which are used for movement and feeding. One of the commonest examples is the 'slipper animal' Paramecium bursaria. It is covered with fine beating cilia which enable it to glide and rotate through the water in a remarkable fashion. The beating cilia also sweep tiny particles of food down the food groove into the animal's body, where they circulate and are gradually absorbed.

A final group of microscopic animals is the Rotifers, or 'wheel animalcules' as they were once known. There

Above left - A well-known desmid, Closterium, characterised by its moon-shaped cell, There are over 60 species, some of which are common in ponds (magnification x400).

Above right - One of the 500 or so species of rotifer found in Britain. These exquisite microscopic animals possess a crown of cilia which are usually short and fast-moving, but in this specimen are long and spine-like. Nearly all rotifers are female; males are small and degenerate creatures (magnification x100).

are more than 500 species in Britain; most are free-swimming, others live attached to water plants, and a few are parasitic. The feature they all share is the crown of cilia which resembles one or more tiny rotating gear wheels from a wrist watch - hence their name. The body wall is almost transparent, making it easy to observe the intake of food and its passage through the gut.

In this section I have mentioned just a few of the microscopic organisms in pondwater. There are many more, including the coelenterate Hydra, a large number of microscopic worms and an even larger number of microscopic crustaceans including Daphnia and Cylops well known in their role as food for aquarium and pond fish. These tiny plants and animals, viewed under the microscope, have provided me with many hours of absorbing study.

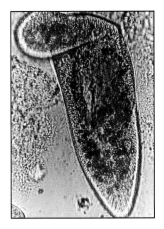
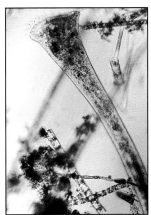
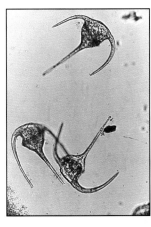
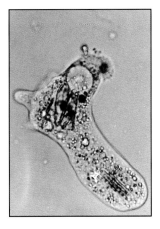

Microscopic animals discovered in samples of pond water. All the organisms were alive, and were photographed using the half-silvered mirror and electronic flash technique.

Top left - The 'slipper animal', Paramecium bursaria, is a protozoan covered in beating cilia which propel the animal through the water (magnification x100).

Top right - The 'trumpet animal', Stentor polymorphus. The ring of cilia around the trumpet-end beat rapidly and sweep food particles down a food groove into the body (magnification x100).

Above left - Another protozoan, the flagellate, Ceratium, is interesting because the body is covered by interlocking plates whose angles are extended into long spines (magnification x100).

Above right - Amoeba proteus, probably the best known of all protozoans. This photograph shows several dark food vacuoles near the centre and a large contractile vacuole at the top right, which pumps water out of the animal, (magnification x400).

Photographing pond organisms through the microscope

Adaptor tubes to attach the SLR camera body to the microscope eyepiece are available for most of the popular makes of camera. The standard camera viewfinder screen looks excessively grainy when set up on the microscope and should, if possible, be replaced by a very fine matt screen, preferably with a clear centre patch with cross hairs. As the

magnification increases the brightness of the image on the screen decreases dramatically. As it is an aerial image, the cross hairs allow you to use the 'no-parallax' focusing technique. This works as follows. If, when you move your head a little from side to side while still looking at the camera screen, the cross-hairs and the magnified image of the specimen appear to be locked together, then they are coincident and in the same plane of focus. If, however, the cross-hairs and the image move independently of one another, the image is not in focus and should be refocused so that the aerial image and the cross-hairs coincide in space.

When using a basic microscope, the eyepiece is covered by the adaptor tube and camera body, so you focus through the camera viewfinder. Some microscopes have an eyepiece tube and a camera tube in the same housing, in which case you can carry out the initial focusing using the microscope eyepiece.

Illumination

As living organisms move quite rapidly under the microscope, electronic flash is the only form of lighting suitable for taking the actual photograph. Continuous lighting, either built into the microscope base or available as a separate bench lamp, is required for searching and focusing. Use of a half-silvered mirror allows both flash and continuous lighting to be used simultaneously.

After a few test exposures to calibrate the system (even when using TTL flash metering) accurate exposure should not present any difficulties. The arrangement using basic bright-ground illumination is satisfactory for most subjects. However, you should try out other methods, including dark-ground illumination and oblique surface illumination. In both cases you must have clean, dust-free slides, as the techniques show up any surface dust particles.

I have introduced a few of the organisms commonly found in ponds, with suggestions on how to collect and photograph them, but I am very much aware that I have barely scratched the surface of the subject.

Although there may be little activity in a pond during the winter, things really come to life in April and May and continue right through until September and October, giving a full six months to study and take photographs.

A common water flea, Daphnia, an example of a microscopically small crustacean. Very common in ponds and horse troughs where they may be present in incredibly large numbers. They breed rapidly and produce live young without fertilization. Most females will be seen to be carrying several eggs in a broad pouch under the carapace. In this preparation an egg is clearly visible (magnification x10).

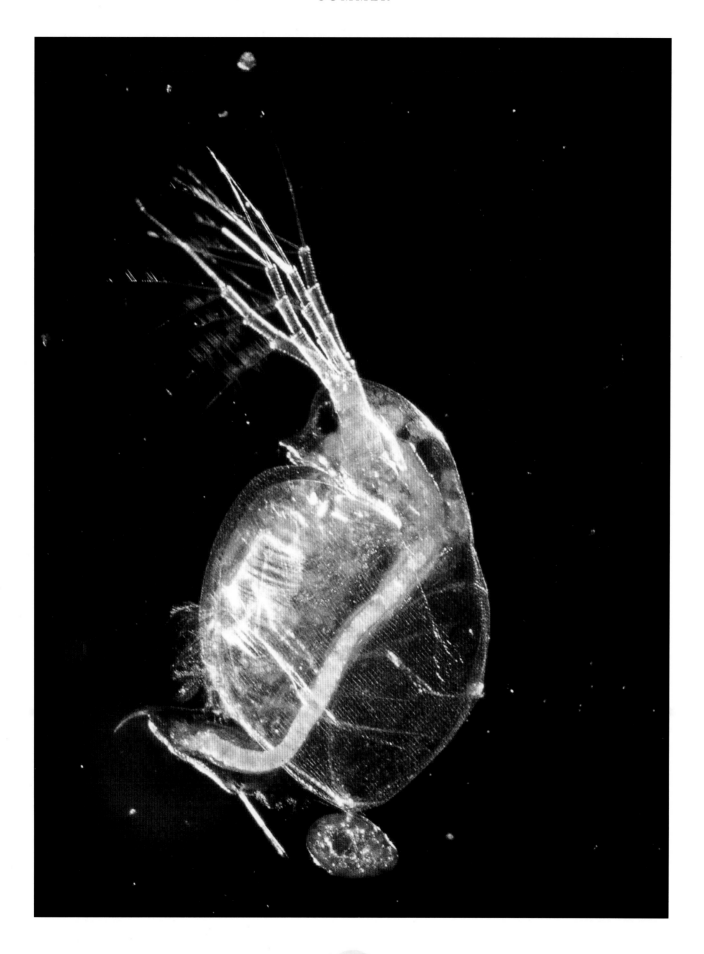

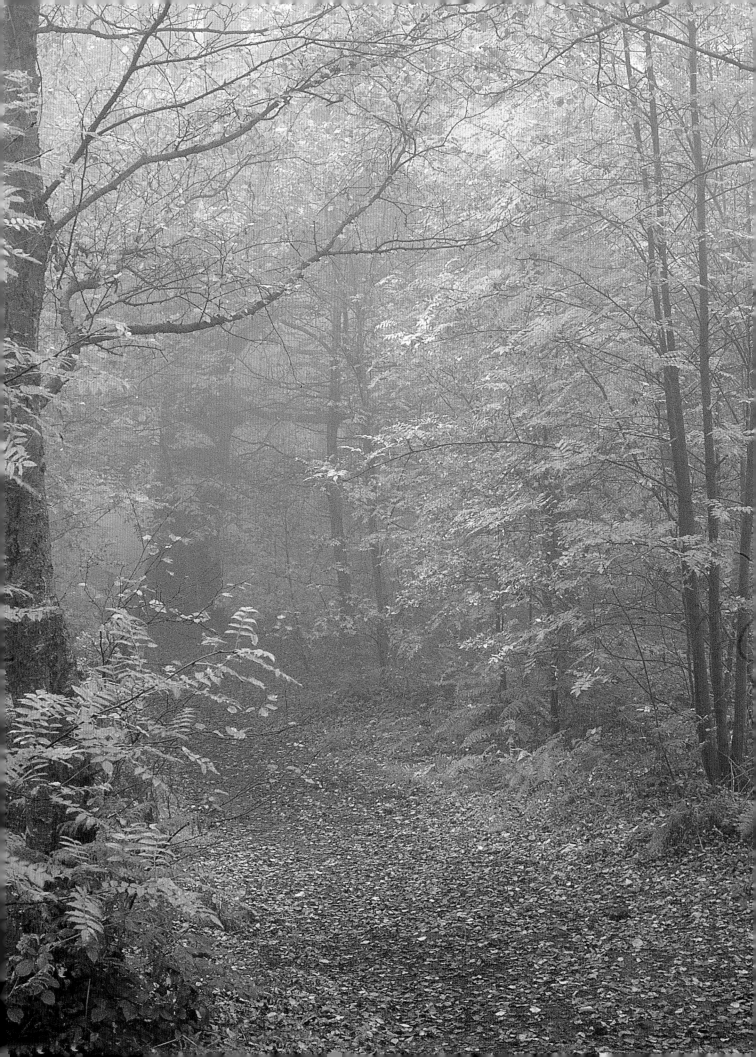

AUTUMN

'Season of mists and mellow fruitfulness,
Close-bosom friend of the maturing sun;
Conspiring with him how to load and bless
With fruit the vines that round the thatch-eves run...'

KEATS

The long summer days are drawing to a close; the quality of light is becoming less harsh; there is a nip developing in the evening air, and mist and dew blanket the fields and hedgerows in the morning. Most plants and animals which have been active during the summer are now preparing for the chills of winter, as temperatures slowly fall and day length shortens. However, we can still experience pleasant balmy days, with the occasional high temperature, as the landscape slowly takes on the golden hue of autumn. If we are lucky the autumn tints will give us joy for several weeks; yet, caught in a spell of squally weather, the leaves will be down in a few days.

The trees are ready to take a rest as the ground becomes too cold for the roots to take in water and mineral salts efficiently. Chlorophyll pigments are broken down, producing autumn colours, and a barrier of tissue grows across the base of each leaf stalk, leading to the eventual detachment of the leaf.

Autumn landscapes

Landscapes, particularly those which include autumn leaves and water, are well worth the attention of the serious photographer. Although you may occasionally discover an attractive scene by chance, it is more usual to go looking for possible photographs. You can use a compass to find North, so that you can note the position of the sun at various times of the day, and by the end of the visit you will have decided what, and when, to photograph, and from which angles. Frontal lighting will always give a well-lit result, whereas side and backlighting are more risky, though the results may be exciting. Study the composition of the picture in the viewfinder; very small changes in position can

A woodland scene as the early morning mist is burnt off by the emerging sun. A few minutes earlier the mist was too thick to make an attractive picture: ten minutes later it had largely disappeared. Patience and choice of the best moment are important in photographing this type of scene.

Bright side lighting concentrates the interest on the colours in the bracken, while the conifers, mainly in the shade, form a suitably subdued background.

have a significant effect. Once you are satisfied, fix the camera on a tripod and think about the exposure.

Closing down the aperture to f/16-22 will produce full depth of field, but will demand a longish exposure time. This might be acceptable on a windless day, assuming the subject remains stationary. If you want to arrest any motion you need a shorter exposure, but this means a larger lens aperture, and the depth of field may become unacceptably small. Most people adopt the former plan, and eschew photography on windy days.

Although TTL metering controls the exposure, this may not be the optimum for a particular scene. If you are in any doubt, bracket the exposure one-half and

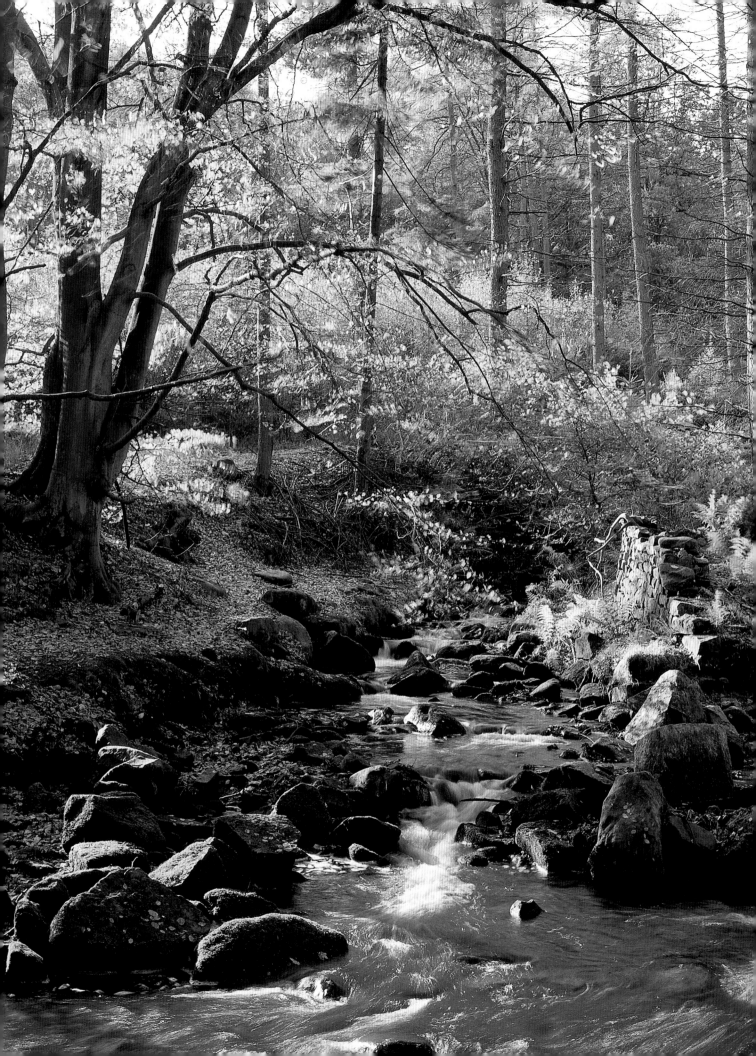

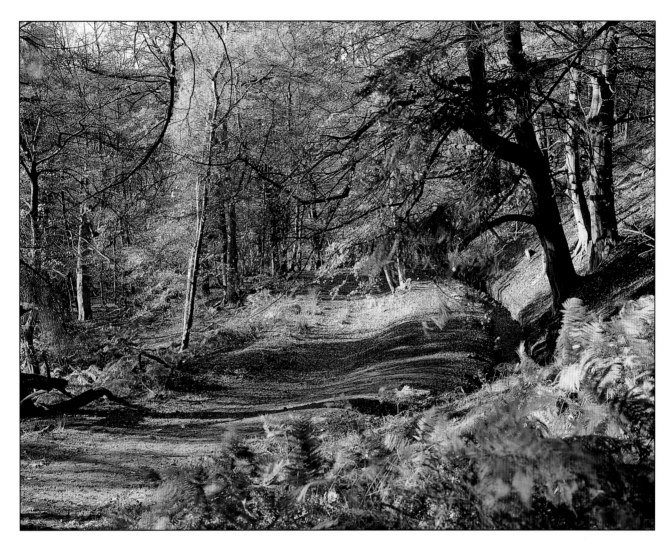

Above - Strong side lighting cast long shadows across the leaf-strewn path, adding to the interest. Some blur in the foreground bracken and evergreen tree indicates a gusty wind and a longish exposure coupled to a small aperture and increased depth of field.

Left - Autumn view with the sun to the left and slightly behind, lighting up the autumn leaves. The standard 75 mm lens was stopped down to f/16 for maximum depth of field, resulting in a shutter speed of 1/8 s which smoothed out the tiny waterfalls.

one stop above and below the indicated exposure (for slide film). Backlit scenes tend to be underexposed, and may need to be bracketed upwards.

Working closer to the autumn leaves, you can again use frontal, grazing or backlighting. The latter is illustrated on page 102, showing an attractive arrangement of shapes in a range of warm harmonious colours. Strong backlight from the sun can produce an enchanting effect. The contrast of the original scene may be as high as 200:1 (reduced slightly in the transparency), but prints can cope with ratios of only about 50:1, so that the final picture may lose some of its sparkle.

Fruit and seed dispersal

Autumn is harvest time, and a study of the fruits and seeds of common plants and their method of dispersal can result in some exciting photographs. Flowering plants first appeared about 120 million years ago, so it is not surprising that they have adapted to a very competitive environment. The general form and detailed structure of many of the fruits and seeds are interesting, particularly in close up and when illuminated to advantage. Most important is the ability to recognise an interesting pattern of light and shade, a delicately sculptured surface or an attractive shape.

Airborne methods

If a plant species is to survive it must be capable of producing seeds which can be scattered to grow into next year's plants. The range of wonderful mechanisms is well worth investigating. There are four basic ways fruits and seeds are dispersed: wind, explosive mechanisms, water, and animals. For

example, the seeds of legumes (peas, beans, vetch, clover) are primarily dispersed by explosive mechanisms, but may also be dispersed by animals.

Photography is possible both in the field and the studio, the ancillary equipment being an electronic flash unit, a reflector and various portable backgrounds. Examples of fruits and seeds dispersed by wind include dandelion, ragwort, creeping thistle, willow herb and cotton grass. None of these is particularly difficult to photograph in the field. There are many different species of thistle (genus Cirsium). One of the commonest is the creeping thistle, C. arvense, which can grow a metre or more tall, and flowers from July to September. The stem is prickly and the leaves are flexuous, divided and very thorny. The flower heads are deep purple in colour. You can obtain an attractive photograph if you find a bee searching one of the flower heads for nectar. The dispersal mechanism is interesting: after the tiny ovules have been fertilized they develop into seeds each of which is surrounded by a thin fruit coat attached to a very delicate hairy pappus. In damp weather the fruit remains attached to the dead flower head and the hairy pappus remains folded up. However, in warm sunny weather everything dries

Beech leaves strongly backlit against a dark out-of-focus background are the right ingredients for an attractive picture. A pity some of the leaves were disfigured. I used a 50 mm lens on a hand held camera.

out, the dead flower head splits open, the hairy pappus expands like a parachute and the fruits are dispersed by the wind.

To photograph the thistle you need to decide on the best direction for the lighting (using the sun) and position yourself accordingly, then compose the picture in the viewfinder, using the camera hand-held. Balance the distribution of the flower heads in the frame, and the features of the background, then fix the camera on the tripod , check the framing, close down the lens aperture to the appropriate f/number to give a depth of field that will keep the dispersing seeds in sharp focus but leave the background out of focus. A little discreet 'gardening' behind the subject may be necessary to remove any eye-catching distractions. If it is to be a backlit shot, you must decide whether to use a reflector card (white on one side, silver foil on the other) to reflect some of the sunlight on to the front surfaces of the plant. If the sun is not available but strong backlighting is still indicated, use an electronic flash unit on an extension lead.

The creeping thistle photographed indoors using electronic flash in a 45° backlighting position. A white reflector bounced some of the light back on to the front surfaces of the plant.

You can obtain much more interesting photographs if you take a thistle indoors and photograph it using electronic flash positioned about 0.5 m behind and slightly above the specimen, providing a powerful backlight. The technique is simply to blow on the specimen and almost at once operate the shutter. After a little practice you will be able to photograph the fruits just as they leave the thistle head.

Another plant belonging to the same group as the thistles (Order Compositae) is the common ragwort Senecio. The flowers are bright yellow, and consist of a collection of small florets, some of which are tubular. The seeds are dispersed by the parachute mechanism described earlier. The two photographs a) and b) on page 104 illustrate the effect of changing the shutter speed from 1/125 s (which freezes everything) to 1/30 s, blowing on the heads; movement will be apparent, coupled with some general blurring of the image. The ragwort in the photograph was backlit by two small spotlights.

As a final example of fruit and seed dispersal by parachute mechanisms we may consider the common dandelion Taraxacum officinale, which produces seeds somewhat earlier in the year. Photographing a

green patch covered with seeding dandelion 'clocks' is difficult if you want to obtain something other than a straightforward record, and calls for some skill with the lighting angle, viewpoint and depth of field. Photographing a complete dandelion head in close-up is difficult because, being a sphere, it is almost impossible to keep both the front and rear equally in focus. One solution, illustrated on page 105, is to remove most of the parachutes, leaving a fringe around the centre, and setting up the camera so that the film plane is parallel to the parachute ring. The specimen was illuminated using two flash units, one at each side, at 45° behind the subject.

Tall trees such as ash, elm, sycamore, birch and lime produce winged fruits which spin to the ground, and in a strong wind can be carried a considerable distance from the parent tree. The fruits develop early in the year, but some persist until the autumn. The photograph of the sycamore fruit taken indoors, was designed to illustrate the method of dispersal. The camera was set up to produce a vertical tilted action.

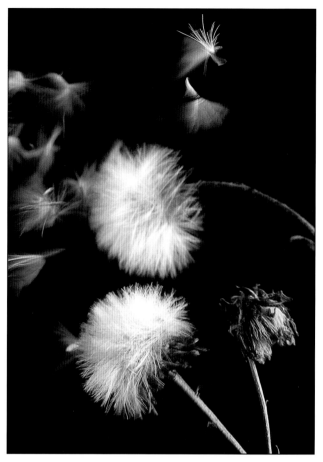

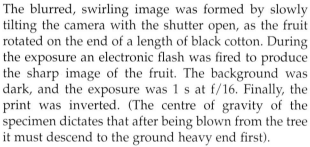

The blurred, swirling image was formed by slowly tilting the camera with the shutter open, as the fruit rotated on the end of a length of black cotton. During the exposure an electronic flash was fired to produce the sharp image of the fruit. The background was dark, and the exposure was 1 s at f/16. Finally, the print was inverted. (The centre of gravity of the specimen dictates that after being blown from the tree it must descend to the ground heavy end first).

Explosive mechanisms and wind dispersal

The second method by which plants disperse their fruits and seeds is by the drying and splitting open (dehiscence) of the seed coat, often with considerable force. Some of the more common examples include crane's-bill, antirrhinium, lupin, hairy bittercress balsam, and gorse. All can be photographed in the field, but for exciting pictures which show something of the dispersal mechanism, we need to move to the studio and electronic flash.

In spring we welcome the deep pink flowers of the red campion which continue to bloom throughout the summer months. The flower has five-point symmetry, with five hairy united sepals, five deeply notched

Above left - The common ragwort, Senecio, illuminated by two small spotlights: a backlight and a side, given an exposure of 1/125 s which has 'frozen' the dispersing parachute fruits.

Above right - the same set-up, but the heads were blown and the shutter speed changed to 1/30 s. There is plenty of movement visible but the ragwort heads are too blurred.

petals, five pistils and five pairs of stamens. Although the flower is attractive, the main interest lies in the seed dispersal mechanism. The seed capsule dries and develops ten slits which extend a short way down and, as the tissue dries, curl downwards to form teeth. These teeth open wide on fine days, but remain closed when the weather is wet. The wind blows the capsule about and the seeds are thrown out (page 32).

The second example concerns the garden perennial crane's-bill which produces masses of attractive magenta flowers throughout the summer and dies down in the autumn to a dry reddish-brown tangled mass. However, careful observation will reveal small but attractive seed arrangements. Each of the five seed-boxes is attached to a fine spring-like structure, and as the fruits dry the tension in the springs increases until finally it pulls away the seed boxes and flings out the seeds. The picture on page 107 is an attempt to illustrate the dispersal mechanism in

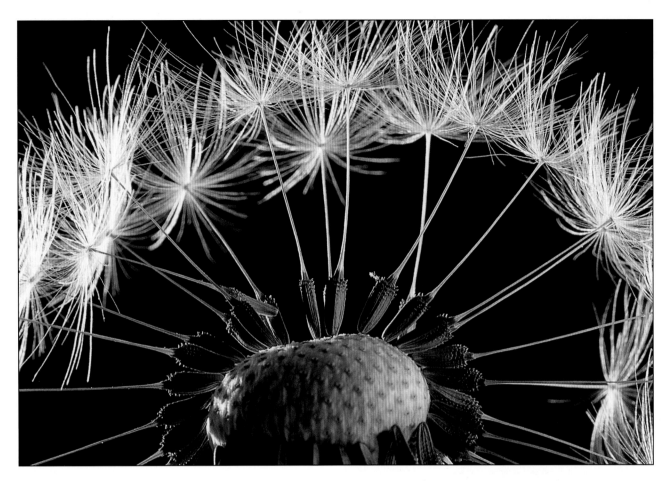

Above - A dandelion 'clock' is very difficult to photograph in close-up as it is almost impossible to keep both the front and rear surfaces in focus. This photograph, lit by two 45° backlit flash units shows clearly the surface structure of each long brown fruit with its extended stalk and parachute top.

Right - Dandelion, Taraxacum officinale, photographed at ground level. A waist-level or right angle finder would have been useful but I had to lie prone and use the standard eyepiece.

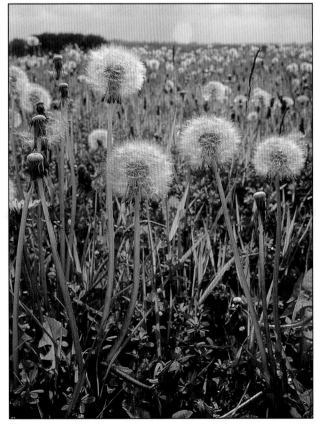

action. The photograph was taken using two electronic flash units arranged at 45° (backlights) and a white card reflector to fill in the dark areas on the front surfaces of the fruiting body. The length of the flash exposure was controlled by varying the lens aperture, to either 'freeze' the seeds in mid-air, or show them as blurred images.

The final example is the bluebell. After flowering, the seeds continue to develop during the summer months. The picture on page 107 shows the ripened seeds in their dry translucent seed cases as they appear in the autumn. The photograph was taken using natural backlighting provided by the late evening sun, supplemented by artificial light from a car spotlight run from a 12 v battery.

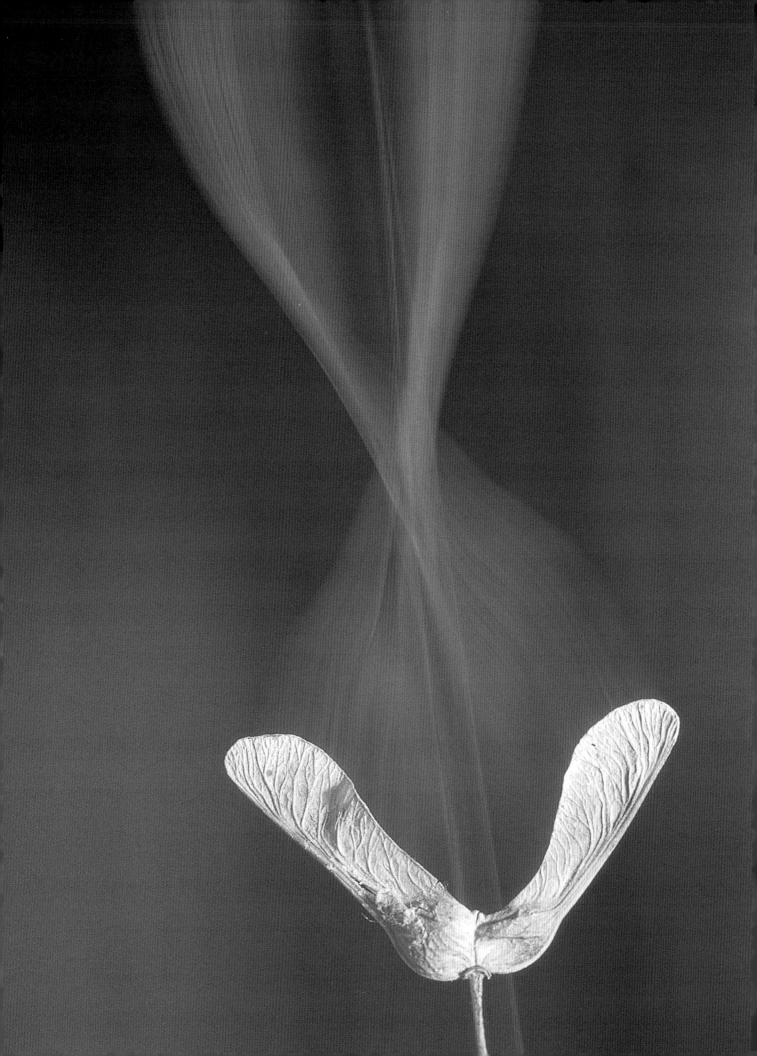

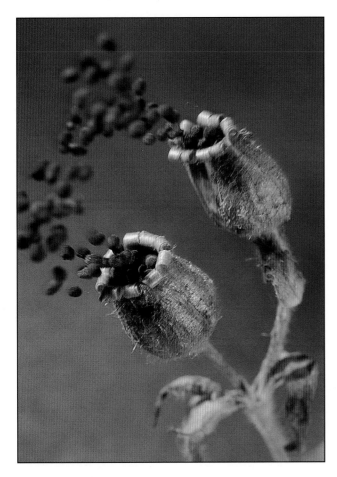

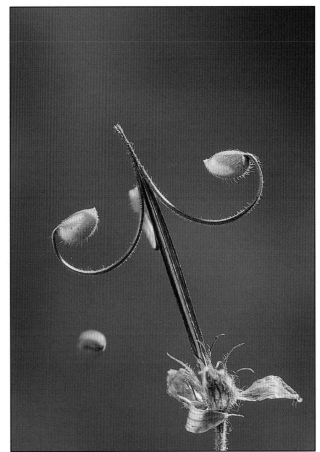

Above left - Seed dispersal in the red campion, Silene dioica. The specimen was tapped sharply with a pencil and almost simultaneously the cable release depressed, triggering the shutter and two flash units. This was the best of several attempts.

Above right - Seed dispersal in the crane's-bill. The stem was tapped with a pencil followed almost simultaneously by operation of the shutter and two flash units. The seeds were 'frozen' in space by using a modest aperture of f/8 and a short flash exposure.

Below right - The dry seed-boxes of the Spanish bluebell, Endymion hispanicus. The photograph was taken in the garden and the natural backlighting was supplemented by artificial light from a car spotlight run from a 12 V battery. A black card formed the background.

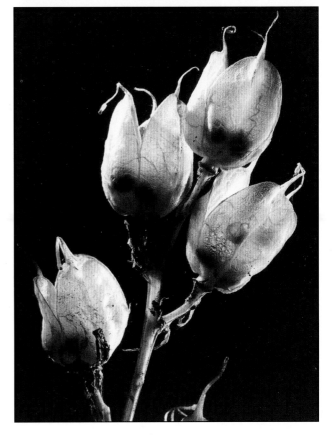

Opposite - An attempt to illustrate the dispersal mechanism of the sycamore, Acer pseudoplatanus. During windy weather the winged fruits are blown from the tree and spin to the ground, although this is not a very effective method of dispersal.

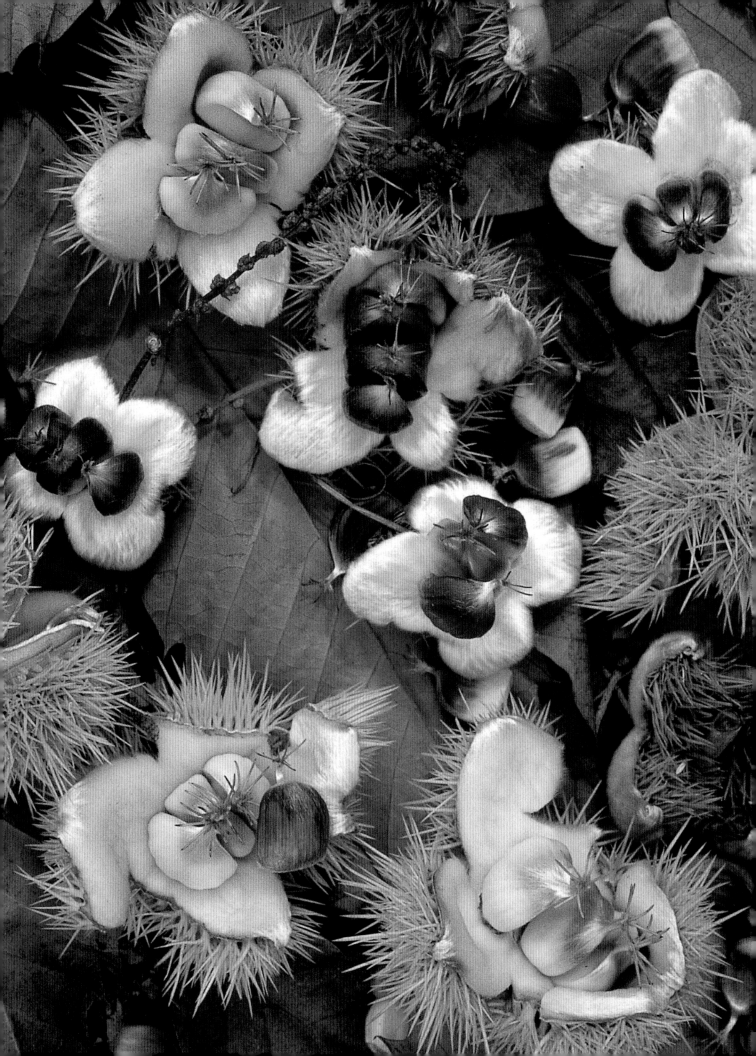

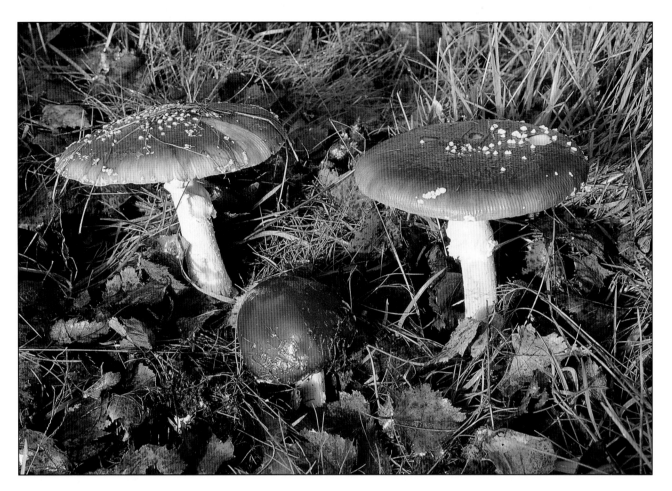

Dispersal by animals

Dispersal of fruits and seeds by animals can occur in several ways, the most common being by birds feasting on the glut of berries in the autumn. Many of the seeds are carried some distance in the bird's digestive tract and pass out in their droppings. The seeds of ivy and hawthorn are spat out and do not pass through the bird's gut.

Nuts such as beechnuts or sweet chestnuts are examples of seeds dispersed by animals. The beechnut, a 4-lobed pericarp, falls to the ground and splits open, exposing the dark brown triangular-sectioned seeds, which are collected by mammals (mainly squirrels) and either eaten immediately, or carried away and hidden or buried in a food store. The sweet chestnuts illustrated opposite were found carpeting the ground under the parent tree, and were photographed in natural sunlight.

A common plant which spreads over the hedge like a clinging green net is goose-grass. Its name is derived from the supposition that geese have a liking for this plant. When magnified with a hand-lens its beauty is revealed. The tiny fruit are covered with delicate hooks, as are the leaves and stems. Almost the whole

Above - The fly agaric, Amanita muscaria, a favourite subject for artists and model-makers and one of the few fungi to feature widely in children's books. An infusion of the pileus in milk was at one time used to kill flies, hence its name. Although a little 'gardening' was required the basic environment has been left undisturbed.

Opposite - The fruits of the sweet chestnut, Castanea sativa, are easily identified by their green 'hedgehog' cases. During October when the nuts are ripe the spiny coat splits open revealing up to three glossy brown nuts. The photograph was taken under the parent tree in diffused sunlight with the film plane parallel to the ground to produce a sharp image right across the frame.

plant is involved in the dispersal process rather than just the fruits and seeds. The picture below right on page 107 was taken using close-up techniques to illustrate its fine structure.

Fungi

A large group of non-flowering plants which reach their peak in the autumn are the fungi. The group includes cup fungi, morels, truffles and earth tongues; and the better known Basdiomycetes, with spores usually in fours in microscopic club-shaped sacs or basidia, including the common mushrooms, ink-caps, fleshy toadstools, puffballs and bracket fungi.

Fungi lack chlorophyll and are unable to manufacture food by photosynthesis. They obtain nourishment as parasites or saprophytes. The absorption of food takes place through minute filaments (hyphae) which secrete digestive juices to liquefy the food so that it can be absorbed. The visible part of a fungus is the fruiting body, which produces microscopic spores which germinate to give rise to a new mass of hyphae. Fruiting bodies are often large and complex, but consist of simple hyphae densely woven into a mass of tissue (mycelium). Although some of the bracket fungi persist for months or even years, most fruiting bodies grow very rapidly and survive for a few days, during which time they disperse millions of spores.

Many species of fungi are edible. Although in Britain most people eat only the (cultivated) field mushroom, in some countries, particularly France, puffballs, parasol mushrooms, beefsteak fungus and truffles are regularly eaten and enjoyed. Several fungi are poisonous, and any would-be fungus eater should learn to recognise such species as the 'death cap' (Amanita phalloides), the 'destroying angel' (Amanita virosa), Clitocybe rivulosa, C. dealbata and some species of Inocybe, particularly I. napipes and I. patouillardi. Several fungi are used in the preparation of antibiotics, the best known being the micro-fungi (moulds) Penicillium notatum and P. chrysogenum, which are used to manufacture penicillin. Some micro-fungi cause diseases in animals and plants.

Availability

In Britain, September, October and early November are when most species produce their fruiting bodies. There are some exceptions, such as the crustaceous fungi of the Corticium genus and the winter truffle, Tuber brumale, which produce fruiting bodies through the winter months, whereas the morels and cup fungi fruit in the spring. Perennial woody bracket fungi, such as the common ganoderma and polyporus species, persist for years on tree trunks and can be photographed in winter when the leaves are absent.

Fungi seem to appear almost anywhere during the autumn months. They have two basic requirements. The first is a supply of food from fallen timber, leaf mould or compost; the second is a moist environment. Fungi produce very poor fruiting bodies in dry conditions, but a short period of wet weather followed by a rise in temperature is almost guaranteed to yield a good flush within a few days. Late autumn frost, however, kills off most species very rapidly.

Photographing fungi

Since this involves a fair amount of close-up work you need to equip your camera with either a macro lens or a set of close-up lenses or extension tubes. Working at ground level, a waist-level finder is more useful than the eye-level pentaprism finder; cameras with a fixed pentaprism can have a clip-on right-angle viewfinder attached as an alternative. Lighting can often cause problems, and your equipment should include a silver/white reflector, a portable macro-light, a small electronic flash unit and two tripods, one normal size and one table-top.

The first task is to set up the camera and frame the specimens. The final print must be interesting as a composition, as well as a vehicle for biological information. It may be necessary to do a little 'gardening'. This means tidying up the environment without altering it drastically, and may involve removing leaves, twigs or grass stems from the area between the specimen and the camera. Don't overdo it: ruthless gardening can play havoc with the immediate environment, leaving the fungus exposed and naked. Next, study the background in the viewfinder, if possible with the lens at the taking aperture. This will bring into focus many structures which appear discreetly out of focus at full aperture. In most cases the background should be natural but unobtrusive. Distracting highlights and splashes of strong contrasting colour in the background also need to be eliminated, so that in the final photograph the eye concentrates on the centre of interest - the fungi.

Although I do advocate using natural light whenever possible, you mustn't hesitate to use flash or macro-light if the ambient light is not sufficient. You can usually combine daylight and flash successfully. You can use the flash as either the main light or a fill-in light, and in both cases you should diffuse the harshness of the flash by covering it with a white handkerchief. If you use flash as the main source of illumination, don't use such a short exposure that the background comes out almost black! A small macro-light producing continuous illumination has a big advantage over flash lighting: one can actually see the effect on the specimen, whereas with flash one is to some extent guessing. However, the macro-light needs an 80A or B blue conversion filter to bring its colour temperature up to that of natural daylight.

The viewpoint is quite important. Many photographers choose a viewpoint just above the horizontal. This enables the details of the pileus and stipe, including the ragged membranous ring or

A studio set-up to show spore dispersal in the common puff-ball, Lycoperdon periatum. Two flash units were used, one at each side and slightly behind the specimens, while a white reflector card added a little light to the front of the set. Camera's 90 mm macro lens set at f/22 on auto exposure with minus 2/3 stop compensation for the very dark background.

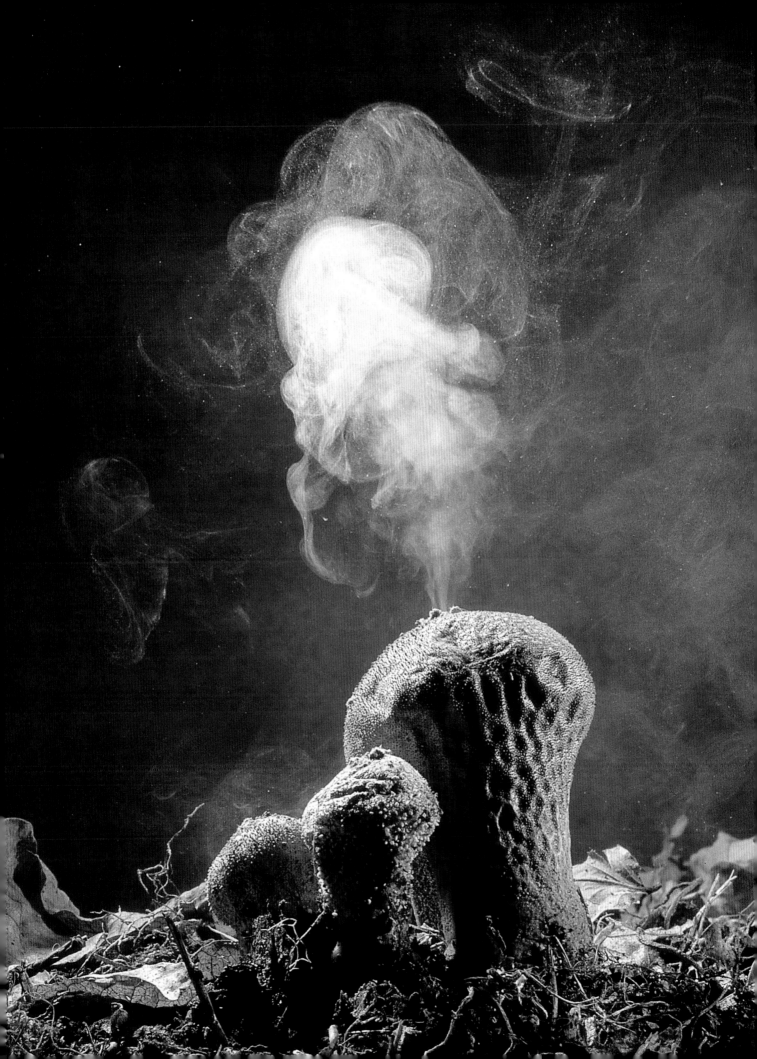

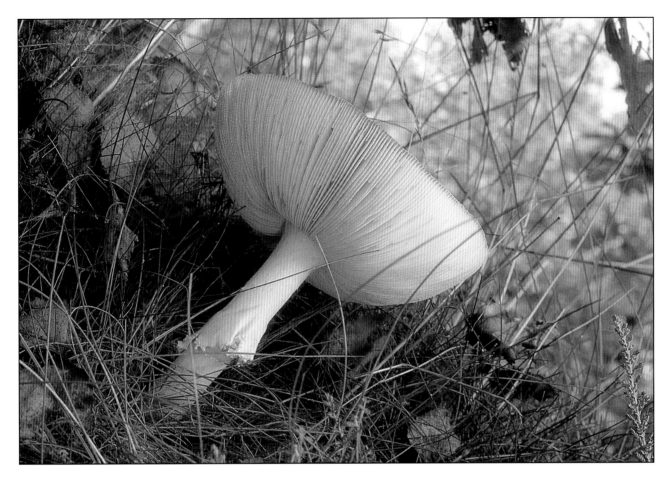

annulus (if present) to be seen; but it will not show the gill region under the pileus. If it is important to include gill details, you can use the old trick of picking a nearby specimen and placing it on its side amongst the group being photographed. Another technique is to photograph the fungus through a mirror at ground level. With small encrusting fungi you need to set up the camera with the film plane parallel to the encrusted surface, so that most of the fungus is in focus. This is particularly important for very small specimens, where the depth of the field may be only a few millimetres. You may need to use quite a small lens aperture. The photography of bracket fungi on the trunks of trees doesn't present any serious problems, although you may need to use either a telephoto lens or a step-ladder to obtain a large enough image. Take care when you are estimating the exposure, because the meter reading will probably include a fair amount of sky, resulting in the fungus and bark being underexposed. In case of doubt, bracket the exposure upwards.

There is little call to photograph fungi indoors, because the natural background is important and this is often difficult to arrange artificially. Also, most fungi, with the exception of the woody types, either dry up or go slimy after being picked and transferred

One method of producing a really low angle shot is to photograph the fungi through a mirror placed in the grass at an angle of around 45°. Although front-surface mirrors are often recommended, I simply borrowed an ordinary mirror from the bathroom cabinet door - and I can't detect any 'ghost' images!

to a warm atmosphere. If you need spore prints (essential for identifying some species) you must indeed produce these indoors, by removing the stipe, placing the pileus on a white card and covering everything with an inverted glass jar. After a day or two the spores will have been shed on the card, and a beautiful spore pattern formed. However, if you are interested in trying to photograph a fungus in action, as it were, the common puffball is a good challenge. In the natural environment the microscopic spores, measuring only 4 µm (0.004 mm) in diameter are puffed out through a small apical pore by any disturbance, such as drops of water, falling leaves, or a passing animal brushing against the fruiting body.

The photograph of a puffball releasing a cloud of spores was taken indoors against a made-up background, with the fungus growing naturally in soil and leaf litter. The spore clouds are normally barely visible, but with powerful backlighting using two flash units the results are quite dramatic.

Mosses and liverworts

These are small inconspicuous plants and are flattened creepers or erect structures usually little more than a few millimetres high. Although mosses prefer damp shady areas, they have a very wide distribution, because they can tolerate conditions which would be unsuitable for most other plants. They spread from the Arctic to the Equator, and are at their most luxuriant in tropical rain forests. In the British Isles they are more abundant in the west, where there is a high annual rainfall. Mosses can be found in inhospitable habitats such as bare rock surfaces, brickwork, footpaths, walls, as well as in more favourable areas such as woodland, meadows and shaded river banks. Mosses are often among the first plants to colonise burnt ground, disturbed soil or exposed rock.

The moss plant consists of a stem with the leaves arranged more of less spirally around it. The leaves usually have a midrib, but are not lobed or divided as in the liverworts. The plant is attached to the ground by root-like rhizoids. There are over 14,000 species of moss, and the common ones include species of Sphagnum, bog mosses, Bryum, hair mosses, Funaria, cord mosses, and Mnium, thread mosses.

Liverworts can be broadly classified into two groups, the thalloid types and the leafy types. The thalloids, which supposedly resemble lobes of liver (hence the name liverworts) are represented by species such as Marchantia polymorpha, the common liverwort, and Conocephalum conicum, the great scented liverwort. The form of the thallus is varied but is typically flattened, branched and creeping. The other group contains the leafy liverworts and typical examples are Alicularia scalaris, the ladder-like scale moss, and Plagiochila asplenioides, spleenwort scale moss. In this group there is a distinction between stem and leaf, with the leaves tending to be flattened and arranged in one plane in two overlapping rows.

Mosses and liverworts have a similar life cycle: the plant is the gametophyte generation and produces the gametes or sex cells, which on fusion develop into the sporophyte generation. This is the spore-bearing part and actually grows on the gametophyte. When the spores are ripe they are dispersed by the wind.

Photography of mosses

As examples of the group I have selected two common mosses and photographed them in very different ways. The first, Bryum capillare,, is a very common moss that forms compact cushions on walls, roofs and rocks, and illustrates the plant in relation to its environment. It was photographed outdoors

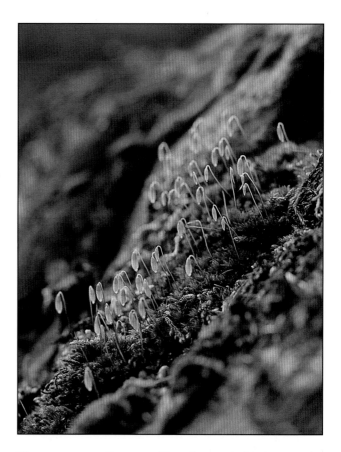

The common moss Byrum capillare photographed in its natural environment. 50 mm macro lens on a tripod-supported camera.

among the rocky outcrops of an upper moorland where the dull grey day was in keeping with the surroundings. However, a very different image results when material is brought indoors and photographed under controlled conditions. The photograph of another common moss Hypnum cupressiforme was taken in a kitchen, with natural daylight providing overall lighting, but direct sunlight (reflected from a mirror) generating a strong backlight. A piece of coloured card was positioned some 50 cm (20 in) behind the specimens to provide a suitably subdued background The backlighting outlined each sausage-shaped capsule with its pointed cap, slender reddish brown stalk (seta) and delicate green leaves clustered around the stem. In this plant, when the spores are ripe, the cap falls off, exposing a ring of hair-like teeth (peristome) which opens and closes with variations in humidity, releasing the spores over a period of time.

Lichens

Lichens are typically small greyish-green plants, but various shades of red, orange, yellow and even black also exist. They are very slow-growing, and tend to be found in extreme habitats such as bare rock, roofing tiles, stone walls, areas which other plants find difficult to colonise. Their special interest lies in the

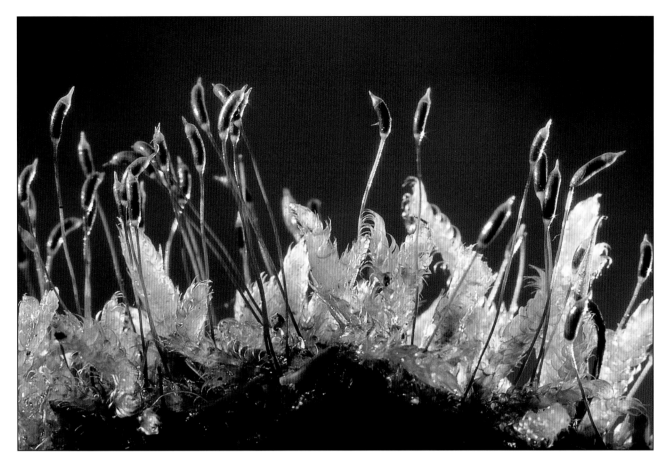

Hypnum cupressiforme photographed indoors in natural light but with backlighting by direct sunlight reflected by a mirror.

fact that they consist of an alga combined with a fungus, each helping the other in a relationship known as 'symbiosis'. The plant body and shape are produced by the fungus; the algal cells are squeezed between the fungal hyphae. The alga makes food, some of which is utilised by the fungus, which in return supplies the alga with essential mineral salts. It would be convenient to suppose that the fungus protects the delicate algal cells against desiccation, but this is not supported by evidence.

Three basic types of lichen can be recognised. The fruticose form is characterised by a flattened branching thallus growing either upright, like the reindeer 'moss' Cladonia, or hanging from trees, as in the beard lichen Usnea. The foliose form is leaf-like, and often resembles a liverwort, whilst the crustose type develops as a crust on the surface of rocks, headstones etc., often so closely attached to the substrate as to be irremovable. Lichens are very sensitive to air pollution, in particular to sulphur dioxide, so very few grow in or around cities. Litmus, an important pH indicator in chemistry, is extracted from the lichen Rocella, while other lichens have been found to contain antibiotic substances active against gram-positive bacteria. The nature photographer can find much to photograph in the fascinating shapes, patterns and colours to be found in lichens.

Pteridophytes

This class includes ferns, horsetails and clubmosses, and has been around for well over 400 million years, being one of the dominant groups of plants when the dinosaurs roamed the earth some 200 million years ago. All three sections included examples of tree-like proportions which reached their peak in the Carboniferous period, 250 million years ago. Well-known present-day European examples include the common bracken Pteridium aquilinum, which grows on heathland and in open woods, the male fern Dryopteris filix-mas, which prefers damp sheltered habitats such as the shady banks of streams, and Athyrium filix-femina, the lady fern common among shaded rocks. In Britain the field horsetail (Equisetum) is small and fairly inconspicuous. As a group the clubmosses have declined even more than the horsetails, and today only half a dozen or so species exist in Britain.

Reproduction in all these groups is by means of spores in sporangia, which in the ferns are usually found on the undersurface of the frond, often protected by a shield-like cover. In horsetails and larger clubmosses

114

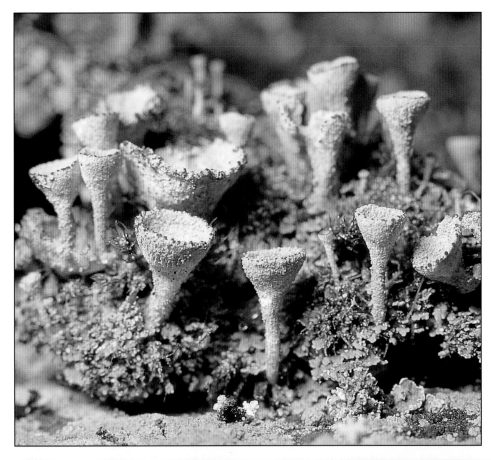

Left - Cladonia fimbriata is a common lichen on walls and tree stumps, forming flat cushions from which grow stalked outgrowths like trumpets, bearing the powdery reproductive structures. Photographed in the natural environment surrounded by lots of greenery, (hence the overall green cast) using a 50 mm macro lens.

Below - Frond of the common bracken Pteridium aquilinum photographed in the field with the low setting sun acting as a backlight. Camera set up with the film plane parallel to the frond to achieve maximum overall definition.

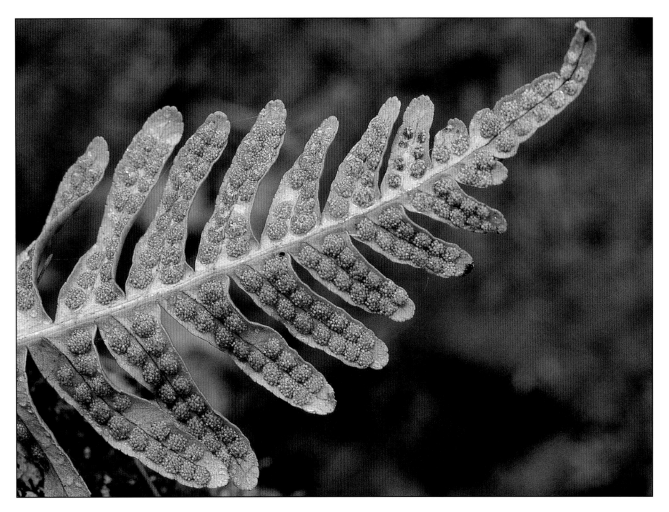

they develop in cones at the tips of the stems. In the smaller clubmosses, the spores occur on the upper side of the leaf bases.

Photographing ferns in the field

In the autumn the fern fronds change colour from a fairly uninspiring green to a very attractive gold as the pigments are broken down and the aerial parts begin to die down for the winter.

The golden fronds are not seen to advantage when viewed en masse with normal frontal lighting. From a photographic viewpoint the best results are obtained by photographing a single frond against a dark background with the sun acting as a strong backlight. This will reveal their true beauty and the exquisite symmetry of the side branches and leaf blades. The photograph was taken during the autumn, late in the afternoon with the sun low in the sky.

To photograph fern sporangia, the frond must be turned over to expose them, with some degree of side lighting to emphasise their shape and texture. With the onset of spring the aerial parts of the fern grow very rapidly with the uncurling of the young fronds,

allowing interesting photographs to be taken at this stage in their development.

There is little doubt that for many nature photographers autumn is the favourite season, with a rich variety of landscapes and life-forms waiting to be photographed. However, the period when the autumn leaves are at their best may well be limited to a few days in Britain, before they are stripped from the trees by the wind. So keep your eyes open and seize every opportunity.

Above - Underside of fern frond showing the groups of spherical orange-coloured sporangia which contain the tiny spores. Photographed in woodland with diffused sunlight providing almost shadowless (but rather flat) lighting.

Opposite - Carpet of flowering cherry (Prunus sargentii) leaves after rain. I set up the camera with the film plane parallel to the ground to obtain maximum sharpness across the frame.

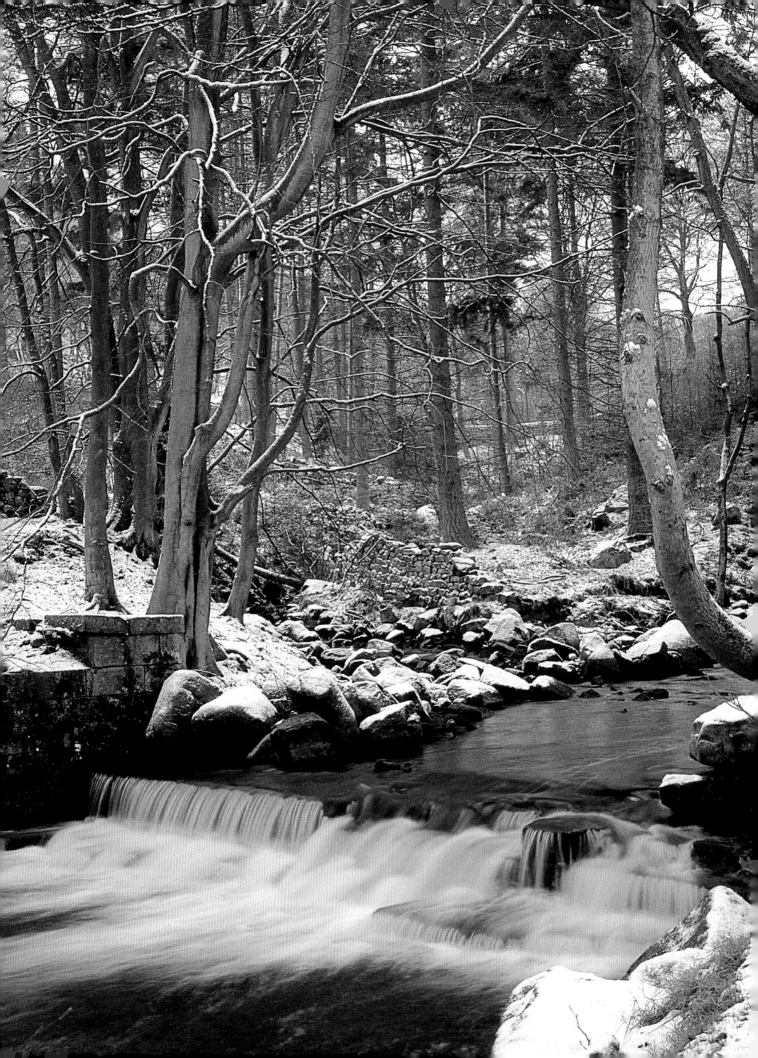

WINTER

'When icicles hang by the wall
And Dick the shepherd blows his nail,
And Tom bears logs into the hall,
And milk comes frozen home in the pail...'

WILLIAM SHAKESPEARE

For many people winter is a depressing season as temperatures fall below freezing, the days have become short, the hours of sunshine reach an annual low and are replaced by rain, sleet or snow. Some unfortunate folk suffer from 'seasonal affective disorder'; others travel to warmer climes. Many trees and shrubs have already shed their leaves and taken on their winter appearance. Trees stand skeletal against the skyline and identify themselves by their shape and the outline of their twigs and branches. For example, the ash has a broad spreading crown with long smooth twigs and black buds; the beech has a massive domed crown with a delicate tracery of fine branches leading to long slender cigar-shaped buds; while the mighty horsechestnut spreads its branches low and then turns them up to terminate in the familiar large sticky buds.

Most shrubs are dormant, having dispersed their fruits and seeds some months previously, yet, fortunately for the birds, there are still berries available: privet, rowan, yew, holly, juniper, mistletoe and wild rose.

At this time of year the bird population has stabilised as far as range of species goes, although their overall numbers decrease as winter takes its toll. Winter visitors such as geese, ducks, Iceland redwings, snow buntings and redpolls from the Arctic have migrated south to the warmer winter climate of Britain. Others which winter with us have travelled from northernmost Europe; they include many songbirds such as blackbirds, song thrushes, chaffinches, redwings and robins. Most numerous are starlings which join the resident population in large numbers.

In addition to the winter visitors we have a fairly stable population of permanently resident birds. Some

River, trees and a little snow combine to make an attractive picture. An aperture of f/11 and an exposure of 1/15 s produced a good depth of field.

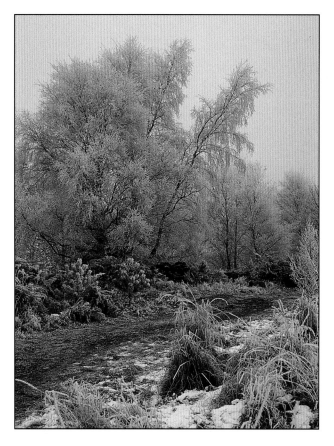

A foggy night and freezing temperatures resulted in a widespread hoar-frost the following morning. Alas, there was no sun or blue sky to highlight the frost but I still made a few exposures. The following day it had all gone. Standard 50 mm lens, camera and tripod.

of the more common ones found in gardens and parks include the song thrush, blackbird, robin, dunnock, tree and house sparrows, wren, tits and finches, magpie, starling, black-headed gull, tawny owl, collared dove and the ubiquitous feral pigeon.

With the approach of winter, amphibians and reptiles find a cosy place in which to hibernate. Older frogs and toads usually forsake the water, preferring a hole in the ground or the warmth and insulation of a compost heap. Snakes, lizards and slow-worms survive the winter beneath dead leaves and bracken. As water freezes from the surface down, aquatic creatures can survive for many weeks below the surface ice.

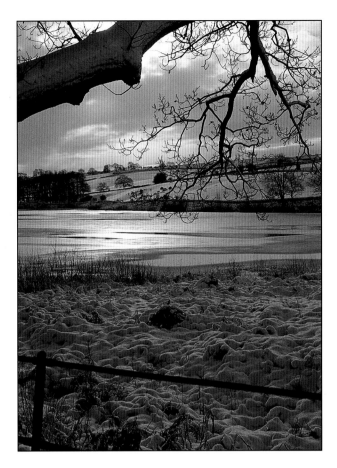

Late afternoon shot of a frozen lake. The weak sun is directly in front of the camera but blocked by the bough of a tree. The overall blueness was not filtered out by a warming -up filter as it added an appropriate coldness to the winter scene.

Some mammals, for example hedgehogs, are true hibernants, spending the winter curled up and dormant in their leafy moss-lined nests. Gradually their breathing rate drops from around 50 per minute down to 5-8 per minute, while their heart rate sinks from 100-150 beats per minute to around 20 beats per minute. Body temperature falls, and oxygen uptake decreases to about five per cent of the normal requirement. This is true hibernation, and normally lasts until the warmth of spring brings it to an end. Dormice and bats behave in a similar manner. Badgers have a shallower winter sleep, and wake up and forage for food on temperate evenings.

Mammals such as rabbits, hares, squirrels, foxes, stoats and weasels are much more active during the winter. They all experience great difficulty finding food, particularly when the ground is frozen or snow-covered. Rodents resort to stripping the bark from young shrubs and trees, while urban foxes raid dustbins and refuse tips. Yet despite the weather and the apparent scarcity of animal life, most nature photographers find winter a very exciting season,

providing a wide range of photo-opportunities. These include winter landscapes, tree silhouettes, ice and frost on leaves and berries, winter-flowering plants, garden birds, and household pets. They may also profit from visits to tropical houses.

Winter landscapes

During the winter months in Britain the sun never climbs very high in the sky, and when it shines it provides long soft shadows. Frontal lighting is traditional and safe, and guarantees uniform illumination, but because the shadows are immediately behind the subject the result is flat and lacking in contrast. Low-angle lighting from the winter sun can highlight texture and give a distinctive quality to the picture. Backlighting can be even more exciting, if you can prevent any stray, non-image forming light from striking the surfaces of the lens elements by using a good lens hood.

Some of the most attractive and atmospheric winter scenes are available when mist, ice or snow are added to the otherwise bare landscape. The texture of the snow in the photograph (left) is highlighted due to its uneven surface and the direction of the sun. To achieve the best composition I had to wait quite a while until the sun was directly behind the tree bough. Although the light level was quite high I still used a tripod and a cable release for the shutter.

A river, trees and a little snow can often make a pleasing picture. As the (Western) eye tends to scan a page from left to right we meet the rushing water head-on. Had the picture been reversed right to left, the eye would follow the river down to the right and out of the frame. To obtain maximum depth of field I used a small aperture, with a longish exposure which smoothed out the surface of the river (page 118).

In Britain the weather can change rapidly. A miserable foggy evening followed by a quick drop in temperature can produce a 'winter wonderland' the following morning. You need to be out early to catch the full glory of the scene. The following day a rise in temperature will remove all traces of frost, leaving a very ordinary landscape (photograph page 119).

Low afternoon sun filtering through trees and mist can also result in an atmospheric scene, especially if there is snow to brighten the foreground. But (once again) don't allow direct sunlight to fall on the lens.

Woodland path in the late afternoon in midwinter. The morning mist had not cleared completely and the sun was still trying to burn its way through. With the sun behind a tree the possibility of lens flare was reduced, while the dusting of snow helped to lighten the foreground. Lens set at f/16 with an exposure of $^1/_2$ s.

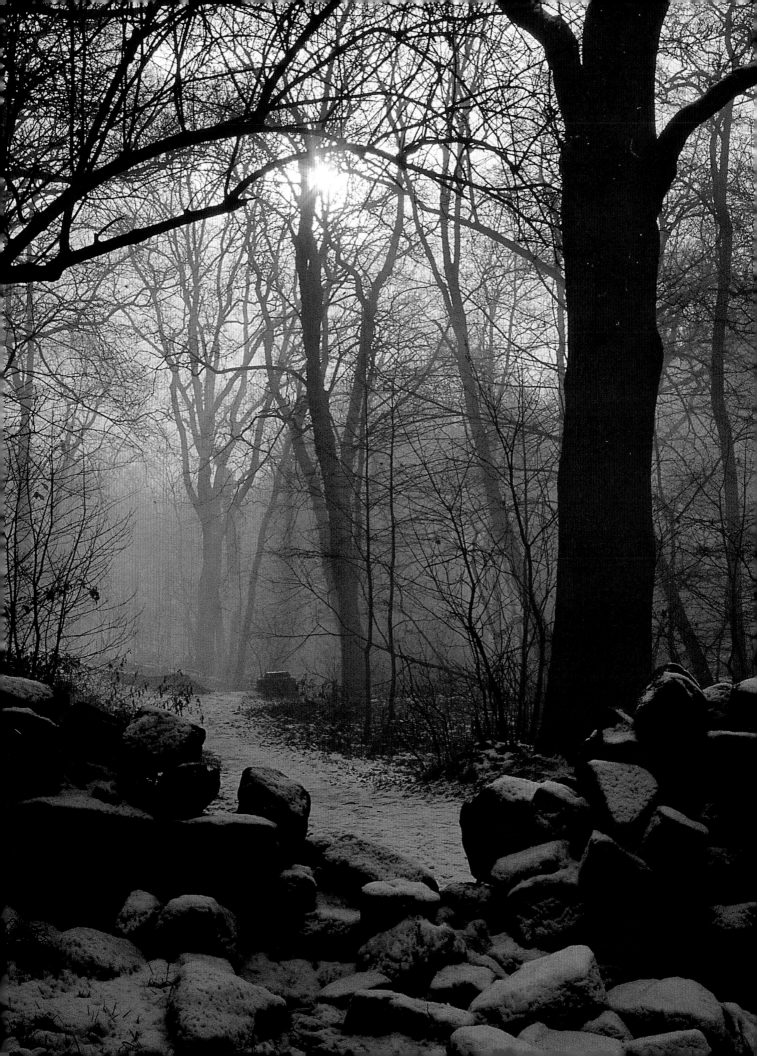

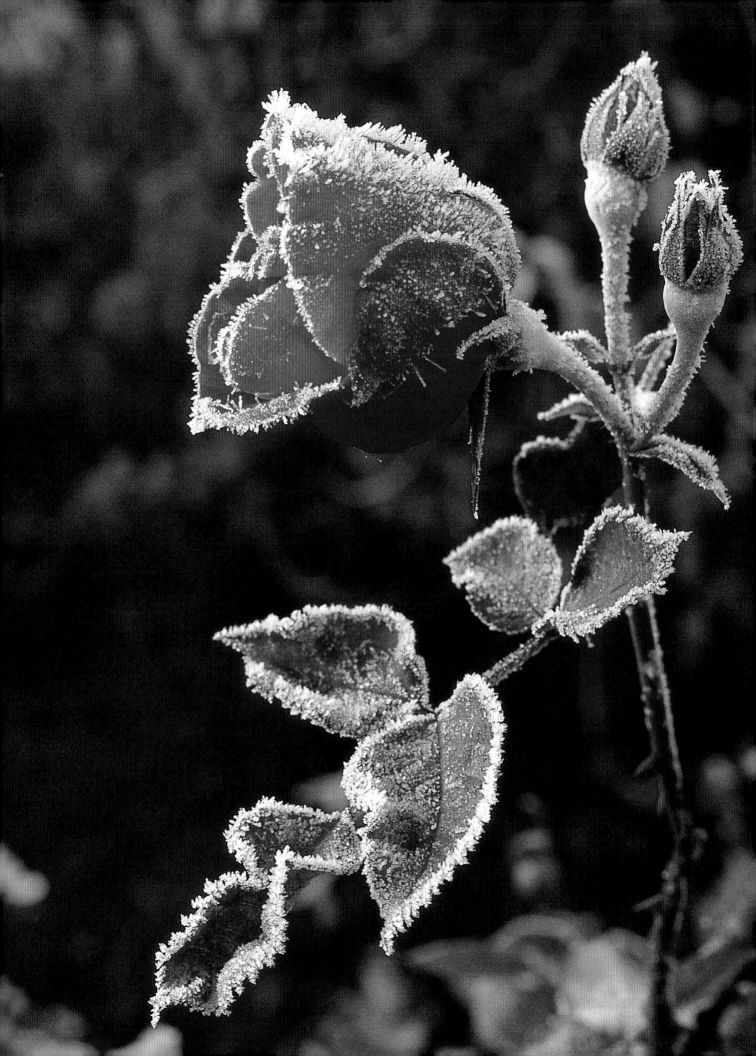

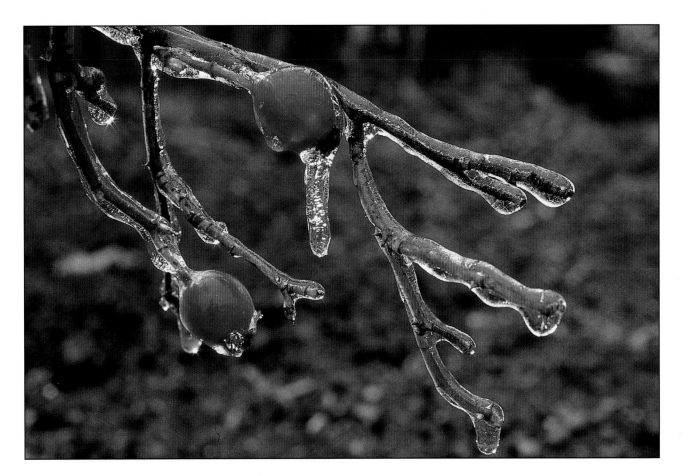

Producing interesting landscape photographs with a full covering of snow is not easy. Without the sun most scenes look flat, and even when the sun is shining frontal lighting merely makes the scene lighter. Ideally, the scene should be side or backlit to provide texture. When blue sky is reflected from snow it produces a violet-blue cast in the shadows, which (though natural) is not to everyone's liking. You can reduce the effect with an 81A (+15 mired) amber filter.

Highly reflective snow against bare trees and shrubs tends to result in a monochromatic effect, emphasising tone and composition. Moving the camera a few inches up, down or sideways can significantly alter the relative positions of near and distant objects. So don't be in too much of a hurry to press the shutter release. Find the right spot first.

All reflected-light exposure meters are calibrated to produce a correctly-exposed negative (or transparency) when the subject is reflecting 18% of the light falling on it. Snow, which reflects 70-80% of incident light, is bound to give an incorrect reading, resulting in an underexposed picture with the snow recorded as a dull grey mass. Bracket your exposure by up to two stops upwards, or take an exposure reading on a Kodak grey card. If your camera does not have an exposure override facility, set the

Above - Rose-hip twig fringed with ice, backlit by the late afternoon sun. The camera with its 90 mm macro lens was tripod-mounted. I used my hand to shield the lens from the sun, as the conventional lens hood was ineffective.

Opposite - Hoar-frost on a rose taken with the morning sun to the left and slightly behind the flower. A white reflector put a little light on the dark front surfaces of the petals and leaves. A 90 mm macro lens was used on tripod-mounted camera.

ISO film speed index two stops lower (e.g. ISO 100/21° to ISO 25/15°).

Hoar-frost on flowers and berries

Roses, a common sight through the summer and autumn until the end of November, are hardly given a thought by the nature photographer. But if foggy weather coincides with freezing temperatures roses are transformed, as the petals and leaves become fringed with ice crystals. On this occasion the fog had lifted by early morning, and the sun was shining brightly and almost backlighting the rose. I used a white reflector to throw a little light on the front surfaces of the rose petals. The hedge in the background was in the shade, which helped to highlight the rose and the ice crystals. A photograph of the rose-hip was taken at the same time. Again it was sunlight which highlighted the ice crystals.

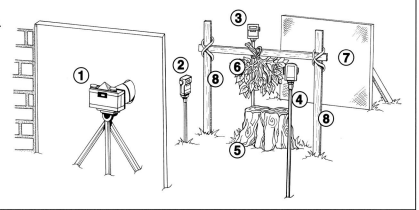

1 *Garage side door with hole for camera lens.*

2 *Fill-in flash at subject level.*

3 *Backlight flash (same strength as fill-in).*

4 *Main flash (2x strength of fill-in) positioned in the '45° portrait' position.*

5 *Tree stump baited with crushed peanuts.*

6 *Evergreen twigs to 'frame' the picture.*

7 *Background board spray-painted in dark browns and greens.*

8 *Support woodwork – anything available.*

On another occasion several years ago, freak weather conditions resulted in sheaths of clear ice forming around the stems of several garden shrubs and bushes. I removed a small rose-hip twig very carefully and set it up at ground level. As there was no sun I used a portable car spotlight as a backlight to add some sparkle. The ice sheaths stood out well against the dark natural background of the garden.

Birds in the garden

Bird photography is a specialised and time-consuming activity. If you are keen to make a start, the garden is the best place to acquire some of the basic skills. Looking through your living room window at a robin sitting on a spade handle, or a group of blue tits feeding from a peanut holder, you might imagine that they are unconcerned about human presence. But as soon as you walk into the garden they take flight, and will not return as long as you remain there. To photograph them you must get close without their being aware of your presence.

Attracting birds

During the winter months birds are preoccupied with finding food and water. When we provide these regularly, our avian friends will take up more or less permanent residence in our gardens.

In winter small birds such as robins and blue tits need to consume about 30 per cent of their body weight in food every day just to survive. Although soaked bread and table scraps are appreciated, such items as suet, mealworms, peanuts and mixed birdseed containing sunflower, millet, oatmeal, maize and wheat seeds will provide a much safer and better-balanced diet. This type of bird food, which is readily available in bulk from wild food specialists, can be placed in one of the many types of feeder available, sprinkled on a bird table, or simply scattered on the ground. Once you begin supplying food you must keep it up every day if the birds are to stand any chance of surviving

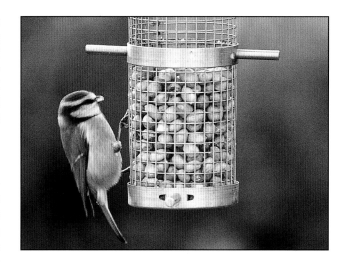

Above - Minimalist arrangement: no flash and a natural background. The head of the blue tit, Parus caeruleus, is slightly blurred due to movement and the whole image rather 'soft' in definition.

the winter. Fresh water is equally important, particularly in freezing weather.

Hides

A hide not only conceals you from the birds but also allows you to get close enough to obtain a reasonably large image on your film. Some of the most useful hides - garages, sheds, sunhouses - have been in place for many years and the birds are fully accustomed to them. I work from the far end of my garage behind a wooden door which opens on to the garden, making the conversion into a hide easy. I simply cut two holes (10 cm and 7 cm diameter) about 1 m above floor level; the former is large enough to take my 500 mm f/7.2 telephoto lens, and the latter serves as a viewing hole. Once the camera is set up on a tripod just behind the larger hole, it is much easier to view the bird activities through the other hole (sitting on a chair), than to be constantly peering through the camera viewfinder. If you are considering adapting a

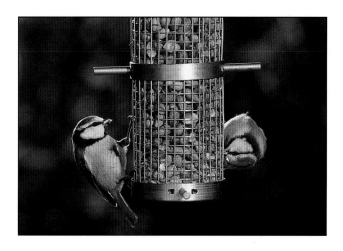

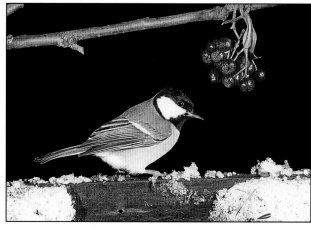

The Olympus OM2n camera was set on 'manual' and the flash used to supplement natural daylight. With the lens set at f/11, the exposure time was 1/8s.

Blue tit on snow-covered wood. This was a two-flash set-up (two highlights in the eye) but the flash could not penetrate the distant background which registered black.

sunhouse, or even your living room, as a hide, keep the windows covered to conceal you from the birds.

Should a suitable building not be at hand you can select a hide from the wide range available (see Appendix 1).

Lighting

In winter the overall light level is low, with photographic time being limited to about two hours before noon and three hours after; even this is possible only on bright sunny days. The low sun may present a problem if your permanent hide happens to face south with the afternoon sun shining directly into the camera lens. If so, you may need to pull the camera well back from the hole so that it acts as a lens hood.

Garden birds such as blue tits, finches and sparrows are fast movers, rarely resting for more than a fraction of a second. You will need a fast shutter speed to freeze the movement. As you also need a reasonable depth of field, you must reach the best compromise between lens aperture and shutter speed. Elimination of movement is the first priority. You have to learn to operate the shutter during the brief instant that the bird is stationary, and this calls for fast reflexes. It is worth while employing a higher speed film than usual (ISO200/24°) and accepting the penalty of higher granularity and lower contrast. The alternative is to use electronic flash, and I shall return to this later.

Photographic techniques for the garden

Several types of lighting are possible when photographing birds in the garden: natural daylight, a combination of daylight and flash, and flash on its own. If you're not using a hide you need natural

sunlight as the birds will be too far away for flash illumination to be effective. In the garden you have more control over lighting, but it is still a good training exercise to try working with daylight alone.

With this in mind I loaded ISO100/21° slide film, and using my 500 mm f/7.2 telephoto lens with the set-up shown on page 124 (minus the flash units and background board) I sat in the garage behind my hole in the door. During a five-hour session I shot half a roll of film. The exposure varied from 1/2 to 1/15 s at full aperture, and later, on examining the transparencies, I discovered that the majority showed blurred images, particularly around the birds' heads and beaks, as they pecked furiously at the peanuts in the feeder. The best result shows a small amount of head movement, very little depth of field and a slightly soft image.

For the second method you use a fill-in flash to brighten up the bird and benefit from the short flash duration. You can get away with a smaller aperture to obtain more depth of field, and include the middle distance background lit by the ambient light. Calculating the strength of the flash in relation to the lens aperture and shutter speed goes something like this. My flash unit (GN 20, in metres) was set to 'manual' and positioned two metres from the peanut feeder, resulting in a calculated lens aperture setting of f/11. This at first seems to be a full exposure by itself; but in fact, the manufacturers' guide numbers are based on indoor use, with plenty of reflecting surfaces. Out of doors you need to halve the guide number for a full exposure. Thus in these circumstances the flash is two stops underexposed. With the camera meter set to 'manual' you can then give the correct exposure for daylight, and the flash will now provide the appropriate amount of fill-in light for the shadows.

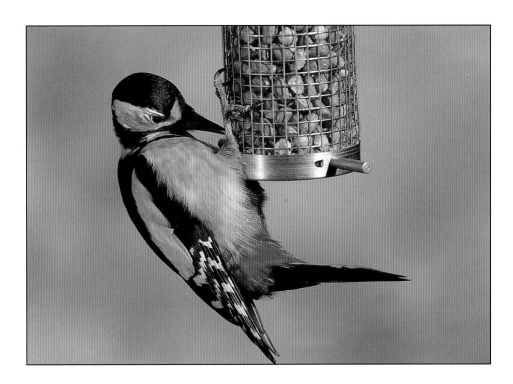

In theory this method should result in a well-exposed transparency with the bird emphasised by the flash. Unfortunately, unless you are working in bright daylight the exposure is likely to be 1/30 s or longer, which may be sufficiently slow to produce ghost images of the bird's head or body should it move during the exposure.

My preferred method of photographing birds in the garden during the winter months is the third alternative, namely to disregard the available light and use electronic flash as the only source of lighting. Skillfully arranged, it is possible to produce completely natural-looking pictures, and you can work late into the afternoon, when the ultimate limiting factor is the gradual dimming of the viewfinder image.

As a rule, I use the lighting arrangement which portrait photographers have employed successfully over the years, with the key light (one or two flash units) set up at 45° to the side and above the subject at a distance of 1-2 m. A fill-in flash is positioned slightly to the other side at the same level and the same distance from the subject. Occasionally I use a fairly high backlight to help separate the subject from the background. Even though the flash units are quite close to the birds they soon accept them and return again and again to the feeder unit. I fix a twig from a nearby shrub horizontally and suspend the peanut feeder from it. When a bird comes to feed it invariably alights on the twig first, surveys the scene, and when the coast is clear drops down on to the feeder. This allows me to take two different photographs, one of the bird on the twig and the other of it feeding.

Backgrounds

If a natural background is within one or two metres of the subject, you can probably use it as such. Anything much farther away will register very dark on the final image. Of course, you can illuminate the background using a separate flash unit, but you will probably use up a lot of film before you get the light balance right. I prefer to use an artificial background, positioned about two metres behind the subject, and consisting of a piece of 81 x 113 cm (32 x 44.5 in) art board or hardboard, sprayed in appropriate colours using car body spray paint. With practice you can make this appear indistinguishable from a natural background.

With the background board in position you should then look along the sight lines from the flash units through the feeder, twig and artificial supports, to ensure no shadows are going to fall on the background board.

With everything set up and working you now need to choose a camera position. You can work from inside the hide, using a 300-500 mm telephoto lens and operating the camera yourself, or set up the camera outside the hide, around 1.5 m from the subject with a 100 mm lens. Pre-focus the camera on the feeder unit and operate it remotely (page 31). This is a hit-and-miss approach, yet some good shots of birds in flight around the feeder can come out of it.

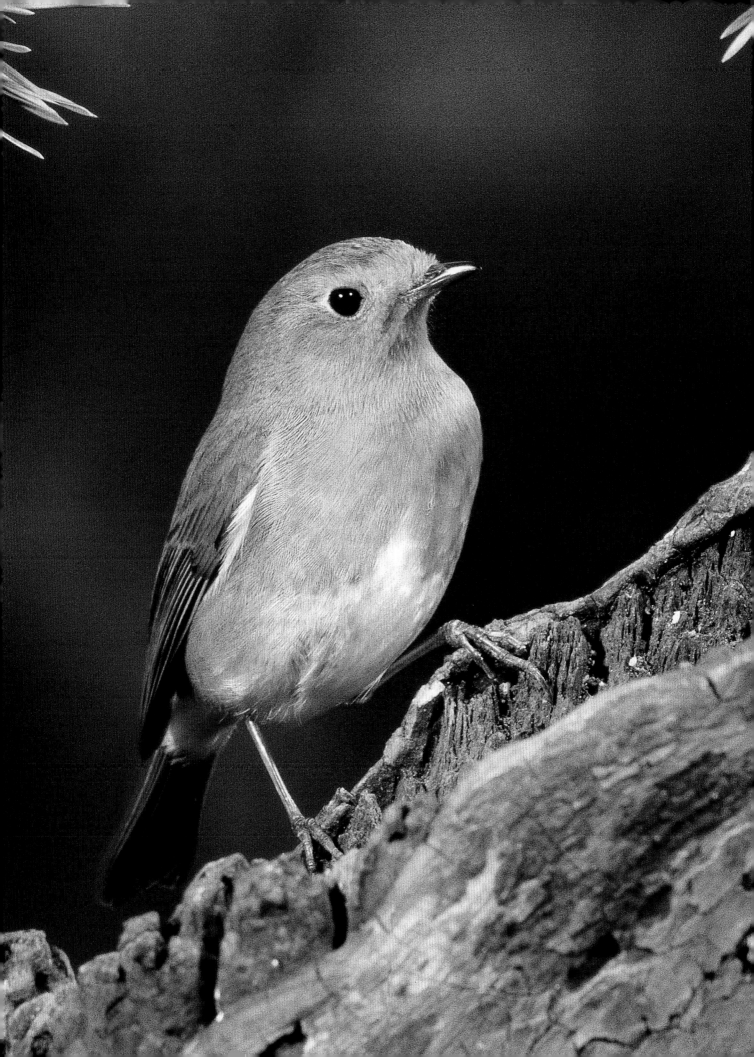

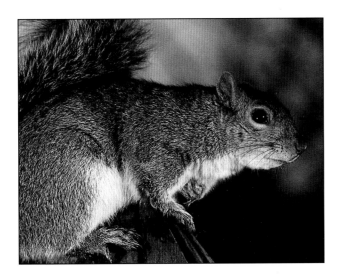

A grey squirrel, Sciurus carolinensis, perched on the pointed roof of the little bird house ready to move down to the food supply below. It was above my set-up, which explains the rather low lighting and the dull grey background.

The friendly little robin

This cheery little bird has a special place in the hearts of British gardeners, as it follows the spade hoping for juicy worms. Its continental cousin, however, is shy and prefers the cover of woodland. Robins feed on insects and their larvae, earthworms and some fruits and seeds, but the best bait to attract them is something small and moving. My technique is to set up a small platform and bait it with a few maggots from the local fishing tackle shop. Regular baiting will accustom the robin to visiting the table. After a while I fix a perch just above the table but out of shot and bait it with maggots. I use the flash arrangement described earlier, and operate the camera manually from behind my garage door.

The marauding squirrel

The flash units, set and background board in the garden provide a good opportunity to photograph a squirrel. My wife feeds the birds twice a day, but despite her best efforts much of the food is taken by the bushy-tailed raiders.

Squirrels are much easier to photograph than birds, as once they have found food they are happy to sit and gorge themselves. The two photographs illustrate the ways in which squirrels tend to be regarded by haters and lovers of the species. The first which depicts the squirrel as a tree rat, a marauding rodent causing severe damage to young trees, was taken as the squirrel was perched on the pointed roof of the bird house and was well out of my set-up area. The flash units were therefore tool low, tending to light the

underside of the squirrel, while the natural background is grey. The second photograph shows the lovable little squirrel in its classical tail-up pose. It made several visits to the peanuts concealed in a hole in the log before it decided to lift its tail, but when it did a fine picture was there for the taking.

Winter-flowering plants

Although most plants flower in the spring and summer months and die down in the autumn with the production of fruits and seeds, quite a number do flower in winter and early spring. These include the winter aconite with its yellow cup-shaped flowers; winter heliotrope with daisy-like pale pink flowers, winter iris with primrose-scented lilac flowers; winter jasmine with small bright yellow flowers; and witch hazel with its yellow crimped petals borne on leafless branches. There are also several flowering heathers such as Winter Heath, Pink Joy, White Glow and Winter Chocolate, all with tubular or bell-shaped flowers in pink, white or purple.

Among the smaller bulbs are several cultivated varieties of Hyacinthus orientalis (Pink Pearl, Jan Bos, Delft Blue and City of Haarlem) as well as some ten species of snowdrops, including varieties of Galanthus nivalis.

Finally, various cacti and succulents flower during the winter months including some species of aloe, the coral cactus, the perennial succulent Kalanchoe 'Wendy' with its clusters of hanging bell-shaped pinkish red flowers, and, of course, the popular Schlumbergera Bridgesii ('Christmas cactus') with its Chinese lantern-like purple-red flowers.

Photographing flowers out of doors

When photographing winter flowers indoors or out in the countryside, it is worthwhile attempting to produce more than just a pretty 'seed-packet' type of photograph. Examine the flower from different angles to find the most interesting viewpoint, one which communicates something of the essential nature of the flower. Unless you particularly want to illustrate the flowers in relation to their environment, with a mass of blooms photographed using a wide-angle lens, it is better to select just one or two flowers to concentrate on. Frontal lighting, as a rule, produces flat, boring images; backlighting will highlight translucent petals and hair-fringed leaf margins, while side lighting will emphasise surface texture. Soften strong sunlight by holding a sheet of tracing paper or a stretched white

The same squirrel a few minutes later, right in frame with its tail held high. A 75-300 mm zoom lens set at f/16 was focused manually from inside the garage. Three flash units were used.

The sprigs of white-flowered heather, a Calluna vulgaris, were part of a sizeable bush, and in order to isolate the two pieces shown, a blue board was slid behind them. Tripod-mounted camera with 90 mm macro lens. Exposure 1/8 s at f/11.

handkerchief between the sun and the plant, and lighten dark shadows using a white or foil-covered card as a reflector.

Artificial lighting, in the form of electronic flash or a hand-held video light, can be combined with daylight, and used either as a main light to improve the modelling on overcast days, or as a fill-in light on sunny days. Electronic flash is better, as the colour temperature matches that of daylight.

The area behind the flowers requires special attention, as a cluttered background can mar an otherwise good photograph. Watch particularly for anything incongruous such as an empty crisp packet, or a large very dark or light object which may not be obvious in the finder but will be obtrusive in the finished photograph. Areas of strong colour not associated with the flower can also be distracting, as can pieces of out-of-focus vegetation in the foreground.

Tall plants with coloured flowers are often best photographed from a low viewpoint using the blue sky as a background, whereas white flowers stand out more against a dark out-of-focus background. Use a fairly large aperture and check the sharpness of the background in the viewfinder; use the depth-of-field preview button. When the background is distracting, use a piece of background board, appropriately coloured.

Finally, when photographing flowers out of doors you may need wind protection. A few millimetres of wind-induced sway will move the subject out of focus. You can stabilise long-stemmed flowers using a cane and tape, or you can hold a piece of transparent Perspex sheet on the windward side of the plant. The ultimate wind protection device is a wire cloche with transparent PVC sides and top, but open ends. This is simply placed over the specimen, and is effective under quite blustery conditions.

Photographing flowers indoors

Flowers photographed near windows often require an artificial background to hide an unwanted garden gate, garage or bicycle shed. You can produce a striking effect with a piece of black velvet. This concentrates attention on the flowers, but does look somewhat artificial. As an alternative you can make up a selection of coloured background cards, but the final result should always look natural. Variations on 'straight' photography could include using a soft-focus lens attachment, or spraying the flowers with a water mist from a small plant sprayer, or even using pale blue, sepia, or tobacco colour filters (though this raises the question of artistic license). A suitable lens for this work would be a 50, 80 or 100 mm macro lens. The next best choice would be a good quality standard lens plus a close-up lens or a set of extension tubes (p. 33). There is nothing to be gained from using a fast film as the subject is static, and a slow film (ISO25/15°) will produce impressively-resolved fine detail and an overall smoothness of tone.

A flower of a Christmas Cactus, Schlumbergera Bridgesii, lit as in a portrait by diffused lighting provided by a flash unit with a white handkerchief fastened over it. The background was a piece of black velvet. A 90 mm macro lens was stopped down to f/16.

Above - A spray of freesias photographed in the conservatory in natural sunlight with an unobtrusive blue board background. It was important to arrange the spray so that the stamens and pistil in both flowers were in sharp focus.

Left - Perfectly-formed bilaterally symmetrical orchids photographed in a hot, humid orchid house. The camera and lenses needed to be warmed up before use to prevent moisture condensing on the surfaces (a hot air machine installed for spectacle wearers was pressed into action). The 90 mm macro lens and camera were set up with the film plane parallel to the face of the flowers, and natural daylight provided the lighting.

Reptiles and mammals

During the cold dark winter days, why not spend a little time indoors photographing some of the more exotic animals and plants from the tropical regions of the world? They are housed in large heated humidified buildings which are low on visitors during the winter, providing ideal conditions for the nature photographer to work undisturbed.

There are a few problems, however. The first concerns the instant misting up of the lenses and camera eyepiece and even the inside of the camera - and the film - as you leave the cold winter air and enter the tropical house. You must avoid this at all costs. Keep all the equipment on the car floor next to the heater to warm it up, and then carry it quickly, in an insulated holdall, into the tropical house.

Most reptiles, with the exception of tortoises and terrapins, are kept behind glass. The next problem, therefore, is how to photograph them without including unwanted reflections from the glass surface. The best method is to keep the camera lens close to the glass. The next problem is the cleanliness (or otherwise) of the glass. Go prepared, with a soft cloth and a spray container of window-cleaning fluid.

As the ambient light level is usually quite low I prefer to use flash and have the flexibility of using the camera without a tripod. When I took the photograph opposite above, I was working solo, and needed both hands to hold and focus the camera. I had to attach the flash unit to the top of the camera, resulting in somewhat flat frontal lighting.

Before leaving this subject I offer two tips. First, although the camera lens must be flat to the glass, you should tilt the flash unit slightly down, to avoid a direct reflection from the back of the enclosure, which if shiny will produce a hot spot on the image.

Opposite above - The common iguana, Iguana iguana, native to S. America, photographed through the glass of its enclosure. The hand-held camera was held with the lens flat to the glass which then acted like a plain glass filter. Flash was used with minus 2/3 stop exposure compensation.

Opposite below - An Eastern Chipmunk, Tamius striatus, a resident of SE Canada and E America, photographed through glass. The on-camera flash unit was tilted down slightly to avoid possible reflections from the back surface of the enclosure.

The golden hamster, Mesocricetus auratus, a popular household pet, nibbling a small nut. Electronic flash was used and the camera was hand-held.

Secondly, if the animal is fairly close to the glass it is likely to be overexposed and only the background correctly exposed. Bracket your exposure up to one stop downwards to compensate.

Tropical plants

When conditions are suitable tropical plants grow luxuriantly, producing flowers that are attractive in both structure and colour. You again need to pre-warm your camera and lenses to prevent them from misting up. Concentrate on just one or two flowers at a time, and study the subject carefully to ascertain the best camera angle. If the flower is basically flat (i.e. most of the petals are in the same plane), set up the camera with the film plane parallel to it so that all the petals are in focus, because the depth of field is quite shallow.

A macro lens is ideal for this type of work. A focal length of 90 or 100 mm will allow you to move a little further back from the flower, which will help the perspective and make it easier to throw the background out of focus. Use a tripod and cable release, as exposures are quite long (1/15 - 1/4 s), particularly if you are using a slow film. A hand-held video light (filtered for daylight balance if necessary) can add a little sparkle to what might otherwise be fairly uniform lighting.

Household pets

When the weather is cold, wet and dull out of doors nature photographers can turn their attention to photographing living creatures in the comfort of the home. I am thinking of pets such as hamsters, gerbils and mice, and ornamental fish, both cold-water and tropical.

If you want a natural-looking photograph of a pet such as a hamster, then you will need to remove the animal from its cage and place it in its natural environment. The picture above illustrates such a set-up. It consisted of a seed box filled with sand and planted with small cactus seedlings. The hamster was quite happy to roam about in the sand and even when it came out of the box was easily retrieved, in stark contrast to the fast-moving field mouse.

Tungsten illumination does not generate sufficient light to permit the use of both a small aperture and a short exposure. If you are aiming at producing a sharp

Orchids photographed in daylight supplemented by hand-held video light. As each flower is very three dimensional I focused on the most interesting part, the lower petal or lip of each flower. I stopped the lens down to f/22 to produce maximum depth of field, with an exposure of 1s on ISO 100 film.

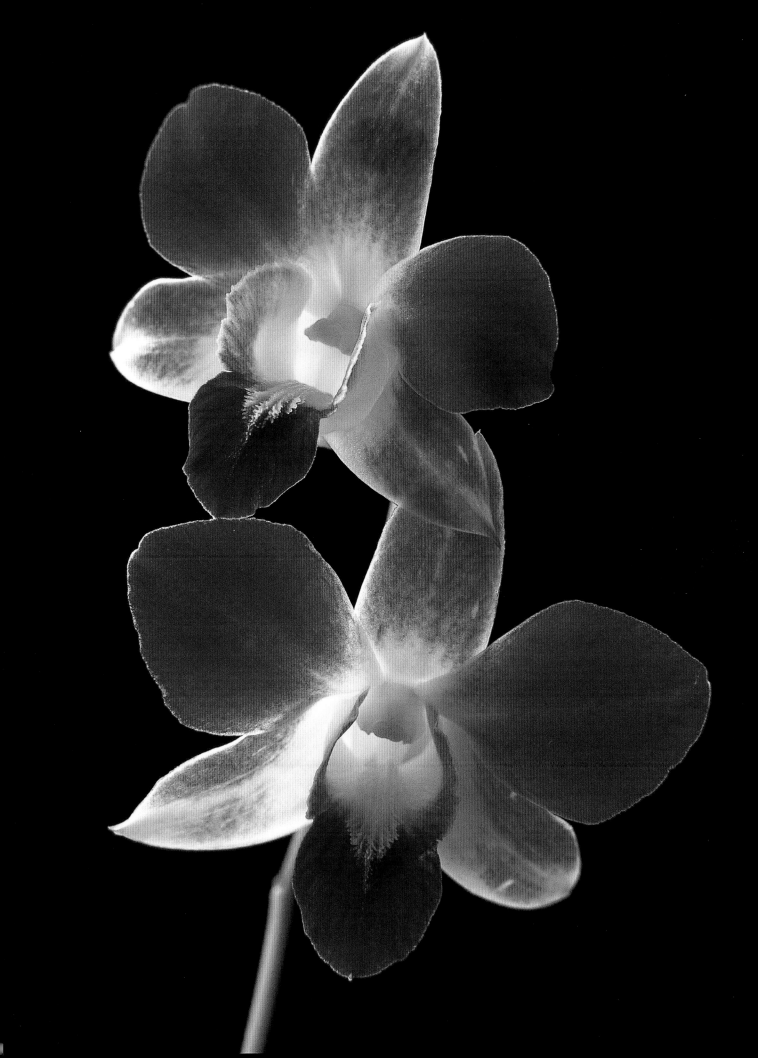

Above - Gerbil photographed through the glass of an aquarium using an off-camera main flash unit and a rear backlight flash.

Right - The family pet, a Tibetan spaniel, photographed in the living room against a dark (too dark!) background board. A two-flash set-up with the main light in the 45° frontal position and the smaller fill-in unit at the right and slightly behind the dog.

image with a good depth of field then you need electronic flash. Try a flash unit in the 45° frontal position, with a second less powerful unit at subject level and at 90° to the main light. Use the camera hand-held, so that you can follow the animal's movements more easily.

Photographing a pet such as a dog or a cat requires a rather different approach, as the home is its natural environment, and to photograph it on its favourite chair or in its basket is perfectly acceptable. Again, electronic flash is simplest and best, using either two units as described above, or a single unit as key light and a reflector as fill-in. Close-ups of pets can be very arresting, but focusing can be tricky. Focus on the eyes, and, if the animal has a fairly flat face, stop down the lens to f/8-11 to include the nose and whiskers in the zone of sharp focus. Most dogs have elongated skulls, and in full face it is virtually impossible to have both eyes and nose in focus. Take the photograph from slightly above the animal's head, or go for a semi-profile rather than a fully-frontal shot. A two-flash arrangement is again appropriate, possibly using a third flash as a backlight ('kicker') to separate the head from the background.

Cold-water and tropical fish

Keeping fish in an aquarium is popular, and many people find peace and tranquillity in contemplating the fish slowly swimming around in the clear water. Photographing your fish through the front of the aquarium is not difficult if you bear in mind that these creatures are moving in three dimensions. The main problems are keeping them in focus and avoiding unwanted reflections. To produce an acceptably large image you need to work close to the subject, and the depth of field will be very small. You will therefore need to devise some means of keeping the fish within the zone of sharp focus. The best method for smallish free-swimming fish is to place a glass or Perspex sheet, approximately the same length and height as the aquarium, in water about 5 cm (2 in) behind the front surface. This allows the fish complete freedom of movement in two dimensions but limits it in the third dimension. You need to match the spacing to the size of the fish, of course; for tiny tropical fish about 2 cm is sufficient. You can also use the glass cell devised for marine life (page 87). As the volume of water in front of the glass sheet is rather small, it will soon become depleted of oxygen if several active fish are present, and you should remove it as soon as you have made your exposure.

Unwanted reflections on the front of the aquarium can arise from the immediate surroundings (windows and glass-panelled doors), the camera itself, and the source of illumination. The window problem can be solved by blacking out, and you can check its effectiveness in the viewfinder. To eliminate reflections of the camera and yourself, take a piece of black card some 25 cm (10 in) square, cut a round hole in it and fit it over the lens barrel. Position the key light above and slightly in front of the aquarium. This will produce illumination similar to that found in the natural environment, and should not produce unwanted reflections. This simple overhead lighting,

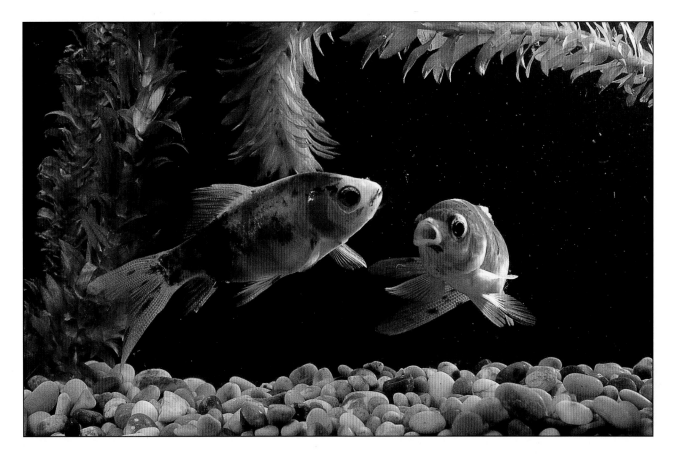

although intended to simulate sunlight, often produces flat results. Two or more lights will give more effective illumination and, if the aquarium has accessible glass sides, a light can be directed through each end, producing a pleasant modelling effect.

Always use electronic flash, because the flash provides a high level of illumination and a very short exposure time, important in this type of work. You will also find it improves the picture if you stand a coloured (or black) card behind the tank to act as a background, with the colour selected to emphasise the mood of the photograph.

The photographs in this section were taken using electronic flash (usually two units) linked by 2 m (6 ft 6 in) flash leads to a hand-held camera. By not using a tripod I followed the fish around the aquarium, making exposures at the appropriate moment.

In this chapter, I have tried to demonstrate that you can take many interesting photographs during the winter months if you are prepared to face the elements and go out into the local countryside. And when the weather outside is unsuitable for photography you can do much stimulating work in your own home.

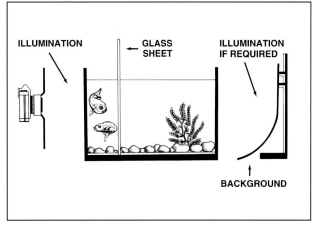

Top - Two Israeli Shabunkins limited in their out-of-plane movements by a glass sheet positioned some 6 cm behind the front surface, but allowing space for the fish to turn easily. Two flash units were used.

Above - Set-up for photographing fish in an aquarium. Note the position of the glass sheet insert and the supported background.

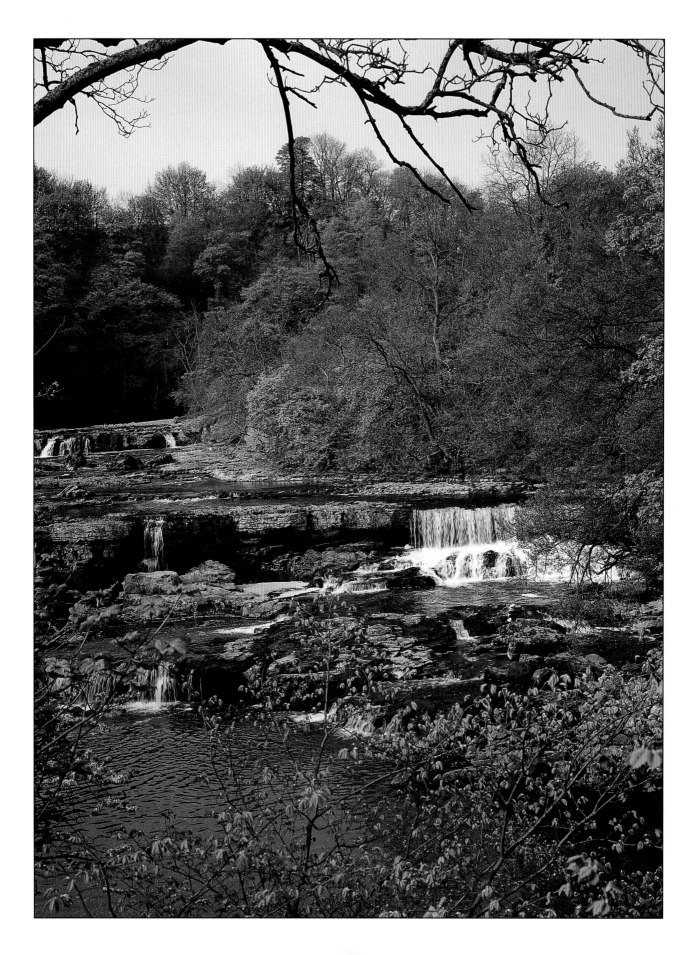

ACKNOWLEDGEMENTS

n common with most photographers I am an avid reader of photographic books and magazines and over the years much of my knowledge has been gained in this way. I would like to express my gratitude to three nature or wildlife photographers - Heather Angel, Stephen Dalton and Laurie Campbell - whose writing and photographs have been a constant source of pleasure and inspiration to me.

My thanks to Dr. Allan Calder and Dr. Mike Kelly, both keen amateur photographers, for their interest and support throughout this project, Olympus Optical (U.K.) Ltd. for providing the diagram on page 17, and Andy Rouse for his photograph of a badger on page 68.

I am greatly indebted to the late Aileen Edwards and to Juliet McIntosh who typed my handwritten script with great care and accuracy, correcting a few spelling errors on the way. I am extremely grateful to my publisher, Harry Ricketts of Fountain Press, who not only provided me with the opportunity to write this book, but gave invaluable support and advice throughout its preparation. My special thanks to Dr. Graham Saxby who, with great diligence and expertise, read and edited the entire manuscript and made several useful suggestions. Thanks also to Grant Bradford who has done such an excellent job on the design and layout of the book.

Finally, my special thanks to my wife, Margaret, who never complained about my total commitment in time and thought to the project, while many household tasks had to be re-scheduled because of it.

Arnold Wilson

Leeds 1997

Opposite - And the Earth awakes to Spring again. Aysgarth Falls, Yorkshire Dales.

BIBLIOGRAPHY

Angel, H. 1992. **The Book of Nature Photography.** Ebury Press, London.
A first-class book with lots of practical tips and illustrations on technique supported by superb photographs. Most animal and plant groups included plus sections on composition, lighting, art in nature and global environmental considerations.

Beames, I. 1995. **Nature Photographer's Handbook.** David and Charles, Newton Abbot.
A unique book which combines in a very informal way both natural history and photography. It covers the ecology of Britain's main habitats, with excellent photographs of the areas and some of the animals and plants to be found there. There are many maps showing either species distribution or the locations of good examples of each habitat.

Campbell, L. 1990. **Guide to Bird and Nature Photography.** David and Charles, Newton Abbot.
Scottish wildlife photographer renowned for his very high-quality photographs taken outdoors in all weathers. First part of this very readable book concentrates on equipment and techniques, while the second part discusses the problems of working in the field. Superbly illustrated.

Dalton, S. 1982. **Caught in Motion.** Weidenfeld and Nicolson, London.
Stephen Dalton, world expert on high-speed nature photography, developed a unique high-speed flash set-up which could 'freeze' any bird or animal in mid-flight or mid-leap. The resulting images (insects, birds, amphibians, reptiles and bats) are bitingly sharp and beautifully composed - a joy to behold.

Dalton, S. and Bailey, J. 1989. **At the Water's Edge.** Random House, London.
A year in the life of the organisms in one small ecosystem lavishly illustrated with critically sharp action photographs. Natural history and ecology text clearly written by biologist Jill Bailey.

Delly, J.G. 1988. **Photography Through the Microscope.** Eastman Kodak, Rochester, NY.
Although still a slim volume, this ninth edition is packed with useful information on all aspects of the subject from the structure and handling of the basic compound microscope to the choice of cameras, control of colour and exposure and image enhancement techniques. New material includes microcircuit photomicrography and updated film data. A closely-written text with many helpful diagrams and interesting (but largely assignated) photomicrographs.

Izzi, G. and Mezzatesta, F. 1981. **The Complete Manual of Nature Photography.** Harper and Row, New York.
A very useful reference book covering a vast range of nature photography subjects from mountain peaks and deep-sea fish to micro-organisms as seen through a microscope. Includes detailed technical information in words, diagrams and charts.

McCarthy, S. 1994. **Nature and Wildlife Photography.** Allworth Press, New York.
A useful wide-ranging book with an eye on the commercial market. Text very readable but only a few black-and-white photographs included. Concludes with interesting and informative interviews with a dozen or so leading wildlife photographers, including one British photographer, Heather Angel.

Mcdonald, J. 1994. **Designing Wildlife Photographs.** Amphoto, New York.
A particularly interesting book with a strong emphasis on composition in relation to subject placement and background characteristics. Part One covers the fundamentals of the subject, while Part Two concentrates on the vertebrate classes from amphibians to mammals, illustrated by stunningly beautiful and well-composed animal portraits.

Meehan, J. 1994. **The Art of Close-Up Photography.** Fountain Press.
Clearly written, easy-to-read book with the emphasis on equipment, materials and technique. Excellent nature photography (mainly plant material) by Art Gingert interspersed with interesting abstract images. A large-format quality publication.

Peterson, B.M. 1993. **Nikon Guide to Wildlife Photography.** Silver Pixel, Rochester, NY.
Friendly, informed text interspersed with illustrative colour photographs. Most of the book concentrates on equipment and technique; the remainder deals with photographing specific organisms from the savannah sparrow to the bald eagle, and from the tiny harvest mouse to the mighty bison. The book is confined to photography of birds and mammals.

Thompson, G. and Oxford Scientific Films. 1981. **Focus on Nature.** Faber and Faber, London.
A superb book by the world-acclaimed Oxford natural history film makers headed by Gerald Thompson, founder member and senior director of the group. Each chapter is written by an acknowledged expert in their respective field and is illustrated by outstanding photographs. Many of the special sets and equipment designed by the group are described in detail and accompanied by photographs.

Warham, J. 1983. **The Technique of Bird Photography.** Focal Press, Oxford.
Classic book now into its fourth, much updated, edition. Written by a famous bird photographer, it covers all aspects of bird photography, including a fascinating historical introduction, and is lavishly illustrated with excellent photographs and diagrams.

APPENDIX 1

Equipment and cameras

M Billingham & Co. Ltd., Little Cottage St., Brierley Hill, West Midlands. DY5 1RG. Tel: 01384 482828
Camera bag manufacturer.

Canon (UK) Ltd. (Photo Dept.), Brent Trading Estate, North Circular Rd., Neasden, London N10 0JF. Tel: 0181 459 1266
Cameras and accessories.

C.Z. Scientific Instruments Ltd., P.O. Box 43, 1 Elstree Way, Borehamwood, Herts. WD6 1NH Tel: 0181 207 5888
U.K. distributor of Sigma Cameras and Lenses

Jamie Wood Products Ltd., Cross Street, Polegate, E. Sussex BN26 6BN. Tel: 01323 483813
Fenman and other hides.

Johnsons Photopia, Hempstalls Lane, Newcastle-under-Lyme, Staffordshire, ST5 0SW. Tel: 01782 717100
U.K. importers of Tamron lenses and Mamiya cameras.

Lakeland Microscopes. Rockland Road, Grange-over-Sands, Cumbria LA11 7HR. Tel: 01539 534737
Large range of microscopes, slides and chemicals.

Lastolite Ltd., 8, Unit 8, Vulkon Court, Hermitage Industrial Estate, Coalville, Leicester LE67 3SW. Tel: 01530 813381
Portable reflectors and diffusers.

Mazof, 61 Tytherton Road, London N19 4PZ. Tel: 0171 263 3837
High speed camera triggers.

Minolta (UK) Ltd., 1-3 Tanners Drive, Blakelands North, Milton Keynes MK14 5BU. Tel: 01908 200400.
Cameras, lenses and accessories.

Nikon (UK) Ltd., Nikon House, 380 Richmond Road, Kingston-on-Thames, Surrey, KT2 5PR. Tel: 0181 541 4440
Cameras, lenses and accessories.

Northern Biological Supplies, 3 Betts Avenue, Martlesham Heath, Ipswich, IP5 7RH. Tel: 01473 623995
Slides, specimens, instruments and microscopy kits.

Olympus Optical Co. (UK) Ltd., 2-8 Honduras Street, London EC17 0TX. Tel: 0171 253 2772
Olympus cameras, lenses and accessories

Paterson Photax Ltd., Vaughan Trading Estate, Tipton, W. Midlands DY4 7UJ. Tel: 0121 522 2120
Benbo tripods and photo accessories

Philip Harris Ltd., Lynn Lane, Shenstone, Staffordshire WS14 0EE. Tel: 01543 480077
Large range of microscopes, both British and foreign, Longworth trap, laboratory equipment.

RS Components Ltd., P.O. Box 99, Corby, Northants, NN17 9RS. Tel: 01536 201201
Electronic components for light-beam switch.

Wildlife Watching Supplies, Town Living Farmhouse, Puddington, Tiverton, Devon EX16 8LW. Tel: 01884 860692
Camouflage materials, leafscreens, belts, webbing, etc.

Worldwide Butterflies Ltd., Over Compton, Sherborne, Dorset. Tel: 01935 74608
British and tropical butterflies and moths.

Useful organisations

The Licensing Section, English Nature, Northminster House, Peterborough, PE1 1UA. Tel: 01733 340345

The Department of the Environment for Northern Ireland Parliament Buildings, Stormont, Belfast, Northern Ireland DT4 3SS. Tel: 01232 63210

The Countryside Council for Wales, Plas Penrhos, Fford Penrhos, Bangor, Gwynedd LL57 2LQ. Tel: 01248 370444.

Scottish National Heritage, 12 Hope Terrace, Edinburgh EH9 2AS Tel: 0131 447 4784

The Royal Society for Nature Conservation, Wildlife Trust Partnership, The Green, Wiltham Park, Waterside South, Lincoln LN5 7JR. Tel: 01522 544400

The Royal Society for the Protection of Birds, The Lodge, Sandy, Bedfordshire, SG19 2DL. Tel: 01767 680551

World Fund for Wildlife (WWF), PO Box 49, Burton-upon-Trent, Staffordshire, DE14 3LQ. Tel: 01283 506105

American suppliers and organisations

Equipment and cameras

Bausch & Lomb Incorporated, 635 St Paul Street, Rochester, New York 14602.
Microprojectors, microscopes, other special scientific instruments.

Carolina Biological Supply Company, 2700 York Road, Burlington, North Carolina.
and Box 7, Gladstone, Oregon.
Biological models, microscopes, and laboratory equipment

General Biological Supply House, Inc. (Turtox), 8200 South Hoyne Avenue, Chicago 20, Illinois.

Canon USA, One Canon Plaza, Lake Success, NY 11042. Tel: 516 488 6700

Mamiya America Corporation, 8 Westchester Plaza, Elmsford, NY 10523. Tel: 914 347 3300

Minolta Corporation, 10 Williams Drive, Ramsey, NJ 07446. Tel: 201 825 4000

Nikon Inc., 1300 Wall Whitman Road, Melville, NY 11747-3064. Tel: 516 547 4200

Olympus Corporation, Crossways Park, Woodbury, NY 11797. Tel: 800 221 3000

Sigma Corporation of America, 15 Fleetwood Court, Ronkonkoma, NY 11779. Tel: 516 585 1144

Specialist equipment

Bogen Photo Corporation, 565 East Crescent Ave., Ramsey, NJ 07446. Tel: 201 818 9500
Bogen/Manfrotto tripods, clamps, stands, Metz flash & accessories.

Ivan Eberle, P O Box 51307, Pacific Grove, CA 93950-6307. Tel: 408 373 8476
Light-beam trigger set-ups.

A. Kenneth Olson, 3 Woodhill Ln., St Paul, MN 55127 2140. Tel: 612 484 0151
Custom-made high-voltage, ultra-high-speed flash units and electronic control units.

Protech Inc., 5710-E General Eashington Hwy., Alexandria, VA 22312. Tel: 703 941 9100 Fax: 703 941 8267
Dale Beam triggers.

Saunders Group, 21 Jet View Drive, Rochester, NY 14624. Tel: 716 328 7800
Benbo, Domke, Lepp, Patterson, Wein triggers and slave units.

Quantum Instruments, 1075 Stewart Av., Garden City, NY 11530. Tel: 516 222 0611
Rechargeable battery packs, radio slaves and triggers.

Conservation organisations

National Wildlife Federation, 1400 16th St. NW., Washington, DC 20036-2266. Tel: 202 797 6800

Nature Conservancy (US), 1815 North Lynn St., Arlington, VA 2209. Tel: 703 841 5300

Wildlife Conservation International, New York Zoological Society, 185th St. and South Blvd., Bronx, NY 10460. Tel: 718 220 5155

World Wildlife Fund (US), 1250 24th St. NW, Washington, DC 20037. Tel: 202 293 4800

APPENDIX 2

UK Wildlife Protected under the Wildlife and Countryside Act of 1981

Birds specially protected at all times

Avocet
Barn owl
Bearded tit
Bee-eater
Bewick's swan
Bittern
Black-necked grebe
Black redstart
Black-tailed godwit
Black tern
Black-winged stilt
Bluethroat
Brambling
Cetti's warbler
Chough
Cirl bunting
Common quail
Common scoter
Corncrake
Crested tit
Crossbills (all species)
Dartford warbler
Divers (all species)
Dotterel
Fieldrare
Firecrest
Garganey
Golden eagle
Golden oriole
Goshawk
Green sandpiper
Greenshank
Gyr falcon
Harriers (all species)
Hobby
Honey buzzard
Hoopoe
Kentish plover
Kingfisher
Lapland bunting
Leech's petrel
Little bittern
Little gull
Little ringed plover
Little tern
Long-tailed duck
Marsh warbler
Mediterranean gull
Merlin
Osprey
Peregrine
Purple heron
Purple sandpiper

Red-backed shrike
Red kite
Red-necked phalarope
Redwing
Roseate tern
Ruff
Savi's warbler
Scarlet rosefinch
Scaup
Serin
Shorelark
Short-toed tree-creeper
Slavonian grebe
Snow bunting
Snowy owl
Spoonbill
Spotted crake
Stone curlew
Temminck's stint
Velvet scoter
Whimbrel
White-tailed eagle
Whooper swan
Woodlark
Wood sandpiper
Wryneck

Birds specially protected during the closed season

Goldeneye
Greylag goose (in Outer Hebrides, Caithness, Sutherland and Western Ross only)
Pintail

Specially protected animals

Mammals

Bats (all fifteen species)
Bottle-nosed dolphin
Common dolphin
Common otter
Harbour (or common) porpoise
Red squirrel

Reptiles

Sand lizard
Smooth snake

Amphibians

Great crested (or warty) newt
Natterjack toad

Fish

Burbot

Butterflies

Chequered skipper
Heath fritillary
Large blue
Swallowtail

Moths

Barberry carpet
Black-veined
Essex emerald
New Forest burnet
Reddish buff

Other insects

Field cricket
Mole cricket
Norfolk aeshna dragonfly
Rainbow leaf beetle
Wart-biter grasshopper

Spiders

Fen raft spider
Ladybird spider

Snails

Carthusian snail
Glutinous snail
Sandbowl snail

Specially protected plants

Adder's-tongue spearwort
Alpine catchfly
Alpine gentian
Alpine sow-thistle
Alpine woodsia
Bedstraw broomrape
Blue heath
Brown galingale
Cheddar pink
Childling pink
Diapensia

Dickie's bladder-fern
Downy woundwort
Drooping saxifrage
Early spider orchid
Fen orchid
Fen violet
Field cow-wheat
Field eryngo
Field wormwood
Ghost orchid
Greater yellow-rattle
Jersey cudweed
Killarney fern
Lady's-slipper
Late spider orchid
Least lettuce
Limestone woundwort
Lizard orchid
Military orchid
Monkey orchid
Norwegian sandwort
Oblong woodsia
Oxtongue broomrape
Perennial knawel
Plymouth pear
Purple spurge
Red helleborine
Ribbon-leaved water-plantain
Rock cinquefoil
Rock sea lavender (two rare species)
Rough marsh-mallow
Round-headed leek
Sea knotgrass
Sickle-leaved hare's-ear
Small Alison
Small hare's-ear
Snowdon lily
Spiked speedwell
Spring gentian
Starfruit
Starved wood-sedge
Teesdale sandwort
Thistle broomrape
Triangular club-rush
Tufted saxifrage
Water germander
Whorled Solomon's-seal
Wild cotoneaster
Wild gladiolas
Wood calamint

INDEX